WATERBURY
IRISH

WATERBURY
IRISH

From the Emerald Isle to the Brass City

Janet Maher with John Wiehn

THE
History
PRESS

Published by The History Press
Charleston, SC 29403
www.historypress.net

Front cover: John Thomas Shea and other workers pose in front of an unidentified factory, presumed in Waterbury, to which he immigrated in 1892.

First published 2015

Manufactured in the United States

ISBN 978.1.62619.735.0

Library of Congress Control Number: 2015945059

For the descendants of Waterbury Irish,
may they discover their stories and work for peace and progress in our multiethnic
present and future.

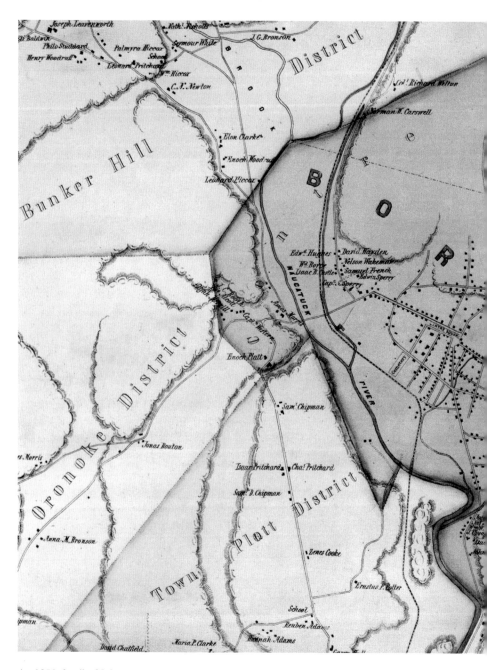

An 1852 detail of Waterbury map. *Courtesy of Mattatuck Museum, Waterbury, Connecticut.*

Norman Allen

Ira Frisbie

Riley Alcott

Reuben Brown
Turner & Hine
Alex Lynch

Leonard Warner

Jared Warner

Sophia Curtis
Lucius Curtis

Dr. Platt
Edw. Robinson
Longhill Barns

Heirs of
Danl. Frisbie

Mark Warner

Alex. McNeill

Jos. Bronson

Plain District

Horace Porter
D. B. Hurd
Geo. E. Lewis
Geo. Pritchard
Geo. B. Minor
Orlando Upson
Willis Upson
Henry Chatfield
Munson & Riggs
R. F. Sandford

Luther Todd

Sawmill

School

Chas. Frost
Ino Smith

Byron
Thos. Kilduff
Moran
L. C. Crane
Waterbury Leather Manf. Co.
Patl. Martin
Jim Doolittle
Horace Frost
Edmund Walsh
Wm. A. Fish

Miles Sackett

Hobart H. B. Welton
Leonard Hall

Sherman Bronson

Sarah Corcoran
John Reed
Luther Higgins

Thos. Clark
John Corcoran
Wm. McNeill
Michael Neville

Brown & Elton Samul & Co.

Timothy Porter
Elias Porter

Thomson
Brothers

Hotchkiss & Merriman

Joseph Porter

Jos Porter

District

Price

Patl. Bannon
Mich. Bannon
John Deahan
Michl. Loughlin
Waterbury Brass Co.

Dan. Hall
Delight Ross

John Lewis

E. W. Frost
John Solomon
Wm. Sider

School

James Lowey

H. C. Wedge
Chas. Townsbury

Lucius Scovill

POND

Seavr Ferrell

BROOK

BEAVER

Lucinda Roberts

District

CONTENTS

ACKNOWLEDGEMENTS

Stories about the Irish of Waterbury, Connecticut, embody as many interpretations and contradictions as the people who tell them. Details vary due not only to their points in time but also to their narrators' frames of reference. Recall the Indian fable of six blind men who tried to describe an elephant while each held a different part of its body. While perhaps still revealing only portions of the story, this book attempts to resurrect and preserve aspects of a complex tale about Waterbury's once highly significant Irish community.

Some material condenses portions of *From the Old Sod to the Naugatuck Valley: Early Irish Catholics of New Haven County, Connecticut*, published in 2012. The result is a greatly expanded focus on Waterbury, where John Wiehn has also studied the history of the Irish. Deepest gratitude goes to the many people who have accompanied this journey in any number of ways since it began at least nine years ago. I extend humble apologies for any exclusions that became necessary due to page limitations.

Thank you to Paul Powichroski, John Wiehn, Bettejane Wesson, Suzanne McDonald Welles, David Farrell, Emmett McSweeney and Raechel Guest, who have read portions of the manuscript and contributed helpful commentary at different stages. Thank you to friends and family who have allowed me to stay with them during extended research trips and to Waterbury's Ancient Order of Hibernians for allowing us to do a scanning session in its hall. Thank you to the Connecticut Society of Genealogists, through whose membership I've had invaluable access to city vital records since 2006.

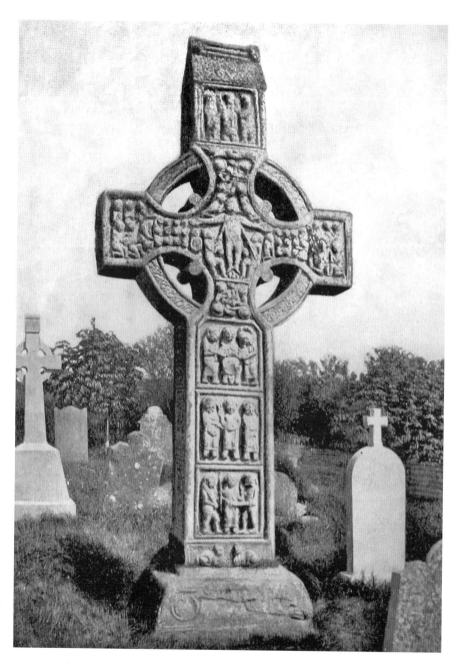

The High Cross at Monasterboice Monastery, founded by Saint Buithe mac Bronach (died circa 521), County Louth, Ireland. *From* '98 Centenary Souvenir, Atlas and Cyclopedia of Ireland. *Courtesy of Rosanne Shea.*

The Waterbury Irish are depicted in this book through representative families and selected events to create links between then and now. Thank you to all who so generously provided the essential spark of living voices, stories, memories, research and photographs: John Burke Jr., Maureen Burns, Bobbi Cappezi, Anne Goggin Carey, Kathleen A. Fruin Corbet, Hazel Boyce Dalton, Michael Dalton, Francis "Pup" Doolan, David Farrell, Betty Goggin, Neil Hogan, Margaret Murphy Jannetto, Eileen Joyce, Joseph Joyce, Jaime Ryan L'Heureux, Maureen Luddy, Dr. Jane Lyons, Mary and James Lyng, David Manzo, Eileen Hussey Maroney, Geri Maxwell, Ruth Conlon McGarty, Pat McGrath, Thomas McNellis, Charles Monagan, Christine Murphy, Jane Scully Parshall, Taryn Phelan, Betty Politivo, Ellyn Bergin Scully, William Scully Jr., John Shea, Rosanne Shea, Robbin Sheppard, Lieutenant Scott Stevenson, Al Sullivan, Suzanne McDonald Welles, Bettejane Wesson, Carole Youle and members of the McGivney Facebook site.

The assistance of the gracious curators, archivists and staff in public collections has been invaluable. Special thanks go to Suzie Fateh, Cynthia Rozney, Michael Dooling and Stephanie Coakley of Mattatuck Museum; Anita Bologna of Silas Bronson Library; Stephanie Gold, Archdiocese of Hartford; Barbara Austen, Connecticut Historical Museum; Wendy Murphy, Bridget Mariano, Sandra Clark and all the volunteers at the Naugatuck Historical Society; Susan H. Brosnan and Anne Ostendarp, Knights of Columbus Museum; Mary Shugrue D'Archangelo, Sisters of Saint Joseph; Laura S. Jowdy, Congressional Medal of Honor Society; the Archdiocese of Providence, Rhode Island; Erika Schulz-Vendrella, Saint Mary's Hospital Library and Archives; Jennifer Rose, Waterbury Mayor's Office; and the staff of the genealogy room in the Connecticut State Library.

Introduction

Irish communities have always consisted of large extended families and clusters of neighbors who celebrate simple pleasures on a regular basis. Cousins often grew up like they were siblings, and holiday gatherings were well attended. Tragedies of life inevitability interfered with the natural continuity of traditions. Yet even those Waterbury families whose Irish connections were broken through disease, deaths, family relocations or the "Irish curse" of alcoholism, which took its toll on so many households, retain a sense that there had been a golden era in their hometown.

Millions of Irish were forced to leave the ancient places of their surnames' origins due to centuries of political and economic upheavals. They abandoned villages and towns that may no longer exist. The Waterbury they and their descendants helped to build is also now a different place. Little is known about the earliest Irish who put down roots in Waterbury, thriving and prospering in a place that was not immediately welcoming to them. The entry of the Irish into Waterbury was a prime example of a worldwide transition from farming-based to manufacturing-based times during the Industrial Revolution. Gradually, they arrived until the early waves of immigration coincided with a devastating famine—one made more horrific by a government that could have averted its severity but chose not to. From the mid-nineteenth century on, the Irish steadily found work and a growing support system in Waterbury. Through grace and grit, they helped to shape the industry and culture, create a Brass City and bring it into the modern era.

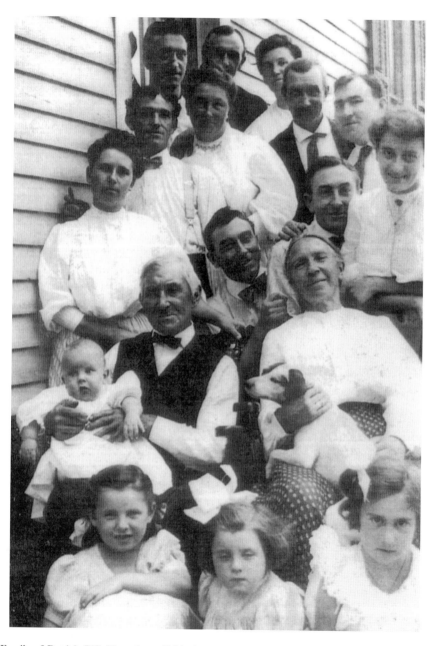

Family of Patrick O'Sullivan from Cahirciveen, Kerry, and Julia O'Mahoney (holding dog) from Tipperary, circa 1907. Among their sons, Dan (top back left by door) and Pat (above Julia) were foremen in Waterbury's brass factory. Dan became superintendent of the millwright department of Chase Metal Works in Waterville. *A copy of a photograph from the private collection of Alfred E. Sullivan.*

Having been the first immigrants to arrive and achieve financial success in factories and their own start-up businesses, the Irish, joined by other families of European heritage, acquired property and relocated to sequentially more desirable locations. They followed a pattern of movement established by the Yankee settlers. Many of the wealthy business owners left the urban center, and Waterbury, altogether. Immigrants of all nationalities who entered Waterbury in the later nineteenth century and thereafter typically found that the Irish had assimilated into the best working situations in the factories, the public service sector and independent businesses. By the twentieth century, Waterbury had become a town of multiple nationalities. Italians shared ethnic dominance with the Irish, who had initially been prejudiced against them. Throughout the early twentieth century, and particularly during the Great Depression, many Waterbury residents lived on the verge of destitution. My eighty-six-year-old relative reminded me that many "were doing whatever they could to scratch out a living. Some took big risks."[1]

The Catholic religion shared among the European nationalities came to override ethnic barriers. It took much longer, however, for racial and non-Christian religious prejudices to be overcome. Eventually, it became common to find ethnic marriage combinations, particularly after Saint Patrick's Church in Brooklyn was established near the Italian area of Town Plot.

The Ardmore Chalice depicted in one of Saint Patrick's Church's stained-glass windows. *Photograph by the author.*

By the 1960s, Waterbury's multi-ethnicity was evidenced in its public high school populations, enhanced through bussing students from some sections of town to others, although certain schools remained primarily white. A Puerto Rican community became established in the south end, formerly an immigrant Irish, French and German enclave. Generations of American-born individuals with local credentials and ethnic connections to the workforce had produced an upwardly mobile working class that continued to relocate to other neighborhoods, marking movement up the socioeconomic ladder. Additional newcomers seeking employment opportunities continued to settle in areas the previous groups had left behind.

By the 1970s, unemployment in Waterbury had become a severe problem, the factory boom years already a long-eclipsed memory. Disparity of economic opportunities, combined with social and racial lines of demarcation and the neglect of buildings by absentee landlords, resulted in increasingly impoverished areas of town. Instances of corruption in the city government had taken enormous economic tolls. The baby boom generation grew up among the last vestiges of a mostly white, Catholic, working middle-class city. Many spent kindergarten through eighth grade surrounded by essentially the same group of people, often continuing their friendships into high school. Even as they found higher education outside town to be valuable tickets to futures beyond Waterbury, many remained forever connected to family and friends who chose to remain and carry on the traditions of their ancestors.

Once considered the "Brass Capital of the World," a city of locally owned businesses with job security, unions and closely-knit neighborhoods, Waterbury grew sadly to resemble many other former industrial centers from which the economic lifeblood had disappeared. Vestiges remain of Waterbury's largely invisible past, however, while the city continues to strive to reestablish its former glory. Waterbury is now composed of many nationalities that are proud of their roots. An openhearted, hopeful and diverse community embraces a place being reshaped and reinvigorated by its residents, one positive step forward at a time.

1
IMMIGRANTS ENTER AMERICA

Irish were considered to have been among the New England colonists from at least 1620, although evidence of their presence in Waterbury was not noted until the early nineteenth century. The early history of the Irish cannot be told without also addressing Catholicism, the two topics being inextricably linked as Irish Catholics were persecuted throughout the centuries and forced to flee their homeland. Major Irish leaders served honorably in armies of European countries that welcomed them and understood their plight. Leading up to the Revolutionary War, 162 ships from Ireland carrying as many as five hundred passengers per ship arrived in New York and Pennsylvania between 1771 and 1773. An article about the origins of Catholicism in America—in Maryland and, to a lesser extent, in Pennsylvania—noted among the earliest Catholics a wide nationality base:

> Colonists who could date back their origin to the foundation of Maryland or Acadia, Florida or Canada, Indians of various tribes, newcomers from England, Germany or Ireland…The first bugle blast of America for battle in the name of freedom seemed to wake a response in many Catholic hearts in Europe. Officers came over from France to offer their swords, the experience they had acquired, and the training they had developed in the campaigns of the great commanders of the time. Among the names are several that have the ring of the old Irish Brigade.[2]

A list of officers included surnames similar to those among early Waterbury's Irishmen: Dugan, Malmady, De la Neuville, Conway, Aedanus Burke of Galway and the Carrolls.

The Irish over all centuries of military service were known to be dedicated fighters. "The Connecticut Irish," Frank Andrews Stone explained, "were among the most zealous patriots, largely because opposition to British rule was virtually an inbred trait with them…many of them had first hand experience with the measures which British used to quell rebellions and realized that the American Revolution had to succeed."[3] In Reverend James H. O'Donnell's praise for the Irish who fought for America, he quoted an Anglo-Irish Royalist, regretfully admitting in 1784 to the Irish House of Commons:

> *America was lost by Irish immigrants. These emigrations are fresh in the recollection of every gentleman in this House, and when the unhappy differences took place, I am assured from the best authority that the major part of the American army was comprised of Irish, and that the Irish language was as commonly spoken in the American ranks as English. I am also informed it was their valor* [that] *determined the contest, so that England not only lost a principle* [sic] *protection of her woolen trade, but also had America detached from her by force of Irish emigrants.*[4]

They also demonstrated Yankee loyalty by fighting England from American soil in the War of 1812 and supporting America in the Seminole Indian Wars in Florida in the 1810s and in war with Mexico in the late 1840s.

Some immigrants to America had advanced in professions, such as shopkeeping, or through the subletting of leases to others and were able to pay their own fares when leaving home. Some had married into families that had retained property over the centuries through changing their religion, sincerely or nominally. Many of the early Irish immigrants were already used to working within an oppressive system and had learned to get along with their Protestant bosses and upper-class landlords.

The Irish arrived while Catholicism began to gain a foothold in the New World. Catholic Relief Acts were passed in Ireland to reinstate possibilities there after Penal Laws had forced the majority of the population into poverty. In 1782, Catholics in Ireland were allowed to have schools and horses, they could own land and priests were no longer banished. In 1792, Catholics could marry Protestants and become lawyers. In 1793, they could vote and could be made military officers below the rank of general, although they could not be members of Parliament or hold seats in the government. The Insurrection

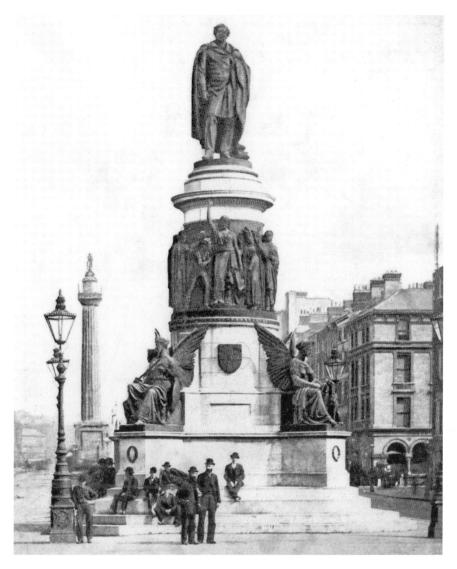

Statue of the "Liberator," Daniel O'Connell, unveiled in 1882. *From '98 Centenary Souvenir, Atlas and Cyclopedia of Ireland, courtesy of Rosanne Shea.*

Act of 1796 forbade the administering of oaths, the storing of weapons and anyone being outside one's dwelling between sunset and sunrise. At any time, authorities could enter a building to search for weapons. No printed materials could be distributed, and no meetings could be held in public places during curfew hours. That year, the writ of habeas corpus was suspended. In

1797, the residents of Ulster were disarmed, and middle-class Protestants as an armed yeomanry force were put in place by Great Britain.

On April 6, 1789, a Catholic archdiocese was established in Baltimore, Maryland, with jurisdiction over all states east of the Mississippi River. In 1808, the area was divided further, with Connecticut represented by Boston. Evidence of an indentured Irish servant in Waterbury was revealed in a New Haven newspaper in 1798. Abraham Hotchkiss offered a two-dollar reward for the return of "an eighteen year old 'Irish lad' who had run off." "John M'Fathing, a shoe maker by trade" was described as having "his left eye smaller than the other." Hotchkiss had purchased his indenture for two years in exchange for his passage to America and forbade anyone to hide the boy "on penalty of law."[5]

Newspapers that supported the Irish—a population determined to be about five thousand by 1830—became established in America. In 1829, the second Catholic bishop in America, Benedict J. Fenwick, began one called the *Pilot*. This was a popular means of finding information about family members through ads in its column "Missing Friends." Boston College's Irish Studies Program maintains a searchable database of these during the years that the numbers of Irish in America increased by quantum leaps—to more than seventy-eight thousand by the 1840s and more than ninety thousand

Thatched-roof structure in County Offaly, Ireland, at the turn-off toward Clonmacnoise. *Photograph by the author.*

by the 1850s. Connecticut's own *Catholic Press* newspaper, which originated the same year as the *Pilot*, is still in existence. It was renamed the *Connecticut Catholic* in 1896 and two years later changed to its current title, the *Catholic Transcript*. By means of such newspapers, an initial sense of isolation was lessened for the earliest groups, aiding their connections.

Throughout history, Ireland has had its share of food crises, including economic weakness from 1820 through 1830 that caused a decrease in the prices of farm produce. Already impoverished workers, some with the support of their landlords, began to openly boycott the paying of tithes to the Anglican Church that they did not attend. Massive power struggles and bloody rebellions occurred over this issue between 1831 and 1838. When the Irish began to arrive in the 1830s and early 1840s in Waterbury, Connecticut, they carried Ireland's conflicted ancestral memory with them, no matter what their individual circumstances had recently been.

The English Enter Waterbury

By 1633, there were Dutch settlers in what became Hartford, Connecticut. Pilgrims from the Massachusetts Bay Colony and archly conservative Puritans from Plymouth also traveled into Connecticut shortly thereafter at the invitation of the Algonquin Indians, who were in fear of the Mohawks. Just as the invitation of the Normans into Ireland by an ousted Irish king inadvertently changed the course of Irish history, the Native Americans' encouragement of European settlement marked American history forever; they never expected that the white men arriving in their midst would end up claiming the land for themselves. The colonists succeeded in seizing sections in and around Hartford during a war with the Pequots that ended with a massacre in Mystic in 1637. Later, a Congregationalist settler group from Farmington became interested in the hunting grounds of the Farmington- and Birmingham (Derby)–area Indian tribes, a place called *Matetacoke*. Translated as Mattatuck, an extensive region within this area became incorporated as the town of Waterbury in 1686.

In 1674, a group of thirty-one men formed Articles of Association and Agreement, purchased land from the Tunxis tribe and began to prepare the first area of settlement for about thirty families on the hillside still known as Waterbury's Town Plot. Metacomet, whom the settlers called "King Philip," chief of the once peaceful and colonist-friendly Wampanoags, became

threatened by continual encroachment by white settlers on Indian lands and their attempts to force foreign laws on the native tribes. War throughout New England came in 1675 between the Indians and the whites. Matacomet was killed in August 1676, and many Native Americans were transported into slavery in areas away from their original homes. Progress was halted on the Waterbury settlement during this time, but in September 1677 the Farmington settlers returned to establish themselves in a new location, making what is now Waterbury's Green the seat of their village. They retained their connection to Farmington, bringing their children to their former church to be baptized.

The fledgling community evolved for at least a century before the first Irish arrived in a visible way. Waterbury City Hall's first Book of Records, beginning with the entry of the birth of Timothy Standly on June 6, 1689, revealed the intimacy of the earliest years. It included land records for each of the first settlers with plentiful room for family birth entries, extending through the late 1700s. The settlement was so stable and slow growing up to 1720 that Bronson was able to account for the additional non-locals beyond the first group in only a few pages. He estimated more than 300 people in 1727, almost 500 in 1734, "about nine hundred" in 1737 and "about fifteen hundred" in 1749. The first official enumeration was 1,829 individuals in 1756, increasing in 1774 to 3,536.[6]

Connecticut settlers had similar problems as those following their chosen religions did in Ireland. Congregationalism was the official religion of Connecticut and Massachusetts, and "Quakers, Ranters, Adamites or such like 'were to be committed to prison or sent out of the colony.'"[7] Fines were levied on people owning Quaker books, and everyone was required to pay taxes to support the Congregationalist Church. In 1708, the law was modified to allow sects that "soberly dissented" to support their own parishes instead.[8] By the mid-1770s, serious religious tensions had arisen in the Protestant community, reinforced by a split in loyalties during the Revolutionary War (1775–83). In 1742, a group began to take steps to build an Episcopal church, completed in 1765 with James Scovill as its minister. This Royalist (Tory) group was aligned with the established Church of England, in contrast to the settlers who had sought to become independent from England. In this light, the Congregationalists were considered to be dissenters. The sects became so polarized that in 1775, the road leading to Farmington and Wallingford was voted into separate districts for the Church of England and the Presbyterians. In the section of Westbury (future Watertown), "the windows of the Episcopal church

were demolished, the principal members of that church were not allowed to attend public worship, but were confined to their farms."[9] Bronson concluded, "For a long time, those of opposite religious views could not agree to differ. The doctrine of toleration in matters of religious opinion had not been learned. It was new to the world. No living examples existed by which its real nature and practical workings could be studied. All sought religious liberty for themselves, but nobody thought of conceding it to others."[10] It would not be until 1784 that a law was passed to allow freedom of choice in some form of Protestant Christian religious practice. A Baptist church was added in 1803 and a Methodist Episcopal one in 1815.

Manufacturing Takes Hold

While they were able to nourish and sustain themselves, the pioneers' possessions were few and relatively expensive, with farming tools, items of clothing and even straight pins being passed down to future generations in wills. It became necessary to experiment with means of providing their own small-scale manufacturing in order to become profitable and remain permanently in the area and prosper.

In 1679, the town's first mills were established. By the early nineteenth century, settlers were making their own cloth from the sheep they raised with processing power derived from fulling mills. In the early 1700s, they began to mine metal ores with the intent of producing raw materials from which to make farming equipment, even though an English act of Parliament in June 1750 deemed it against the law for the colonies "to erect or to operate forging, rolling or slitting mills, or to make steel."[11] In spite of this, steel implements were produced in New England in the eighteenth century. The settlers became entrepreneurs, partnering to form small businesses of many kinds and traveling throughout the towns to sell their wares.

Continual experimentations and the merging of skills and resources quickly advanced the community's range of possibilities for growth in manufacturing. Hopkin's gristmill became Scovill Manufacturing Company when the Porter group bought half of the building and its water rights in 1808 and formed Scovill Brass Works. By 1811, the initial partners had gradually sold their shares. Dr. Frederick Leavenworth,

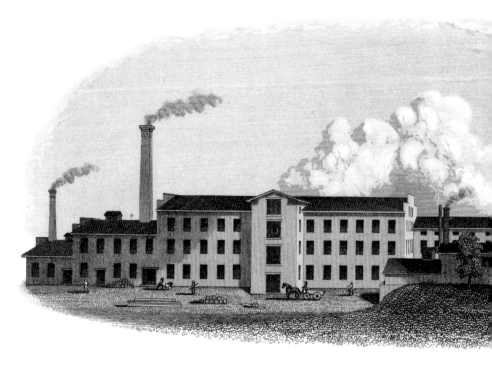

Scovill Manufacturing Company. *From Dr. Henry Bronson's* History of Waterbury, *1858.*

James Scovill and his son James Mitchell Lamson Scovill purchased the company and turned it into the enormous success that placed Waterbury on the map. They produced brass buttons, developed patents for inventions and cutting-edge product designs and finally became the major producer of machinery made from cast metal in the country.

William Henry Scovill joined his brother James Mitchell Lamson Scovill in the business when Leavenworth and Hayden sold their shares in 1827. J.M.L. & W.H. Scovill's Manufacturing, (Aaron) Benedict & Burnham and Brown & Elton were well established before 1840 along with many other smaller industries that continued to expand. Companies were producing clocks, pins, saddles and a wide array of goods along the Naugatuck River, stretching from Waterbury into New Haven. The early metal manufacturers attempted to attract skilled workers from England and purchase formulas and equipment to export to Connecticut for improving the quality and capacity of their companies. With each closely guarded gain in the production of some commodity, another

established and improved business entered Connecticut's richly layered entrepreneurial history. One success built on the knowledge, expertise and success of the last, and former employees often became business owners themselves. By the early nineteenth century, Waterbury was established as a supplier of goods throughout America to the extent that England sought to prevent any further assistance that could result in competition.

Skilled Irish Enter Waterbury

Israel Holmes, trained by the Scovills, founded six brass companies of his own in Connecticut. It was said that he smuggled workers out of England, some sailing first to Wales to escape the guards in Liverpool with a few hiding out in wooden wine barrels. Whether or not the story is true, enough workers with the needed skills—including the ability to sink dies, gild and burnish—entered Connecticut and found their way into the early brass industries. They enabled American companies to compete

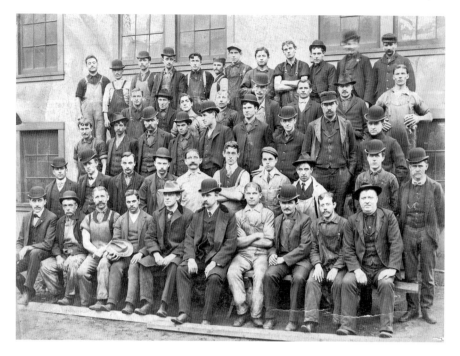

John Thomas Shea (third row, fourth from right) from Tralee was the husband (in 1907) of Mary Kennelly from Killarney, both of County Kerry. He emigrated in 1892 and became a toolmaker/machinist in Waterbury. *Vintage photograph from the private collection of Rosanne Shea and her brother, John.*

with England in the production of rolled- and cast-brass commodities of all kinds. Holmes made his first trip in search of skilled labor for his own first company when it was against the law for "the exportation of machinery or models or the enticing away of workmen from their employers." The law was repealed in 1825.[12] Holmes succeeded, however, in purchasing machinery and gathering several England-based workers and their families to come back to Connecticut with him in 1822. The first group of immigrants, with their families, totaled twenty. Others arrived in 1831, with thirty-eight more in 1834. Aaron Benedict, of Benedict and Coe, sent back one of his own English immigrant workers, James Croft, seven times to acquire more equipment and people.

William G. Lathrop explained the formative years of brass manufacturing in Waterbury (1830–50) to have contained three classes of labor: "the proprietors actively engaged in the management, the English mechanics and native helpers."[13] Although the Penal Laws had limited the number of Catholics who could be trained in skilled professions,

Irishmen did number among the skilled workers. At least a few of the "English mechanics" that Holmes and others brought to Connecticut in the early 1800s were probably Irishmen who had immigrated to England to find employment and learn desired skills there. The U.S. census of 1840 included in Waterbury, at minimum, the households of William and Timothy Corcoran; William Moran; Cornelius Donnelly; Michael and Patrick Donohue; Patrick Riley; John Burns; John Gallavin; James, Joseph and Patrick Martin; Nathanial Carroll; Peter Kavenaugh; Patrick and Thomas Delany; Michael Neville; Michael Cochran; and Patrick Henessey.[14]

While most Irishmen in the 1850 census of Waterbury were classified as "laborers," some additional skilled workers from Ireland at that time included a physician (William O'Reily), three merchants (Fenton Phelan, John Hart and George Traynor), an engineer, a caster, a stonecutter, a wool dyer, a gardener, a button maker, a cutter, an iron foundry worker, two masons, three tailors, four "smithers of metal," five blacksmiths, five shoemakers and at least thirteen brick makers. From Scotland were two machinists, two weavers, a wire drawer, a joiner, a cotton dyer and a shoemaker. In Waterbury during that census year, there were 1,032 people who had been born in Ireland between 1780 and 1849, most of them adults.[15]

In 1846, James Scovill, with Benedict, Holmes and Coe, worked to bring a railroad into Waterbury, with tracks running directly to and from the Scovill factory near the Irish settlement at Dublin and Bridge Streets. (Dublin Street later became Hamilton Avenue.) In order to further enhance the connection between the manufacturing centers throughout the river valley, tracks from Bridgeport opened in Waterbury and Winsted in 1848 and 1849, respectively. Labor in bridge and railroad construction provided additional employment opportunities for Irish and other immigrants in the mid- to late nineteenth century, and Waterbury's train station became increasingly active. By the mid-nineteenth century, Waterbury had become a booming manufacturing center. Branches of local businesses had bases of operation in New York and Boston. There was plenty of work, and the Irish were firmly in place. From the earliest settlement twenty years earlier, the Irish had spread farther southeast, east and northeast of the center, settling within walking distance to work and church.

Timothy Corcoran

Timothy Corcoran was one of Israel Holmes's skilled Irish workers, although he apparently came into Waterbury after first having lived in England. A note written by Solomon B. Minor, then bookkeeper for a factory of Brown & Elton's (later owned by Rogers & Brother) in Waterbury, was found in 1860 in a bottle that had been placed in the cornerstone of the original building. It read:

> *The Manufactory for which this Counting House was erected, was built by Israel Holmes, Horace Hotchkiss, Philo Brown and John P. Elton for the purpose of casting and rolling brass, making brass and copper wire, brass and copper tubes, etc. The machinery and men to conduct the business were imported from Birmingham, England in the year 1831 and 1832. The wire manufactory being the first and at this time the only one in the United States, now employs about twenty-five hands.*

The note had been signed by Timothy Corcoran, head wire drawer, and Solomon B. Minor, accountant, and was dated November 5, 1835.[16]

In Connecticut, on January 7, 1831, Timothy Corcoran married Sarah Glover, from Birmingham, England.[17] Six children were born to them in Connecticut, although their daughter Sarah Ann died in 1837 before having reached her first birthday. She was buried in the old burial ground, Grand Street Cemetery, beyond the center of town. In later years, members of the Corcoran family were buried in the Catholic Old Saint Joseph Cemetery, and the Corcoran family was considered to have been among the earliest Catholics in Waterbury.

Four individuals in Timothy Corcoran's household of 1840 had been "employed in manufacture and trade."[18] One man and one woman in their thirties, three more men in their twenties and three men and three women between the ages of five and nineteen lived with him. This suggests that the Corcorans housed other family members and/or friends before they found their own places to live. Among his neighbors were the Irishmen William Moran (future husband of Bridget Neville), William Corcoran and John Reid.[19]

In the U.S. census of 1850, the Timothy Corcoran family lived in a two-family house. Upstairs were John and Catherine Hughes and James Sheron, all from Ireland, with the Hugheses' two children born

in Connecticut. Timothy and his seventeen-year-old son, James, were wire drawers, as was John Corcoran, who also appeared in the census. A Corcoran relative is aware that by the time of his death in December of that year, Timothy had acquired at least fourteen pieces of property in Waterbury, some of which were on the east side of town around the area that became Old Saint Joseph Cemetery. An 1852 map of Waterbury revealed the location of the widowed Sarah Corcoran's early home, near the hill that came to be known as the Abrigador. Sarah lived between Scovill's, Brown & Elton and Waterbury Leather Manufacturing and Waterbury Brass Companies. This map also revealed her neighbors: George Byrne, Thomas Kilduff, Moran, Patrick Martin, Thomas Claffy, John Corcoran, William Kelly, Michael Neville, Patrick Bannon, Michael Bannon, John Beahan, Patrick Delaney, Michael Loughlin and John Reed. John Corcoran also appeared at the base of the Abrigador section in 1852.

The Abrigador and the Hill

A small mountain south of the center was home to one of the longest-remaining Irish sections in Waterbury. Modernly called "Pine Hill," formerly the "Abrigador," the outcropping is passed while driving away from town southerly toward Naugatuck or coming into town easterly on Route 84. An undated document from the city engineer's office described the Abrigador as "the rock eminence, occupying nearly all the area lying within the great curve described by the Mad River, just before its union with the Naugatuck River."[20] Although the origin of the word remains a mystery, in Spanish it refers to something kept warm, wrapped up, sheltered or protected. It can also suggest nurturance, to cherish or to hold or maintain in the mind.

Plate J of the 1879 *Atlas of the City of Waterbury* revealed a different spelling of the word, "Abrigado," in proximity to the American Suspender Company between Mill and Mad River Streets. The company made use of water power from the Mad River and its two connecting ponds. Liberty Street made its way across the river to Baldwin Street, above which was Ridge Street. Ridge ran between Pleasant and Stone Streets, with the Abrigado School House nestled between. Ayers Street formed one edge of the area facing the center of town, parallel to Pleasant, with

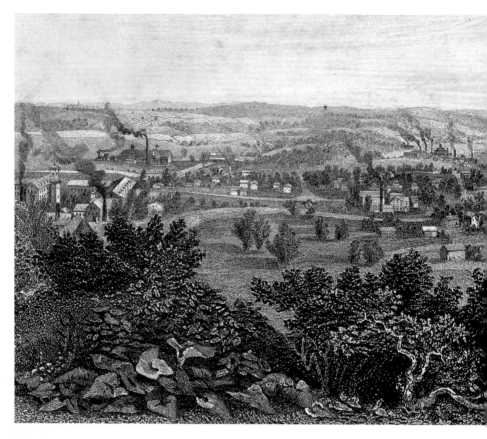

Waterbury, as seen from the Abrigador. *From Dr. Henry Bronson's* History of Waterbury, *1858.*

Pemberton Street between. Some of the major Irish names from the top of the hill down to the water included F. Bergin, J. Galvin, P. McDonald, Mrs. McDonald, B. Reily, Dd. Allman, T. Donahue, F. Phelan, Mrs. Kelly, Wm. Kelly, Mrs. C. Kelly, J. Coughlan, Kearney, R. Phelan, J. Casey and C. Weiss Estate.

Plate Q of the atlas depicted the section where Mad River Street ended at Waterbury Buckle Company and a second Irish extension continued to the southernmost city line. Washington Street defined the next related area, called Washington Hill, followed later by the area known as Hopeville. In 1879, Phelan and Galvin surnames appeared here again, with L. Reilly, Bowes, John Coyle, D. Lawlor, M. Wall, James Wall, M. Flynn, T. Donahue, F. Bergin and another Bergin. Saint Francis

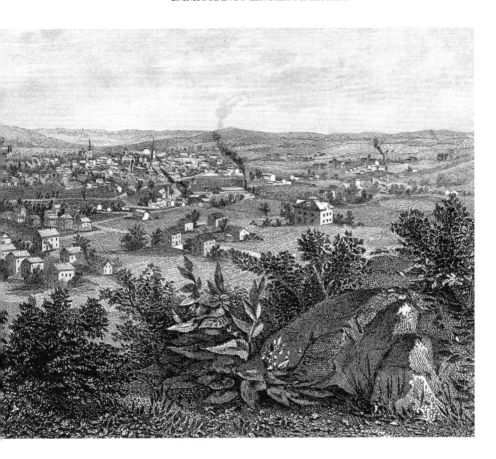

Xavier Church, established in 1896, became the heart of this extensive community. The "Hill" extended to the opposite side of the Mad River, where a large concentration of Irish settled in the Railroad Hill section of Brooklyn. This area famously produced several teachers, nuns and priests in the later nineteenth century.

2

WATERBURY BECOMES PREDOMINANTLY IRISH AND CATHOLIC

In the same way that agreed-upon practices controlled early Anglo-Protestants lives, ethnic-religious identity circumscribed the lives of early Irish Catholics in Connecticut. Masses were celebrated in New Haven by 1829. Middletown had a small Catholic community then, and a group was in place in Waterbury by 1831. New Haven had about two hundred parishioners by 1832, including those traveling from Waterbury and Derby. An 1836 census showed the existence of three hundred adult Catholics in New Haven, twenty-five in Derby, one hundred in Bridgeport, twenty-five in Norwalk and thirty in Waterbury. Hartford was given its own Catholic diocese on September 18, 1843, separating it from Boston and thus allowing the introduction of Connecticut-based resident priests, most of them Irish.

Baptisms performed by Reverends James McDermott and James Smyth of New Haven were recorded for Waterbury residents in the early 1830s, but differing stories claim the first arrival, baptism and Mass held in Waterbury. In 1899, Martin Scully, then a staff member of the *Waterbury Daily Democrat* newspaper and future mayor, attempted to discern the first Irishman who visited the Brass City area. He wrote an article for the *Journal of the American-Irish Historical Society*, which prided itself on being broad and liberal, and included both Roman Catholic members and those from several Protestant sects. He researched beyond the "half a dozen or more of old Irish settlers of the town who came here over half a century ago and who have resided here since, [who] tell conflicting stories in relation to this subject."[21]

Scully determined that Joseph Rourke, a soldier in the Revolutionary War who served under General Putnam, was the first Irishman in the area. He had befriended the great-great-grandfather of Waterbury's Judge George H. Cowell. Rourke lived for about twelve or thirteen years "about three miles southeast of Prospect Centre." When he heard of plans for an uprising in Ireland that became the rebellion of 1798, he traveled to Derby, sailing from there into New York, to return home in time to join the fight. Judge Cowell recalled that the old people remembered Rourke very well and thought there was nothing strange about Rourke's return to Ireland:

> *Everybody knows that the Irish people had been fleeing to all parts of the world to shun the persecution to which they were subjected at home for centuries prior to that time, and it is the most reasonable thing in the world to believe that some of them should show up in these parts. It is a well-established fact that there were a large number of Irishmen in the Revolutionary War, not only in the rank and file, but as captains and generals. Were not several of the signers of the Declaration of Independence Irishmen?*

Scully learned that Joseph Rourke had been an excellent shoemaker and repairer in Waterbury, outfitting "the forefathers of many of the old American families of this section" with "the handsomest footwear ever worn in this state." Every winter, he would travel to New York to "attend divine service on Christmas day." Scully related that Rourke "never tried to deny his religion, and it was a common thing for the farmers for miles around to gather at the house where he was making a pair of boots and hear him tell of the inhuman cruelties perpetrated on his countrymen on account of their faith." In Scully's opinion, "he was the first man that told the old settlers of this town the Catholic meaning of the word 'Mass.'" Once he returned to Ireland, he was never heard of again.

Although he did not seem to know about Joseph Rourke, Reverend James H. O'Donnell provided an otherwise thorough background about early Connecticut Catholicism in his 1900 publication, *History of the Diocese of Hartford*. He had found evidence of Irish living in New London in the late 1760s and of early French Catholics in Connecticut, including Acadians, who had been cast out of Canada by the British. Father O'Donnell had relied on information elicited from locals, newspaper articles, help from H.F. Bassett of the Bronson Library and a manuscript written by John A. Moran to determine those who had been in town the longest. Reverend

Joseph Anderson included Father O'Donnell's information in the third volume of his own Waterbury history, with a note from the priest, attesting to the absence of early Catholic records. It seemed to Father O'Donnell that Cornelius Donnelly was known as "the Catholic who is justly entitled to be named the pioneer of his race and faith in Waterbury." Donnelly had lived "on West Main street near Crane street in 1832 or thereabouts."[22] *The Barbour Collection of Connecticut Town Vital Records* included his marriage to Rachel Elizabeth Lowry in 1826.[23]

The next earliest Irish records for Waterbury appear to have been the marriage of the aforementioned Timothy Corcoran of Ireland and Sarah Glover of Birmingham, England, on January 7, 1831, followed by the birth of a son, James, on January 7, 1833. The New Haven marriage of James Martin and Mary McDougal, both from Ireland, on November 25, 1832, appears to have been next in line chronologically for the Waterbury group. A daughter, Mary, born to the Martins in January 1834, may have been the first female child born to an Irish Catholic couple in Waterbury after the Corcorans' first male child.[24] Father O'Donnell stated, however, that the first children to be baptized were those of Thomas Donahue and James H. Riley and that it was done in the home of Michael Neville.[25]

Along with the Donnelly, Corcoran and James Martin families, the first group of Irish in Waterbury by 1837 or before also included Christopher Casey, John Flynn, John Connors, John Corcoran and his wife, M. Neville and his sister, Michael Corcoran, William Corcoran, John Galvin and his wife, James Byrne and James Grier, or so Father O'Donnell determined. He added the following individuals as having arrived in 1838: Michael Donohue, Patrick Donohue, Patrick Martin, Patrick Reilly and his sister. As arriving between 1839 and 1841, he added Patrick Delavan, Matthew Delavan, Finton Delavan, Thomas Delaney, Thomas Kilduff and his wife, Timothy Whalen and his wife and Thomas Claffey. He made special note of "William Moran, Patrick Delaney and his brother, Andrew Moran, Thomas Matthews, Finton Riley, John Burns, Captain Bannon and John Reid, all honored in their day and generation."[26]

A relative of Timothy Corcoran was told by now deceased local historian Charles Piola, whose family owned a tombstone monument business for several decades, that "Timothy Corcoran was the prime force in bringing the Catholic Church to Waterbury, at a time when it was not welcomed. Mr. Corcoran lived on the second story of a three family house. It was in this apartment that the first mass was celebrated by visiting priests."[27] There was once a marker on Silver Street noting the location of the first Catholic Mass

held in Waterbury, and one of Corcoran's properties was on that street; thus, a claim that his home was where the first Catholic Mass in Waterbury was celebrated might be valid. Reverend O'Donnell, however, placed the first Mass at the home of Cornelius Donnelly, celebrated by Reverend James T. McDermott of New Haven on an unknown date.

Whoever were the first to arrive and receive particular sacraments, the early group was undoubtedly a devout one, eager for a priest to come to town. O'Donnell explained:

> So anxious were the Catholics of Waterbury to have the Holy Sacrifice of the Mass offered for them, and to receive otherwise the consolations of their religion, that they generously presented Father McDermott with a handsome horse, saddle and bridle, in the hope that, being provided with his own means of travel, he might occasionally find opportunity to visit them.[28]

Although Father McDermott was transferred to a parish in Lowell, Massachusetts, in the summer of 1837, Father Smyth officiated in Waterbury through 1847.

Traveling to New Haven

It can be inferred that the early Irish Catholics within nearby settlements of Greater Waterbury knew one another. They likely functioned as one steadily growing community, pockets of which were clustered by location. Many of the immigrants had previously known one another in Ireland, though they settled in different towns based on employment. It was common practice to help others immigrate and become established. Census records show many instances of several Irish immigrants with different surnames living in one household, indicating that new arrivals lived with friends or relatives before they could afford to live in their own homes. Those living in the Naugatuck River Valley originally traveled to New Haven to attend masses, baptisms, marriages and funerals at Christ Church, which had been established between May 14, 1833, and May 11, 1834. It is likely that they also had friends and family members who lived on the way to and in New Haven.

Within the story of the Irish Catholic settlements in Connecticut emerged those of the first Catholic churches. In each town, a similar pattern repeated. Groups gathered for masses whenever one could be held;

"Scenic Naugatuck River Valley." *Vintage postcard from the author's private collection.*

a small mission church was formed, a resident priest assigned and a local church built. A rectory, school, cemetery and, eventually, convent would usually follow. Jurisdictions changed and new churches accommodated the growing populations.

Despite New England entrepreneurs' need for workers, tensions existed in the early settlements that paralleled those that had long plagued Ireland. The first Irish Catholics in Connecticut necessarily kept a low religious profile, as they were in the minority. They arrived in places where some of the Protestant sects still held active prejudices against Catholicism and distrusted the Catholics' reverence for the pope, whom they considered to be a foreign ruler. Despite this, Catholics began to gather to worship, keeping their meetings secret under threat of evictions, loss of employment or worse. Visiting priests, called circuit riders, came to the small Catholic groups in family homes and, when possible, to larger public sites before the first churches were built.

Mission churches were also established in Rhode Island early on, and Rhode Island and Connecticut grew in tandem as Irish came to work in both states. The Catholic population in Derby and Waterbury grew rapidly, and two more churches were built closer to home for those living in the Naugatuck Valley. Until September 18, 1843, Connecticut

Catholics came under the auspices of the Archdiocese of Boston. From that day, Hartford became its own diocese, headed by Reverend William Barber Tyler of Derby, Vermont. Tyler, a Protestant who converted to Catholicism, became a bishop seven months later. Since his jurisdiction also encompassed Rhode Island, he relocated to Providence, which became the first destination for most of the Irish priests who were requested for service in Connecticut throughout the nineteenth century.

Reverend Smyth wrote to Bishop Tyler in April 1845 that he had married thirty couples in 1844, three from Waterbury and two from Derby. He had registered all the 104 baptisms he performed that year under the heading "New Haven." He approximated that in Waterbury there were about 100 adults, including 34 married couples, and about 90 children then and that "about the third part of that number came here the past year."[29]

Father Smyth's attempt to offer Mass in Waterbury at the same home (possibly Timothy Corcoran's) where he had done so on an earlier visit was thwarted when the owner was told that he would be fired from his job if he "entertained the priest."[30] Instead, Michael Neville became the leader among the Catholics, hosting masses from 1837 until 1845 in his home on East Main Street. Alderman Michael Donahue, in an interview about his recollections, explained that "Father McDermott, who was in charge of the parish in New Haven, came here once in three months and said Mass and preached a sermon. After a while we grew in numbers, as you know Irishmen are apt to do, and we met in an old school house on the opposite side of the road from Neville's house."[31] From 1845 to Sunday, December 19, 1847, the group moved its masses to Washington Hall, at the corner of Exchange Place and West Main Street.

About one acre of land was purchased for fifty dollars by Bishop Tyler from J.M.L. Scovill, with John Galvin as agent, for a designated Catholic section of Waterbury's Old Burying Ground on May 6, 1847. Before this, Catholics were buried in New Haven's Christ Church Cemetery twenty-two miles away. Reverend O'Donnell described a habit of group processions from wide-reaching areas in Connecticut with each Catholic death. An editorial from an 1854 *Waterbury American* article noted, "An Irish funeral procession which passed our office on Saturday (September 2) was the largest we have ever seen in this city. It numbered twenty-four carriages and 304 persons on foot, 128 of whom were females."[32] This might have been the funeral of Captain Bannon, whom Father O'Donnell considered to be the last person in Waterbury buried in New Haven.

A funeral procession traveling a great distance together must have represented solidarity of spirit for the Irish community. As friends and families came together regularly for religious and social events, the extended early Catholic community would have retained and expanded its connections begun in Ireland.

Waterbury's First Catholic Church

When Reverend Michael O'Neill became the first resident pastor of the Naugatuck Valley on November 1, 1847, he was responsible for Catholics as far south as Derby and as far north as Winsted. (In April 1851, Derby and West Winsted were granted their own resident priests, making his work slightly more manageable.) He lived in Waterbury with the Neville family until 1850 and then moved to a rented home on East Main Street. The 1879 *Atlas of the City of Waterbury* showed the Neville estate as a large parcel of land at Dublin Street. Immediate neighbors in the area at the time were Dr. Burke, M. Bannan, F. Bowers and John Lyons.

In 1847, the Waterbury Catholics were allowed to purchase property at the corner of East Main and Dublin Streets to build a church. Fortuitously, the opportunity arose to purchase the former Episcopalian church for $1,500. They did so in November and attempted to move it to their site. A photograph in the collection of the Knights of Columbus Museum showed the original building, which had a tall spire that the Catholics removed. Even so, they were unable to push the building up the incline of East Main Street from the green. Instead, they settled it on "the lot on which Saint Patrick's Hall now stands…opposite the present church."[33] Neville, as agent, purchased the site on behalf of the parish for $650 on December 4, 1847, and gave the deed to Bishop Tyler on May 22, 1848.

Father O'Neill named Waterbury's first Catholic church in honor of Saint Peter, celebrating the first Mass on Christmas Day 1847. An image in a centennial publication of the Immaculate Conception Church included the names of the men posing in front of it, presumably key members of the congregation. They included Thomas Callaghan, William McGuinness, John Hutchinson, Michael Donahue, John Galvin, Andrew Moran, William Bannon, John Burns, Michael Flynn, Michael McCormack, Patrick Mulvanney, Edward Delaney, Martin Lacey,

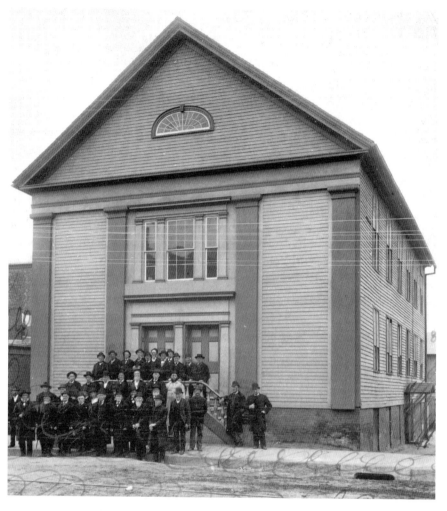

Members of the early Irish community in front of Waterbury's first Catholic church, Saint Peter's. *Courtesy of Mattatuck Museum, Waterbury, Connecticut.*

Thomas Delaney, William Collins, Michael Ney, Michael Bannon, George Burns, Miles McCarthy, Patrick Hosey, John Bowes, John Kennaugh, John Gaynor, Finton Phalen, Martin Wall, John Brophy, Thomas Coyle, Thomas White, John Collins, Patrick Rigney, Patrick McMahon, Finton Bergin and John Finley.

The Nevilles

In the census of 1840, Michael Neville's household of seven people included three "employed in manufacture and trade." One man was aged between sixty and sixty-nine, two men and one woman were between thirty and thirty-nine, one male was between fifteen and nineteen and two others were under the age of five.[34] Names were included ten years later. Living with Michael, his wife, Ann (Delaney), and their five Connecticut-born children, four boys and one girl ranging in age from thirteen to newborn, were: Michael's father, John; Reverend Michael O'Neill; John Phalon; Dennis, Ann, Patrick and Mary Kernan; and William Dunn, all from Ireland.[35] Neville, a wire drawer, had an estate valued at $3,000 in 1850, with real estate in 1860 valued at $8,000 and a personal estate of $2,000—considerable wealth for the time. By 1860, only his immediate family was in his home, and his only daughter, Margaret, was no longer listed. (She married Dr. T.D. Dougherty.)[36]

Each of Michael and Ann's living sons—Timothy, Matthew and Edwin—became successful lawyers. According to Anderson, Timothy was the first Catholic man in Waterbury to enter college, and Margaret was the first Catholic girl to attend boarding school or college. Timothy graduated in 1856 from Saint John's College in Fordham, New York; went to Yale for two years; and developed a large law practice in Rhode Island, continuing it in New York. Edwin also attended Saint John's College from the fall of 1859 to 1862. Edwin had a remarkable service career starting in the American Civil War. While visiting his brother in Providence, he enlisted in the Third Regiment, Rhode Island Infantry, and was discharged due to a serious but unspecified disability after serving three months. On January 13, 1864, he enlisted again, having raised his own company from Waterbury to serve as cavalry for the First Regiment, Connecticut Volunteers. On June 1, Neville was wounded in Ashland, Virginia. On October 1, he was promoted from second lieutenant, Company D, to first lieutenant, Company H. Then, on February 16, 1865, he was promoted to captain of Company C.

General Philip Sheridan commented on Neville's exceptional bravery. After serving under Sheridan, he served under General Wilson and, finally, General Armstrong Custer. Having been in battle more than ninety times and suffering losses among its ranks more than eighty of those times, Neville's regiment had an extraordinary record. Anderson noted its having fought cavalry, infantry and artillery in the field and behind breastworks, capturing many prisoners, guns and flags.[37]

The First Regiment, Connecticut Cavalry, escorted General Grant to accept the surrender of General Robert E. Lee. It was so highly regarded that it was the only regiment allowed to return home on horseback.

Edwin Michael Neville was awarded the Congressional Medal of Honor on April 6, 1865, for having captured one of the opposing army's flags at Sailor's Creek in Deatonsville, Virginia. So many men, artillery and generals were captured in that engagement that three days later, the Confederate army surrendered. Neville received a commendation from the lieutenant colonel of the First Connecticut for "the gallant manner and noble bearing of yourself and men on to-day's reconnaissance, under the trying circumstances and position in which you were placed."[38] He mustered out on August 2, 1865.

Edwin M. Neville, military hero, lawyer and a son of Michael Neville, was awarded the Congressional Medal of Honor in the Civil War. *From Anderson's* History of Waterbury, *vol. 3, 1896.*

Continuing to serve as adjutant general in the army in 1867 and 1868, under General Kellogg, he then joined the National Guard and was adjutant in the "Fighting Sixty-ninth" New York Regiment, which was famously Irish. There he served under Colonel Kavanagh in 1871 and 1872. In 1869, he went to Paris to sell military weapons as an agent for Remington Arms. Anderson recounted Neville's escape before the Germans arrived in the city under siege during the Franco-Prussian War. He fled in a hot-air balloon.

The following year, he received a testimonial as "Companion of the First Class" from the Loyal Legion of the United States "for faithful service in maintaining the honor, integrity and supremacy of the Government."[39] After studying law with his brother Timothy's practice, in 1872, he was admitted to the New York State Bar. Neville was a successful lawyer until he became ill with a condition that would likely have developed into tuberculosis—a disease that affected members of a great many families throughout nineteenth-century Connecticut. Edwin Michael Neville died of "nasal catarrh"[40] on October 4, 1886, at the age of forty-three at the home of his sister on North Main Street, Waterbury. Captain Neville Drive was named in his honor. His

Some Waterbury Irish Catholic Marriages Before 1855

Margaret Corcoran to Edwin Strong (July 12, 1835)

Patrick Martin to Mary Riley (August 23, 1835)

Michael Neville to Ann Delany, in New York (April 16, 1836)

William Moran to Bridget Neville (before 1837)

Patrick Delaney to Mary [maiden name unknown] (April 9, 1837)

Michael Donohue to Rachel Coyle (July 7, 1837)

Thomas Kilduff to Bridget Heffren (1839, in Ireland)

Patrick Riley and bride (July 7, 1839)

Thomas Delany to Charlotte Denny (August 1839)

Thomas Claffey to Mary Phalan (January 1840)

William McNeil, from Scotland, to Margaret Neville, in New York (February 7, 1840)

John Corcoran to Elizabeth Neville (January 29, 1841)

Redmond Welsh to Mary Phelan (April 1841)

Thomas Donohue to Christiana Riley (October 1844)

Matthew Delany to Bridget Parker (October 23, 1844)

James Killduff to Ellen McGuiness (May 1, 1848)

William Delaney to Julia Doolan (May 23, 1848)

Patrick Delany to Mary Kinah (November 26, 1849)

Patrick Renaghan to Ann Reilly (April 14, 1850)

Henry Moran to Margaret Phelan (February 18, 1851)

John Phelan to Bridget Moran (February 28, 1851)

Patrick Kelly to Mary Moore (April 29, 1851)

John Kelly to Julia Butler (May 4, 1851)

Michael Geaghan to Catharine Killduff (May 4, 1851)

Thomas Gannon to Mary Reilly (May 14, 1851)

Timothy Flynn to Catharine McAlister (May 20, 1851)

James Delany to Eliza Bowe (June 4, 1851)

John McAvoy to Julia Bergan (June 19, 1851)

James Bowes to Mary Kelly (July 4, 1851)

Bernard Stapleton to Bridget Cunningham (August 3, 1851)

Timothy Killduff to Maria Loughnane (September 19, 1851)

John Byrnes to Mary Donnelly (September 21, 1851)

James Sheehan to Julia Phelan (October 10, 1851)
Martin Delany to Sarah Corcoran (September 12, 1852)
James Corcoran to Rosanna Lynch (February 8, 1853)
William Phelan to Anne Doherty (April 10, 1853)
Thomas Adamson to Catharine Reilly (June 11, 1853)
James Reilly to Mary Power (January 7, 1854)
Stephen Mackey to Rosanna Donohue (January 13, 1854)
Daniel Bergin to Margaret Phelan (February 17 1854)[41]

Between February 5, 1852, and March 1, 1854, Reverend O'Neill entered 190 marriages for record to the Waterbury Town Hall register.[42] With an ever-increasing number of Irish Catholic marriages followed quickly by births and baptisms, it should come as no surprise that by the end of the nineteenth century, Waterbury's population was more than half Irish.

obituary lauded him as "a man of great generosity, good address, pleasing manners and excellent business tact. And these qualities made him successful in almost everything he undertook."[43]

A large funeral at the Immaculate Conception Church was held for Edwin Neville, with friends and family present from Waterbury and New York. Representatives of Wadhams Post of the Grand Army of the Republic escorted his casket to the family plot at Old Saint Joseph Cemetery, where he was buried with military honors. Tombstones at the Neville family plot link the family to Queens County (Laois), Ireland, and provide more details about his relatives, including his father's and grandfather's ages (Michael, 1805–1866, and John, 1771–1851, respectively).[44]

Exclusive Societies

As much as the Irish immigrants desired to be considered American, their native religion and family traditions proved continually to be sticking points in the way of full acceptance in their new homes. American-born laborers feared competition with the Irish and other immigrants, who were willing

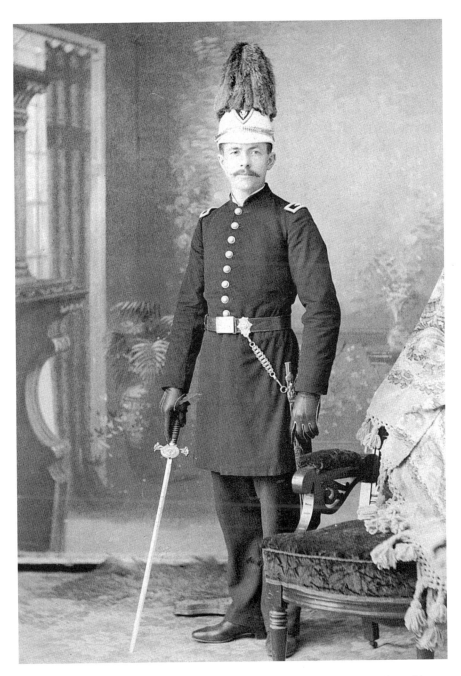

Hibernian member Robert J. Kerr, from Calais, Maine, is shown in the 1890s dressed in an AOH parade uniform. *Vintage photograph from the private collection of John Wiehn.*

to do the hardest work for less pay, and the ruling class sought to protect its comfortable social status. Similar fears came into play during the Civil War when Northerners, with Irish among them, feared the loss of their jobs to free blacks in the North and from the liberation of black slaves in the South.

The Ireland-based Ancient Order of the Hibernians (AOH) became established in the coal-mining region of Pennsylvania and in New York City during 1836–37 as the first organization of its kind in America to support Irish immigrants against the many barriers in their way. It provided welfare benefits for the sick and funds for funeral expenses. Originally open to only native Irishmen, American-born sons of Irishmen were eventually allowed to join.

In many parts of Connecticut, citizens ascribed to another group, called the Know-Nothings, that originated in New York in 1843 as the American Republican Party. By the 1850s, Know-Nothingism had become a widespread movement, and whites born in America who practiced some form of Protestant religion designated themselves as natives. Resembling in spirit the Penal Laws of previous centuries, the constitution of the party stated that its purpose, in July 1853, was "to resist the insidious policy of the Church of Rome, and all foreign influences against the institutions of this country, by placing in all offices in the gift of the people, whether by election or appointment, none but native-born Protestant citizens."[45] In Connecticut, there were 169 Know-Nothings groups with a total of twenty-two thousand members.

Conflicting beliefs and attitudes came to a head with the public trial of Reverend O'Neill in November 1855 at Superior Court in New Haven for his having honored the request of Catholic Helen Lynch Blakeslee to receive the sacraments of Confession and Last Rights at her deathbed. Her husband, an Irish Protestant, won a civil suit of trespass against the priest, who was made to pay "$150 and costs."[46] By the time of the trial, Father O'Neill had already moved to East Bridgeport, remaining away thereafter. The Catholic community of Waterbury deeply felt his absence and honored him with a beautiful monument in Old Saint Joseph Cemetery upon his death on February 25, 1868, at age forty-nine.

Even at the height of the Know-Nothing era, however, liberal and open-minded Protestants came to the support of Catholics when their help was needed, as they had during other times of crisis in both Ireland and early America. Some of the most successful Protestant citizens were employers of Irish workers and contributed financially to the building of the first Catholic churches in the state. Several newspaper articles in Connecticut towns in the1850s spoke out against the Know-Nothing movement, causing

heated divisions and arguments within Connecticut politics. An 1854 editorial in the *Hartford Times* denounced the secrecy of the organization that had grown so rapidly in the previous year. Both political parties of the time courted "the foreign" vote, through which entire ethnic groups would agree to support one candidate or another—a practice that only deepened and continued on both sides of the two-party system throughout the centuries. In the 1850s, however, the Irish and the Democrats (predominantly one and the same) had not yet gained the power of the masses that they eventually acquired and that enabled them to hold their own against opposition. Readers of the editorial were reminded that America was "entirely made up of foreigners…crosses of the Saxon and the Celt—the Pole and German, the English and Italians—the Irish and Spanish—Scotch and French—the re-crossing of bloods has given us the inventive, brilliant indomitable *American character*."[47]

Father Michael O'Neill's tombstone in Old Saint Joseph Cemetery. *Photograph by the author.*

By December, the Know-Nothings had proposed that Congress prevent foreigners from voting until they had been in America for twenty-one years. At the time, one could become a naturalized citizen after five years' residency, and states decided voting qualifications. Another unattributed editorial that year suggested that the government should support immigrants settled in America. "The sailors who man our ships and the soldiers who fight our battles are, many of them, of foreign birth and are entitled by every consideration to the protection of the flag, and interposes the shield of our Government to defend them. Who would deny them this protection—who would compel a residence of twenty-one years before they could obtain it?"[48] Some considered the secret groups' oaths and affirmations to be unconstitutional. "The ascendency of such an Order could be nothing less than the *reign of terror*…This Know-Nothing party is but the disguised retreat

of the old enemy of the Democratic measures and principles, to wit, the old federal and modern Whig party."[49]

Several societies held regular meetings in nineteenth-century Waterbury. The 1868–69 *City Directory* listed the Young Men's Institute, Riverside Cemetery Association, Young Men's Christian Association (organized in 1858), Mendelssohn Society (organized in 1851), the Sons of Temperance (begun in 1859) and three organizations that allowed women as meeting in Temperance Hall. Five different Masonic lodges existed, and the Odd Fellows' Hall hosted two additional groups, established in 1845 and 1854. A parallel opposite to the AOH, the Masons organization had evolved during a time of European inquisition against Protestants. It was formed to protect and support those fearing for their lives in consequence of not being Catholic, the dominant religion of early Europe.

In 1856, Catholics began to form groups of their own. The Waterbury Catholics Institute began in June and lasted at least ten years. Officers included Michael Donahue, Patrick Donahue, John Ryan, Michael O'Connor, John O'Neill, Thomas Donahue, John Fitzpatrick and James Coyle.[50] The Waterbury Roman Catholic Total Abstinence and Benevolent Society (RCTAB) began in 1860. The first officers included Thomas Lynch, Michael Carroll, Patrick Brett and Reverend Thomas Francis Hendricken. Like the AOH, the society provided death and illness benefits. Incorporated in 1865, it included the Sarsfield Guards and a brass band. James Meagher, William Duncan, John Thompson and William Keenan organized a twenty-fifth-anniversary celebration for the group in 1885, by which time there had been 1,674 members and 39 deaths. Treasurers were priests of the Immaculate Conception Church, and officers included the familiar surnames of the earliest Irish families in Waterbury.

Two baseball clubs and church clubs for each of the religious denominations—Episcopal, Methodist, Baptist and Roman Catholic, as well as two Congregationalist parishes—also existed by the end of the 1860s. The Immaculate Conception group, led by Fathers Hendricken and McCabe, his assistant, met in the American Pin Factory. They were joined in 1887 and 1889 by the Saint Thomas Cadets, which added a drum corps and athletic association in 1890 and 1893, respectively. The Brooklyn Athletic Club, whose activities included raising money for charity, began in 1889.

The Young Men's Catholic Literary Society was established in 1869 in the former Saint Peter's Church, after it had served as a school and before Saint Patrick's Hall replaced it. Its first officers were Alpin J. Cameron, James Bradley, John H. Moran and William C. Keenan. It became an important

gathering place for national lecturers and meetings and was a source of fundraising in support of Irish causes.

By 1879, the Young Men's Aloysius Total Abstinence and Benevolent Society had come into being (officers: Maurice F. Carmody and James H. Freney), joined by Saint Joseph Catholic Total Abstinence Society in 1893, which had one hundred charter members. Officers included James H. Freney, Patrick McMahon, Dennis J. Casey, Thomas Luddy and William T. Walsh. Its literary, musical and athletic activities included the Saint Joseph's Dramatic Association. The society joined the Catholic Total Abstinence Union of Connecticut in 1894, which held an annual convention. That year, the Saint Patrick's Total Abstinence and Benevolent Society also began, with J.F. Galvin, D.F. Kelly, J.M. Lynch, Patrick Courtney and Lawrence Cronin as officers and Reverend J.H. Duggan as its chaplain.

Michael Donahue, Patrick Holohan, Thomas Hennelley, Thomas Martin, Thomas Donahue Sr. and Richard Boyle began a Hibernian and Benevolent Society in 1865, but it did not last long. The expense of the band's upkeep had also led to the early demise of the RCTAB society, but fourteen of its early members met in October 1874 to discuss a revival of Hibernianism in the city. At a subsequent meeting at Lampoon Hall (later called Frontier Hall), an early member recalled, "Instead of fourteen, there

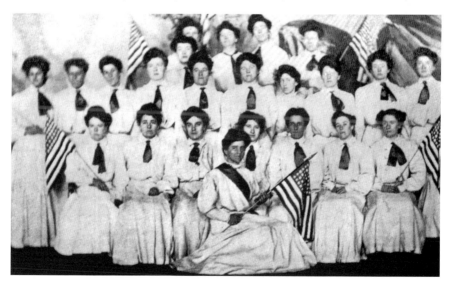

Ladies Auxiliary to the Ancient Order of Hibernians in America, Degree Team Division No. 5, 1907, Waterbury. *From the* Souvenir Book of the Charity Bazaar, *United Catholic Societies, April 13–22, 1907, in the private collection of John Wiehn.*

were fifty present, most of them liquor dealers and their followers. It was our intention to keep them out of the order but it leaked out somehow and they all were enrolled as charter members."[51] On October 9, the fifty charter members formed the first division of the AOH in Waterbury. Officers were Michael Reilly, James Commerford, James Meagher, Maurice Carmody and John M. Keenan. By 1895, there were seventy-six members.

AOH members and their friends attended lectures and forms of entertainment held in support of Irish causes. They contributed funds to the Irish National Land League that existed between 1876 and 1883 with then pastor of Immaculate Conception Church, Father Lawrence Walsh, as treasurer. Between 1884 and 1898, five more Hibernian divisions were formed in town, including one from the Civil War's Company E, First Regiment, Hibernian Rifles (1888). By 1895, there was a combined AOH membership of 1,600.

In 1890, twenty-five people began the Saint Patrick Dramatic Club, with officers J.F. Galvin, William Hetherington and Lizzie Fitzgerald and musical director Miss. B. Coogan. In 1894, 53 women began the Catholic Women's Association with an increase of membership to 183 within the first year. By the late century, Waterbury was full of work-related, social, recreational, performance, religious, civic, philanthropic and insurance organizations, societies and clubs.

Saint Patrick's Hall

Monsignor William Francis Kearney noted that the first rectory in Waterbury was on "the site of the old Immaculate Church, bought on Nov. 11, 1851."[52] Until his transfer in 1855, Father McDermott lived in a house that was torn down in 1857 to begin construction for a new church across from Saint Peter's (110–18 East Main Street). A "house across the street rented and used as rectory until 1870" was also noted by Monsignor Kearney, suggesting an additional one on the same side of the street as Saint Peter's in which both Fathers McDermott and Hendricken lived after him until the Immaculate Conception Church rectory was built. When Father Hendricken arrived in July 1855, he accomplished the building of the first Immaculate Conception Church (101–03 East Main Street) in 1857 and built a rectory next to it in 1869–70 at 97 East Main, having purchased the land in two parcels (fifty-eight [square] feet on June 26, 1860, and thirty-two [square] feet on May 2, 1863).

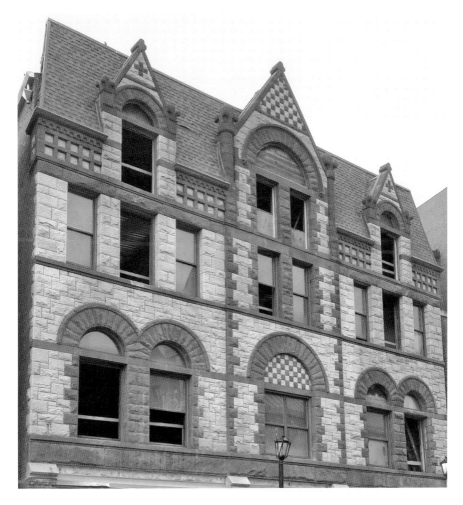

"The Rectory" as it is today, currently under reconstruction. *Photograph by the author.*

A historic multi-patterned stone building next to the Palace Theatre marks the site of the former Saint Peter's today. Colloquially over the years, the building has been called the "Rectory." Father O'Donnell explained, "At the time the church [Immaculate] was dedicated, and for some time after, Father Hendricken resided in the brick building directly opposite the present pastoral residence."[53]

The 1869 *City Directory* revealed that a clergyman from each church served on the Joint Board of Education and Finance for the city. Father Hendricken served on the board for many years and began the first Catholic

schools in Waterbury. The first, in 1857, was in what had been Saint Peter's Church. Staffed with lay teachers, it opened with seventy students. The building was repurposed in 1863 as a public school for $2,900 and leased to the city. It had 750 students on opening day and was used until June 1887. It was torn down in May 1888. Saint Patrick's Hall was built on that site over the following year.

The architectural accomplishment of Saint Patrick's Hall was that of the Immaculate's sixth pastor, Father John A. Mulcahy, along with the Catholic parishioners, whose financial contributions funded so many magnificent buildings in the Brass City. Saint Patrick's Hall included a meeting room, library, gymnasium, Sunday school and space for children's masses. Members of the parish contributed $1,150 to a library fund to establish a reading room. By 1895, the library had magazines, papers and around one thousand books. The building was a gathering place for several social organizations—four divisions of the AOH, the Sheridan and Barcelona Councils of the Knights of Columbus, the Total Abstinence Society, St. Aloysius Cadets and the Children of Mary Societies. The largest hall, on the third floor, could hold almost one thousand people. An 1893 image in the *Waterbury Democrat* revealed that the three-story structure originally carried the name "Saint Patrick's Hall" in raised letters under the center top-floor windows, although by 1928, the words were no longer there. Saint Patrick's Hall was sold in 1925, and it is currently under interior construction such that only the façade of the original structure will remain.

Reverend Thomas F. Hendricken

The early career of Reverend Thomas Francis Hendricken, seventeen years of which was spent in Waterbury, is intricately woven into Waterbury's early Irish Catholic history. He deserves particular note for his contributions to the spiritual, educational and architectural growth in the vastly expanding place.

Born in County Kilkenny, Ireland (May 5, 1827), Reverend Hendricken was the third child of John Hendricken and Anna Maria Meagher. His father descended from a German officer who had fought in the Battle of the Boyne in 1691 under the Duke of Ormond. His mother was a daughter of Thomas Meagher and Mary Byrne, Thomas having descended from an old Kilkenny family.

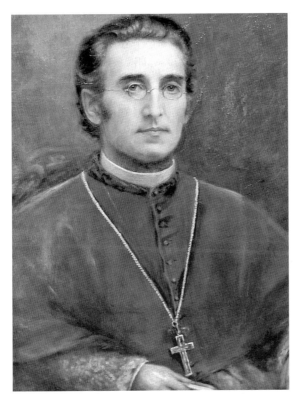

Left: Painting of Bishop Thomas Francis Hendricken, artist unknown. *Courtesy of the Archdiocese of Providence, Rhode Island.*

Below: Plaque on the wall of the Roman Catholic church at the cemetery of Dunmore, Kilkenny, Ireland, placed by Bishop Hendricken in honor of his parents. *Photograph by and courtesy of Dr. Jane Lyons.*

OF YOUR CHARITY PRAY FOR THE SOUL OF
JOHN HENDRICKEN, OF THE TRIANGLE,
WHO DIED IN THE YEAR 1833,
AND OF HIS BELOVED WIFE ANNE MEAGHER
DECEASED IN 1854,
THE REMAINS ALSO OF THREE OF THEIR CHILDREN,
WHO DIED YOUNG, REST BENEATH THIS STONE.

THIS MONUMENT IS ERECTED TO THEIR MEMORY
BY AN AFFECTIONATE SON AND BROTHER,
THOMAS F. HENDRICKEN,
BISHOP OF PROVIDENCE,
UNITED STATES, AMERICA.

Several important members within the international growth of Catholicism emerged from this area of Ireland. Mother Mary Frances (Fanny) Warde, daughter of Jane Maher and John Warde, of Mountrath, Queen's County, brought the Sisters of Mercy to America, establishing an order in Pittsburgh and then Providence, Rhode Island, in 1851. Her cousin Mother Mary Pauline Maher, born in Freshford, County Kilkenny, in 1851, was the first mother superior of the Sisters of Mercy in Hartford, Connecticut, in 1872, having directed Saint Patrick's School there. She was the local superior of Saint Catherine's Convent for seventeen years and elected mother superior of the community in 1870. Among her family were three Carmelite nuns, a Sister of Mercy in Ireland, the mistress of novices in the Pittsburg community and Mother Mary Cecilia (Ellen Maher), founder of the Sisters of Mercy in New Zealand.

Among Father Hendricken's siblings were Catherine/Kitty (born 1831) and William J. (born 1838), who followed their brother to Waterbury. Their widowed mother and her brother had supported Father Hendricken's education such that he could attend Saint Kieran's College in Kilkenny and the Royal College of Saint Patrick, Maynooth, in Kildare. Also known as All Hallows College, this was the first seminary for priests in Ireland.

When Connecticut's Bishop Bernard O'Reilly came to Ireland seeking priests for the early Hartford diocese, he ordained Father Hendricken on April 29, 1853. At the bishop's request, the young priest, who was known as an excellent student, gave up his dream of becoming a Jesuit and serving as a missionary in China or Japan. He agreed to immigrate to America. Three months later, on July 18, 1853, he arrived in New York on the *Columbia* after having endured physical violence on the journey across the ocean. The entire crew of the ship ascribed to Know-Nothingism, and the captain of the *Columbia* was the lodge president of an order in Maine. Father Hendricken was one of six passengers with cabins among seven hundred predominantly Irish and German passengers in steerage. When he looked after a female Catholic passenger who had taken ill, offering Holy Communion to her, the captain of the ship became irate, "declaring that aboard his ship people would have to die without Catholic mummery." Secretly during dinnertime, Father Hendricken succeeded in hearing the woman's confession and performing last rights for her. Upon being told about this, the captain became enraged, shouting, "The papist shall never see New York alive!" and began to beat the priest, kicking him in the head. Fifty German passengers came to his rescue, prevented further attacks, nursed his wounds and took turns guarding him for the rest of the trip until the ship arrived safely to shore. [54]

Saint Patrick, a stone carving on the chapel at St. Patrick's College, Kildare, built between 1875 and 1891 on the grounds of Maynooth Seminary, established in 1795. In 1910, the seminary became a college and in 1997 a part of the National University of Ireland. *Photograph by the author.*

Father Hendricken spent his first months as a curate in Boston and then worked in Newport and Woonsocket, Rhode Island. He was quickly promoted from curate at the Cathedral at Providence to pastor of Saint Joseph Church in Rhode Island and then to a church by the same name in West Winsted, Connecticut. There he dissolved the church debt and in several areas purchased land on which other churches were later built. To the great benefit of the Waterbury Catholics, on July 18, 1855, he became their new resident pastor. "His enthusiasm knew no bounds," wrote Reverend O'Donnell, "and his constant aim was to build up a parish second to none in the diocese. That he succeeded is a fact of history."[55]

The first Immaculate Conception Church on East Main Street in Waterbury was of red brick with a tall spire, designed by architect P.C. Keeley and costing $45,000. "The building ranked among the most pretentious churches of the diocese" (*pretentious* presumably having been meant as a compliment).[56]

Father Hendricken's additional accomplishments included the purchasing of eight other properties and the founding of Notre Dame Academy, originally called Notre Dame Convent. Based in Montreal, Canada, the order of the Sisters of Notre Dame was established in Waterbury in May 1869 with five nuns and their "directress," Madame Saint Cecilia. Father Hendricken purchased a building for them at the corner of Union and Elm Streets for $12,500, remodeling and enlarging it for another $5,880. The sisters began teaching their first thirty female students in September. Eighty more girls enrolled the next year, and the school was enlarged again in 1870. A much larger school was built in 1871 that included dormitories and a large hall. A twenty-five-year reflection about the convent and school lauded:

> *Some seventy-eight young women have received graduating honors, each of whom today occupies an honorable position. Some brighten the homes over which they preside; some are efficient principals of schools. Several are making their mark in the business world. Not infrequently we hear of some one who has gained success in a musical career, the foundation of which was laid at Notre Dame...*[57]

Father Hendricken also purchased the property on which Saint Mary's School was built in 1886.

Hendricken mentored young Michael McGivney. Supporting him on his journey to begin his own seminary studies in Canada, Father Hendricken

First Immaculate Conception Church on East Main Street. *Vintage postcard from the author's private collection.*

traveled by train with McGivney in 1868. That year, Hendricken also received a doctorate of divinity degree from Pope Pius IX.

For $2,000, Father Hendricken purchased the land at Dublin and Silver Streets for Saint Joseph Cemetery from the executer of the estate of J.M.L.

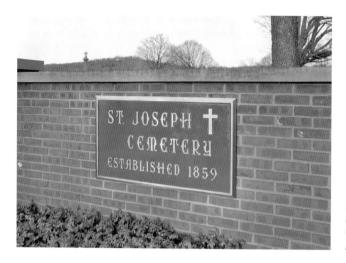

Sign at the entrance of Old Saint Joseph Cemetery. *Photograph by the author.*

Scovill on December 1, 1857. The first burial, for John Rice, occurred in October 1858.[58] Unfortunately, the first book of records for the cemetery was lost in a fire, so no information exists for the early burials apart from what may be gleaned from index entries in vital records at city hall. (Actual death records in Waterbury are not available before 1886.) Tragically, in recent years, two instances of overt vandalism have resulted in the loss of hundreds of historic tombstones in this significant cemetery, which has been an invaluable time capsule of the earliest Irish families in town. It is still possible to read on many of the tombstones the deceased's place of origin in Ireland.

In 1860, Father Hendricken, aged thirty-one, was living in Waterbury with two slightly younger Irish priests, James Bolan and Daniel Mullen, and the church caretaker, Narcisse Gregoine. His real estate was valued at $8,000. Mary Conlan and Margaret Fruin—aged thirty-nine and twenty-seven, respectively—were their servants. In 1870, his home included another young Irish priest, Robert Sullivan, and nineteen-year-old Julia Kearnan. Julia McEvoy, twenty-three, kept house, and Thomas Gordan, eighteen, was a day laborer.[59] On November 7 of that year, Father Hendricken became a naturalized citizen in the city court of Waterbury.[60]

Census records also noted that his sister, Kitty, had immigrated in 1860, appearing that year as the wife of well-to-do Waterbury dry goods merchant Peter Lawlor, who was also from Ireland. The couple had three children and lived at 319 North Main Street. Their eldest son, Thomas Francis, graduated from Yale Law School in 1893 and built a successful practice in Waterbury. He was justice of the peace in 1894. Peter died sometime before

1900.[61] Father Hendricken and Kitty Lawlor's youngest brother, William J. Hendricken, naturalized in Waterbury on March 25, 1867, at age twenty-nine. In 1870, he was a dry goods merchant, perhaps having taken over the business of his deceased brother-in-law.[62]

With his vision and guidance, Father Hendricken grew his parish in Waterbury until it was regarded as among the best examples of a thriving Catholic community in New England. Although the people of the parish would miss him, they were equally proud when he was chosen by Pope Pius IX to become Rhode Island's first bishop in the newly created diocese in Providence,[63] where New York's Bishop McCloskey ordained him on April 28, 1872. "Many were the expressions of sorrow at his prospective departure, and sincere the testimonies to his worth not only as a churchman, but as a citizen interested in the welfare of the city."[64] Father Hendricken's "faithful assistant," Father Robert Sullivan, preached the farewell sermon on April 22 and relocated to Providence himself soon after the new bishop left Waterbury. There would be eight more resident pastors before the cornerstone was laid on August 15, 1926, for the present majestic Immaculate Conception in the city center opposite the green. The church was granted the status of a minor basilica by Pope Benedict XVI on February 9, 2008.

The Late Nineteenth-Century Irish Community

Civil War

The Civil War had its share of Irish and Irish American heroes, and the topic has been well documented by several authors, particularly by Neil Hogan (*Strong in Their Patriotic Devotion*) and Damien Shiels (*The Irish in the American Civil War*). The period was yet another time that found Irish friends and relatives on differing sides of issues. While some southern Irish came north to fight alongside their countrymen, some who had immigrated to the South had other established loyalties. Many in the South had achieved prosperity, which often included the owning of slaves. Others supported the concept of independent states. The majority of Irish in the North, however, were quick to defend the Union. Some enlisted for the money, including the substitution fee of $300, which individuals of means could pay for someone to take their place in the conscription.

Father Hendricken urged the men of Waterbury to join the fight once Fort Sumter was attacked, gathering them in the Immaculate Conception basement, where they formed a company that included Corporal Michael P. Coen. Units were formed and re-formed as death tolls increased. The Civil War Soldiers and Sailors Database for Connecticut members of the Union army includes 65,198 listings in fifty-five regiments. Some men were enlisted "subject to the discretion of the President or otherwise according to law," and some Connecticut men served out of state, particularly in Massachusetts.

Newspaper draft lists contained a healthy combination of Irish and English names. One such entry in Waterbury attested to willing volunteers

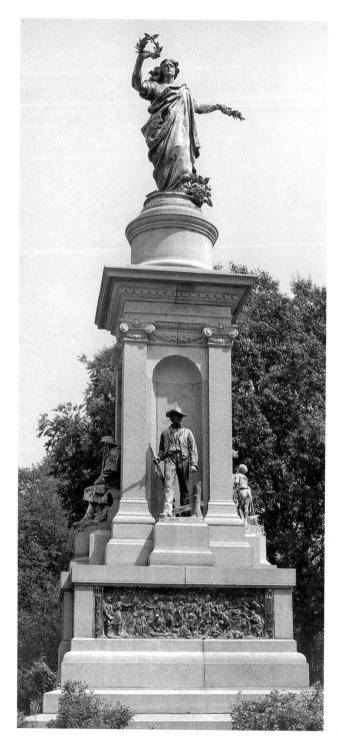

The Civil War Soldiers' Monument, Waterbury's first of two such monuments at the downtown green, was dedicated on October 3, 1884. *Photograph by the author.*

that far outnumbered the quotas requested. On August 22, 1863, a draft for Waterbury residents was held at the statehouse. For the Twenty-sixth Sub-District, first class, with a quota of 143 needed, 496 men volunteered. Some of the names included James Bergin, Edward Carroll, Finton Delaney, Patrick Delaney, Michael Donahue, Patrick Flynn, Peter Galagan, David Gorman, Patrick Healy, two named Thomas Higgins, Dennis Kilduff, James Mulvaney, Patrick Murphy, Michael O'Connor, James Shay, Thomas Shannon, William Shannon and John Shehan.

For the Twenty-seventh Sub-District, first class, to fill a quota of 157, 496 men enrolled. Among the Waterbury names were William Butler, John Carroll, John Casey, Joseph Cassidy, Thomas Conner, C.A. Crowley, Edward Dolan, Patrick Dolan, James Donnelly, John Fitzgerald, Michael Flannigan, Patrick Galvan, John Hickey, Michael Kelly, Finton Lawler, William Luddy, Pat Mahan, Patrick McElroy, Richard Murphy, Thomas Neil, Hugh O'Donell, Finton Phalen, William Phelan and John Reily.[65] Hogan made note of Waterbury's Lieutenant Patrick Claffee, who died at the Battle of Bull Run, and David Allman, a Waterbury "brass dripper," both members of the Irish unit, the Ninth Connecticut Volunteers. Claffey's and Allman's graves are among the oldest in Old Saint Joseph Cemetery. The Allmans, who appeared in the U.S. census of 1850, originated in County Kerry, according to one stone.

Other Civil War grave references in Waterbury's Old Saint Joseph Cemetery include the following, all members of the Connecticut Volunteers unless otherwise noted:

John Brady, Company E, Sixth Regiment
Michael Butler, Company C, Fourth Infantry
John P. Coen, Company F, Eighth Regiment
Patrick Crannell, Company D, Eighth Regiment
Patrick Crannel, Company H, First Regiment, Cavalry
Patrick Delaney, Company B, Ninth Battalion
Thomas Delaney, Company F, Ninth Connecticut Infantry
Henry Dunphy, Company K, First Regiment, New
 York English Volunteers
Patrick Fitzpatrick, Company E, First Connecticut Cavalry
James J. Gilbert, Fourteenth Infantry
Patrick Goggin, Company C, First Heavy Artillery

Michael Kenny, Company E, Eighteenth Infantry, Illinois Volunteers

Andrew Keveney, Company K, Ninth Regiment, Pennsylvania Volunteers

James Kilduff, Company C, First Connecticut Artillery

John Mally, Company H. First Connecticut Cavalry

Thomas Meehan, Company E, Fifty-seventh Regiment, Massachusetts Volunteers

Hugh O'Donnell, Company K, Sixth Infantry

O'Donnell, Company E, Sixth Regiment

Timothy Quinn, Company D, Fifth Regiment

William Rigney, Company E, Sixth Regiment

William Shanahan, Company K, First Regiment, Heavy Artillery

Thomas J. Walsh Company F, Second Regiment (private); Company H, Eighth Massachusetts Volunteers Militia (first sergeant)[66]

Years later, a Waterbury-born ordinary seaman who served in the U.S. Navy was buried in Old Saint Joseph Cemetery. Richard Ryan received a peacetime Congressional Medal of Honor for his rescue of a crew member who fell overboard from the USS *Hartford*. Ryan "displayed gallant conduct in jumping overboard at Norfolk, VA," rescuing his shipmate on March 4, 1876.[67]

Fenians

The Fenians were an outgrowth of the Young Irelanders of the late 1840s, a younger, more radicalized group of mostly upper-class young men discontent with the efforts of County Kerry's Daniel O'Connell's willingness to compromise and work within the system while seeking Catholic independence.

The Young Irelanders attempted an uprising in 1848 while so many were starved and dying from the Great Hunger. The leaders were caught, tried and deported from Ireland as exiles. John O'Mahoney and James Stephens escaped and fled to France, as decades of Irish rebels had done

before them. Stephens formed a secret rebel group, the Irish Republican Brotherhood, and O'Mahoney formed the Fenian Brotherhood. Both continued to strive for Ireland's independence. O'Mahoney's visit to America in 1856 gained much support for his cause among Irish and Irish Americans there, creating an American Fenian extension. While the Fenians remained clandestine in Ireland, those in America boldly announced their support of Ireland's continued struggle to become free from British rule.

Some Civil War veterans became deeply involved, having come home from battle still raring to fight. The American Fenians became divided. A faction headed by William Roberts orchestrated what became a perplexing attempt to invade Canada, then considered "British North America." The Fenians' hope was that the capture of Canada would distract Great Britain and allow a successful rising in Ireland, but that did not occur. Waterbury's Corporal Coen, under Major Bannon, was Connecticut's officer who registered those interested in joining. Several Waterburians signed up and contributed funds to the cause.[68] The most well-known raid on Canada, the Battle of Ridgeway, occurred over three days in 1866, when less than 1,500 men, organized as regiments from within America, attacked Canada from southern Ontario. Thousands of promised reinforcements were not able to successfully join them.

The U.S. government publicly aligned with Great Britain and condemned the actions of the Irish and Irish Americans involved. Arrests were made, and several individuals in positions of power sought leniency regarding the punishments due to people they knew. Father Hendricken appealed on behalf of Terrance McDonald, a member of the Immaculate Conception; however, in Canada, the anti-Fenian Irish leader, the Honorable Terrence D'Arcy McGee, refused to pardon him. By 1870, the popularity of rebellion had settled down in Connecticut, and politics had successfully shifted in favor of the Democrats. On April 9, New Haven's *Columbian Register* celebrated the fact that the entire Democratic ticket had been elected.

The Waterbury Democrat

Josiah Giles's *Waterbury American* began as a weekly newspaper in 1844 and became daily in 1866. A June 1874 supplement, the *Illustrated American Monthly*, in the collection of the Connecticut State Library noted the paper then as the *Waterbury Daily* and *Weekly American*. This archive also holds, however, Volume 1,

No. 30, of what may have been the first of its kind to include views apart from the conservative establishment. Printers Richards and Mattoon published the *Waterbury Weekly Democrat*, "A Political Family Newspaper." The June 21, 1855 issue explained that the men, who also advertised for printing jobs of all kinds, put out a semiweekly version of their paper on Wednesday and Saturday, and the *Weekly Democrat* on Thursday morning. Their office was in Baldwin's Building on Bank Street. Decades later, in July 1881, the *Waterbury Democrat* appeared, likewise representing immigrant and liberal interests. Starting out as a weekly Saturday paper, the *Waterbury Valley Democrat* "was in a field where somewhat similar enterprises had appeared for a moment on the surface and then sunk beneath the wave of public disapproval...but the business never took a step backward." The editors, Cornelius and M.T. Maloney, replaced Saturday with the *Sunday Democrat* in January 1886, increasing their scope considerably. At the end of the following year, the increased four-page, seven-column *Evening Democrat* was launched, coming out every day. (The publication's masthead was *Waterbury Democrat*.) The circulation of this paper became one of the largest in Connecticut—2,500 issues daily in 1893. "It met with approval because it was independent and fearless."[69]

Cornelius Maloney, a newspaperman and printer of New Britain, began the paper in 1881 with a partner who was soon replaced by Maloney's brother, Michael Thomas, as managing editor. (Their parents were Patrick Maloney and Margaret Loughery.) Edward E.F. McMahon was the paper's long-standing business manager. Edward L. Maloney, also of New Britain, and Waterbury-born Richard F. Grady gathered the news as of 1893. Martin Scully later joined the staff. (Cornelius Maloney was also Waterbury's representative in the general assembly between 1887 and 1888. Michael was an active member of Sacred Heart Church and its choir.)

For two months, the *Democrat* contained stirring editorials written by its editor, Stephen J. Meany, born in 1822 in Newhall, County Clare. Known as a distinguished reporter and poet in Ireland throughout the 1840s, he visited America for the first time in 1856. Meany wrote for New York publications and became part owner of one. By 1887, he had settled in Waterbury and become editor for the *Waterbury Democrat* from its daily edition begun on December 5 until his death only a few months later on February 8, 1888. His editorials offered inside information about "the wants and woes of Ireland." Each issue addressed controversial political ideas, calling into question businesses and practices that seemed worth scrutiny. In the sixth issue after Meany's appearance, two entire columns of "Friendly Greetings" from newspapers around the state applauded the newspaper group's efforts. All

were overwhelmingly favorable, except the other local newspaper, John Henry Morrow's the *Republican*, established in 1881, which merely described the paper as "creditable." "We do not believe in the principals [*sic*] of the Democratic party, but there are those who do, and so long as this latter class sincerely believe they are entitled to respect and to fair play, though not exempt from criticism," the letter stated, adding, "*The Evening Democrat* has not lived very long yet, but if it is to live a ripe old age, it will be by maintaining a high standard of journalistic excellence."[70] (Edward B. Cooke's conservative paper, the *American*, existed in town from 1866. In 1901–02, William Jamieson Pape, with William M. Lathrop, purchased and incorporated the *Republican*. Pape, having bought out Lathrop's interest in 1910, also became owner of the *American* in 1922.)

The souvenir edition of the *Democrat* (April 1893) provided a broad overview of Waterbury's cultural, manufacturing and architectural achievements featuring many Irish-surnamed leaders. The population of Waterbury, with an Irish majority, had reached almost thirty-five thousand, with about seven thousand individuals employed in manufacturing. The editors proudly stated, "They are of a most desirable class of factory help; to them liberal wages are paid; the best of feeling exists between employers and employees; a large percentage of the latter own their own homes, and strikes and labor troubles are almost unknown. It is estimated that about $9,000,000 are invested in manufacturing in Waterbury."[71]

Stephen J. Meany

Although only fifty-five editorials exist, Stephen Joseph Meany's writings support his obituary's claim that he was "among the best Irish writers of the day." His explanations and commentaries regarding "Ireland's Penal Laws" (December 29, 1887), "The Irish and the Scotch" (January 28, 1888), "Dynamite and Daggers" (January 31, 1888) and "The Improved Condition of Ireland" (February 3, 1888) were particularly noteworthy. "An eminent journalist and an earnest and indefatigable advocate of the Irish cause,"[72] Meany died at age sixty-three from what seemed to have been a persistent cold but was ruled pulmonary gangrene caused by the bacterial skin condition erysipelas, which he incurred after an operation. Unfortunately, the people of Waterbury were just beginning to recognize him, traveling as he did daily from his room in the Scovill House to the newspaper office. They were certainly familiar with his words. The community might not have known,

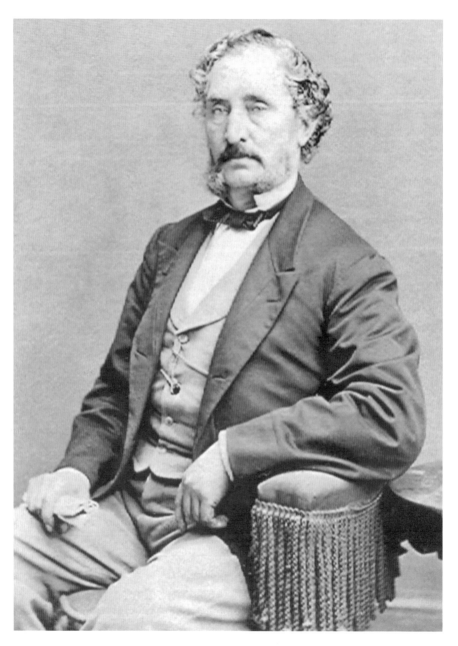

Stephen Joseph Meany, 1822–1888. *Vintage photograph from the private collection of John Wiehn.*

however, that Meany's support of Irish rebel causes and leadership in both the Irish and American Fenian movements had resulted in earlier arrests and imprisonments. His fundraising efforts on behalf of those arrested for their involvement in the Fenian attacks in Canada led to an arrest when he returned to Ireland in 1867. After serving several months of a fifteen-year sentence in penal servitude, he was freed as an exile, forbidden to set foot in his homeland again. He returned to New York, continuing to publish and to work toward Ireland's freedom. He was admitted to the American Bar Association in 1868 and continued to travel back and forth to Ireland, for which he was arrested again in 1882, though he was released quickly. His long obituary referred to his acquaintances as "many of the prominent and leading men in America" and noted that he had traveled widely throughout Great Britain and America. "He was mixed up, one way or another, with every Irish movement. In the O'Connell movement, in the '48 movement, in the Fenian movement, in the Land League movement—in every movement for or about Ireland, he was to be found somewhere."[73] "In his death the down-trodden Irish people lose a strong advocate, the state a worthy citizen, the church a devoted follower, and his associates a warm and steadfast friend."[74]

Described as "a hoary-headed old gentleman," Meany still had a wife and an eighty-four-year-old mother (Mary Sheehan) in Ennis, County Clare, at the time of his death. He also had children, one of whom was a nun in London's Convent La Sainte. It was not known until after many publications had announced his demise that he also had a daughter-in-law, the widow of his son, William, and two grandchildren living in Washington, D.C. William Meany had been the city editor for the *Daily News* in Baltimore, Maryland, until 1886.

While his body lay in state at the Young Men's Catholic Literary Society on Dougherty's block a special meeting was held to discuss whether to bury Meany in Old Saint Joseph Cemetery or take him back to Ireland. At the Immaculate Conception Church, a funeral Mass was celebrated for him by Father Mulcahy, with Fathers Treanor as deacon, Duggan as sub-deacon, Finnegan as master of ceremonies and White from West Albany, New York, assisting. Thirty members of Irish societies in Waterbury, New Haven, Danbury, Bridgeport and Naugatuck accompanied the body to locations outside Waterbury, where Meany was honored. The committee that brought the coffin to New York included C. Maloney, J.H. Moran, M. Wallace, M. Scully, Jas. Coughlan, M.F. Connolly, John Thompson, John A. Moran, John Ryan, John Clohessy, James Meagher, D.H. Tierney, John J. McDonald, John Moriarty, E.P. Reardon, Jas. J. Horrigan, James Sutton, Wm. McGrath and Edward Ducey and, from New Haven, John J. Donegan, James Reynolds and Captain L. O'Brien.

Waterbury's Thomas Francis Meagher Club began a fund for funeral expenses. Martin Scully, representing Waterbury's Press Club and the Naugatuck Valley delegation, was delegated to bring Meany's remains to Ireland. Money raised in Waterbury and by the New York Press Club was intended, after expenses, to purchase a monument for Meany and give anything remaining to his mother. Services were held at New York Press Club and the Church of Saint Jerome. Scully met Meany's sister in Ireland and accompanied the coffin with her to Dromcliffe Graveyard in Ennis, where thousands of people attended Meany's burial.

Women at Work

By 1869, the Waterbury *City Directory* revealed the establishments of several businesses run by people whose surnames suggested Irish ancestry. Among them were fourteen grocers, three dry goods dealers, three physicians, owners of meat markets and boardinghouses, boot and shoe dealers, two merchant tailors, two milliners, a blacksmith, a dressmaker, a painter, a billiard parlor owner and two saloonkeepers. Irishmen were also among the ranks of the city officers, including an alderman, four councilmen, a board of relief registrar, an assistant attorney at the city court, a collector and members of the police force. By 1871, there were several in the "Wines and Liquors" business and several more saloon owners in town, and the Lawlor Brothers were operating as undertakers.

Several Irish heads of households in nineteenth-century Waterbury owned or rented two- or three-story houses, living on one floor and renting out the other(s). Widows and older unmarried women also turned their residences into boardinghouses, creating a means to establish regular income. Given the relatively short lifespans of the male population and the need for most members of families to bring income into the home and send to families in Ireland, young unmarried Irish women, widows and married women with children were often at work. Nurses or teachers were produced from families who could afford to allow their daughters to be educated. Common professions open to women at the time came to have many Irish representatives. After marriage, however, women were no longer allowed to teach. As early as 1869, Ellen M. Donahue, Ellen A. Mulville, Katie G. Mulville, Emily Baxter and Mary A. Galvin were listed as teachers in the *City Directory*.

Bridget Riordan Collins (1873–1942) took great pride in making the beautiful marble steps of the Waterbury City Hall gleam, despite the fact that the job entailed working on her hands and knees. A native of Meelin, County Cork, she immigrated to New Haven in 1899 and began as a domestic there. Upon her marriage to Patrick Collins in 1904, the family moved to Waterbury. She worked for the city from 1918 until her death. *Vintage photograph from the private collection of John Wiehn.*

For those who were not as well educated, a more common profession for Irish women in the nineteenth century, besides factory work, was domestic service. The 1876 census data revealed many female Irish domestic servants in Waterbury in the homes of both Anglo and Irish employers. They could be found predominantly in the Hillside area of town among the wealthy manufacturers but also in the first ward, where Irish business families had Irish and other servants "living in." It would have been a symbol of status and a point of pride if wives were not required to work outside the home, particularly if they had additional hired help. Servants may have cooked, cleaned, helped take care of the children or any combination thereof. In a time when Connecticut-born women considered domestic service to be unsuitable employment beneath their social status, Irish immigrants and American-born daughters of immigrants instead found this work a desirable way to avoid the factories and enjoy privileged surroundings while they worked. Irish women from lower-income classes or those who remained single might, in this way, experience environments they could aspire one day to achieve permanently for themselves.

A seventh-generation descendant of one of Waterbury's settlers, Sturges Morehouse Judd, born in 1809, was a vitally important historian and involved citizen. In addition to documenting significant facts to provide a cultural history for the Protestant community, he singlehandedly conducted a city census in 1876. This census revealed many Irish-born women working as domestics:

Catharine McCue, twenty-four, in the home of a Polish carpenter and family.
Bridget Sheehan, twenty-two, living with four Connecticut-born workers upstairs from the grocer Mortimer Heffernan and family.

Mary Donnelly, twenty, born in Connecticut, living with the James and Ellen Coen family.

Margaret McDonald, nineteen, born in Connecticut, living with brass mill worker Finton McEvoy of Ireland and his family.

Bridget McCarthy, twenty-one, for the Irish dry goods merchant Peter Lawlor and family.

Catherine Rafferty, twenty-eight, with the gunsmith Frank G. Perkins and his family.

Ellen Barrett, thirty-three, in the home of grocer Fredus Ladel.

Bridget Donnelly, eighteen, with twenty-four-year-old commercial agent Charles H. Matthews and his twenty-year-old Connecticut-born wife.

Julia Shields, twenty-five, working as a domestic but living alone.

Margaret Keegan, in the home of the treasurer of Rogers and Brothers Manufacturing David B. Hamilton and family.

Anna Kennedy, twenty-five, of Ireland, and Emma Rolee, twenty, born in Connecticut, both for the secretary of W.L. Coal Company, Frederick B. Rice, and his wife, each thirty-one years old.

Ellen Kane from Ireland and another housekeeper from New York working for Joseph B. Daniels, manufacturer of pins.

Margaret Magee and Mary Sennett, both twenty years old, in the home of physician and surgeon James Brown, his wife and his thirty-six-year-old daughter.

Mary Farrell, forty, for the physician and surgeon John Deacon with his four teenaged daughters and twenty-year-old son (an agent for American Printing).

Bridget Flynn, twenty-three, for Asa C. Peck, carpenter/builder, and family.

Margaret, twenty-one, and Ellen Shannahan, nineteen, for John H. Weldon, deputy sheriff, and his wife.

Catharine Doolan, twenty-five, in a home of several elderly people, the head of household a real estate agent.

Catherine Maher, thirty-eight, living on her own floor of the two-family house of coal, wood and ice dealer John S. Castle and family.

Bridget Hanlon, thirty-one, for Robert R. Stannard, secretary of Blake and Johnson, and family.

Mary McGrath, thirty-one, with a younger Connecticut-born servant, living with the family of dry goods merchant William Merriman.

Nora Keyes, eighteen, in the home of dry goods merchant Charles Tyler.

Mary Donnelly, twenty-four, for the family of the postmaster, John W. Hill.

Maria Doolan, twenty-three, for the family of merchant tailor John B. Mullings.

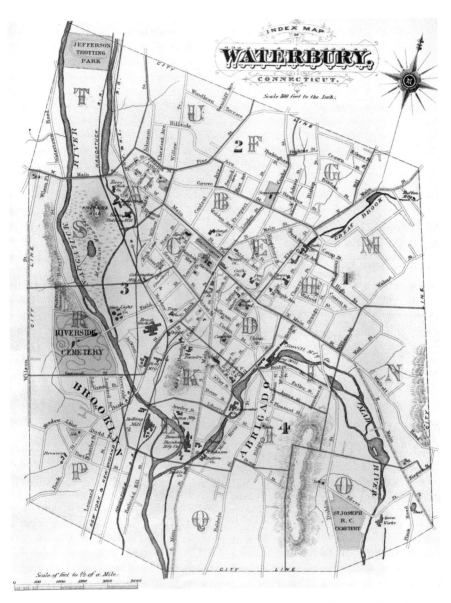

Waterbury in 1879. *From the* City Atlas, *courtesy of Mattatuck Museum, Waterbury, Connecticut.*

Teacher Thomas Odell, thirty-five, from Ireland also appeared in the 1876 census. He was married to a Connecticut-born woman, and the couple had children when the census was taken. Unlike other professional men in town, however, there were no servants in his home.

The Census of 1876 and Atlas of 1879

Judd's census is an invaluable glimpse into the explosion of Irish who arrived between the national censuses of 1870 and 1880, during which time many more deaths had occurred among the first and second generations of immigrants. The entire population of Waterbury in 1876 was 16,039 individuals. Among these people, 6,696 were listed as "Native American." American-born people of combined American and foreign-born parentage totaled 11,179. There were 46 men and 41 women designated "colored persons." Surprisingly, given the multitude of Italian immigrants who had arrived by the end of the century, it appears that in 1876, only seven individuals of Italian heritage were in town—two male and two female immigrants with three children born in America.[75]

Waterbury was divided into four wards, quadrants created by the North, South, East and West Main Streets' intersections extending to the outermost limits of the city. The divisions occurred at the inside edge of the green, the heart of downtown. Scovill Manufacturing Company made up a large portion of Wards One and Two. Ward One, north of East Main Street and east of North Main Street, became one of the Irish enclaves. Ward Two was the north and upper end of Waterbury with Immaculate Conception Church at one end, the Willow Street area at the other and including Hillside Avenue overlooking the city (west of North Main Street and north of West Main Street). Author Bettejane Wesson explained that the Willow Street neighborhood, particularly the upper area, came to be known as "Cracker Hill" since many of the Irish who aspired to live there needed to seriously pinch their pennies, or "subsist on crackers," to afford to do so. The nickname likely started out as a slur against the Irish, who appeared to be "social climbers," but was considered more affectionately in modern times. Many of the most stately large family homes were at the bottom of the hill, "where doctors, lawyers and tradesmen who served them and were doing well settled, emulating on a smaller scale, the Hillside mansions." Some of the architectural gems became funeral homes. Some were torn down for parking lots. In the elegance of the early twentieth century, the nearby streets were called the "Avenues."[76]

Ward Three was the main downtown business area west of South Main Street and south of West Main Street. Ward Four, east of South Main Street and south of East Main Street, included the Abrigador and the Hill. The majority of Waterbury's Irish and German families lived in

these wards in 1876, with more Germans in the third and more Irish in the fourth. There had been an increase of 170 families (but only twenty-nine dwellings) in Ward Four in the six years after 1870. The combination of native Irish and those born in America of Irish parents dominated Waterbury's population, already outnumbering the "Native Americans" by 39 people. Irish Americans owned several of the businesses and were established in white-collar professions. The immigrant and first-generation American makeup of the community in 1876 included 6,735 individuals of Irish heritage; 612 from the German states; 442 from England; 166 from Scotland; 154 from Canada; 118 from France; and 25 or fewer from several other European countries, including Sweden, Poland, Switzerland, Bohemia, Belguim, Wales, Austria, Denmark, Russia and Turkey.

Plate H in the 1879 *Atlas of the City of Waterbury* depicted the North Elm at East Main Street area that included Maple, Cherry, Walnut, Orange and William Streets (some portions called avenues or extensions)—the other area of largely Irish concentration. Within this section were the companies Waterbury Clock, Matthews and Stanley Manufacturing, Abbott & Hood Brass, Platt Brothers & Company, Danes Button Manufacturing, E. Robinson Novelty Manufacturing and Hall & Upson, with its wood yard.

Scovill Manufacturing extended farther up East Main Street to the city line around and beyond Old Saint Joseph Cemetery in sections of both Wards One and Four (Plate O). Rogers and Brothers had its spoon and fork manufacturing company there. Several Irish names appeared on East Main Street, in the section from William to Niagara Streets and along Wolcott Avenue. Included among them were E. Fagan, John Fagan, D. Dugan, P. Phelan Est., F. Phelan Hrs., John McGrath, J. McKean, J. Farrell, Holohan & Lawlor and John Galvin. At either end of the cemetery, land was owned by John Slavin, James Slavin and Claffey.

Most surnames in the Bishop Street and the North Centre School District to the northern extensions of the city line were early Anglo ones. At the outer edges of the area, heading down the back side of the hill toward Waterville, some Irish names appeared: T. Callahan, Phelan, T. Phelan, P. Delaney, P. Kelly, M. Kelly, M. Hayes and Donnelly. At Hopkins Street there were Butler, Mrs. M. Coen, J. Russell, M. Brennan and Mrs. Kalaher.

West Main Street was the division between Ward Two, which extended up Willow Street, and Ward Three, extending southward in the opposite direction. In 1879, both tracks of the railroad crossed West Main

Street. Businesses around Crane and Sperry Streets included Waterbury Brass Company with its Rolling Mill, American Flask & Cap, Terry Clock Company and Hall & Upson Ice House. There was a "regular school" and H.&S. Bronson's Waterbury English & Classical School. Ward Two extended to the Center Square and the First Congregational Church. The area was filled with old settler surnames.

Plate R of the 1879 atlas depicted the part of Ward Three that included old Grand Street Cemetery and the new Riverside Cemetery, with Riverside Street running parallel to the Naugatuck River. Bank Street formed the border of a less residential area that included Waterbury Gas and Light Company, Brown & Brothers Brass Works, Plume & Atwood Manufacturing, Blake Trap Factory, Abbott's Store House, Carrington Manufacturing, a Corset Manufacturing Company, the New York & New England Railroad and the Naugatuck Railroad Freight Depot. Brooklyn, beneath Town Plot, was also part of Ward Three. Riverside Street extended through there to a section between both railroads. It was one of the major areas washed away during Waterbury's Great Flood of 1955. In 1879, along Riverside, Leonard and John Streets, with Meadow Lane and Summit Streets rising into Town Plot, were the Farrell Foundry Company, Holmes, Booth & Haydens, A.C. Peck, Brown & Brothers and the Brooklyn School. The town was a bustling industrial complex.

The Demise of Old Grand Street Cemetery

Reverend Joseph Anderson, DD, gave a talk on April 27, 1884, about the Waterbury Burying Grounds, rebuking the citizens of New England for so badly neglecting their cemeteries. He announced that about a year earlier, Sturges Judd, caretaker between 1862 and 1891, had completely mapped and transcribed all the visible graves in Grand Street Cemetery and all the other cemeteries in town. This invaluable ledger of transcriptions exists in the collection of the Mattatuck Museum. Notable was Judd's inclusion of the Roman Catholic section, which was then about three and one-third acres. Stairs can be accessed from Meadow Street that bring one to the steep ground in the far back corner of the current Silas Bronson Library property where this part of the cemetery used to exist. A fence "ten rods and 24 links in width" once separated the Catholic section. By 1884, no one knew where the division had been. Judd also noted the "colored burial

plot" and that there were about 1,800 unmarked graves overall. The original burying ground had been at the highest section of the Mattatuck settlement and was the town's oldest landmark. After years of protest about the idea, it would soon become a public park. The cemetery had not been used for "almost a score of years." Tall weeds and fallen-over stones had turned it into a public eyesore.

The Town of Waterbury was given charge of the cemetery. "The city shall make arrangements for suitable places in other cemeteries to which the remains and monuments remaining...may be removed, in all cases where the friends of those buried in the old burial grounds do not provide for the same." The mayor at that time, Charles R. Baldwin, "complied...in so far as to cause excavations to be made and the remaining stones to be sunken out of sight—sometimes, but not always, over the graves to which they belonged. In some cases two or three stones were buried together. The remainder were placed in what was once 'the vault.'"[77]

On December 14, 1887, a newspaper article announced the completion of Judd's work: inscriptions of nine of the earliest burying grounds in Waterbury, excluding Riverside and Saint Joseph Cemeteries, which were established in 1853 and 1859. On January 16, 1889, the *American* promised to begin publishing the names of the inscriptions on a regular basis when space in the newspaper allowed. In June (undated, pasted into Judd's scrapbook along with the others), an article appeared about the Old Grand Street Cemetery when work was being done to transfer coffins to Riverside Cemetery, an extensive wooded hill rising from its base at Riverside Avenue. Box coffins were removed, some containing still recognizable individuals, in other places only skulls and large bones remained. The writer found Judd on the scene while the work was being done, his volume of transcriptions in hand. Judd's valuable work, he wrote,

> could never be duplicated as now the last traces of the graves and headstones have been obliterated, and were it not for "Father" Judd's volume there would be lost the record of burials of two hundred years in the Grand street cemetery...Passing from one grave to another and straining my eyes to read the inscriptions I found the names and ages of a great many of the early settlers of Waterbury. We didn't talk very much, there was enough in one thought and we finally sat down on a little grassy mound and silently gazed from one to another of the graves of those so long gone before us.[78]

Those who study gravestones in cemeteries like Waterbury's great ones know well the reverent feeling that accompanies appreciation for the preserved ancestral information the stones contain. While Judd may not have published a list of Catholic tombstones in the Old Burying Ground, he did, thankfully, make a list of names in May 1891, perhaps on the day discussed above. His "Removals from Grand Street Cemetery to St. Joseph Cemetery" (on page 77 of his ledger book) included the following names: Bridget Leerey, Ellen G. Leerey, John Phalon, Catherine Sheeran, Elizabeth Ryan, Patrick McEvoy, Eliza McEvoy, Lawrence Lally, Mary K. Lally, Mary A. Ryan, Margaret Ryan, Patrick Ryan, Edward Gafney, Anna White, William O'Brion, Charles Egan, Peter Fox, Patrick Hines, Alice Mooney, Julia Higgins, Mary Delaney, James Maher, Catherine Maher, Sarah Ney, Mary Turley and Margaret Turley. Some of the horizontal stones that still can be found throughout Old and New Saint Joseph Cemeteries may have come from this original old burying ground, placed where there was room between other graves.

Irish native Fenton Phelan was considered to be "the oldest man in Waterbury" on October 5, 1894, when his death was included as news at home and in the New York–based *Irish World* newspaper. He was ninety-seven years old and had lived in Waterbury the past forty-five.

The McGivneys

By 1896, among the around six thousand Immaculate Conception parishioners, fourteen had become priests: William Hill; F.H. Kennerney; Jeremiah Fitzpatrick; Thomas Galvin; Joseph Read; Martin P. Lawlor; Patrick P. Lawlor; Christopher McAvoy, OSA; Michael J. McGivney; John Donahue; John Tennion; William White; Thomas Shanley; and William Lynch.

Reverend Michael McGivney, born in Waterbury on August 12, 1852, has been given a tremendous amount of attention over the decades for his founding of the Knights of Columbus in 1882. The organization still thrives with millions of members, and it continues to do multibillion-dollar philanthropic work around the world. Like other long-standing organizations, such as the Ancient Order of Foresters, it originally provided financial insurance protection for widows and children. The Knights of Columbus was specifically identified as Catholic, and the Christopher Columbus (due to the

then common belief that he had discovered America) association in the name was meant to brand the group as patriotically American. Irish-born Civil War veterans urged the word "Knights" instead of "Sons," which McGivney had intended for the name. He compromised in that regard, but Father McGivney wanted to steer away from similarities to groups in America and Ireland that harkened back to ethnic history or rebellions as holding fast to negative memories. Neither he nor Father Hendricken approved of the AOH for that reason, preferring to focus on multicultural unity through shared Catholicism and its alignment with concepts of social justice.

Since 1996, the organization's founder has been in consideration for sainthood. The McGivney family story typified many of Waterbury's post-famine immigrants' experiences, in which the suffering of grave illnesses, the making of great sacrifices and the loss of breadwinners in homes including several children were common. McGivney transformed his life experiences growing up on Railroad Hill into efforts to improve life for the entire Catholic community.

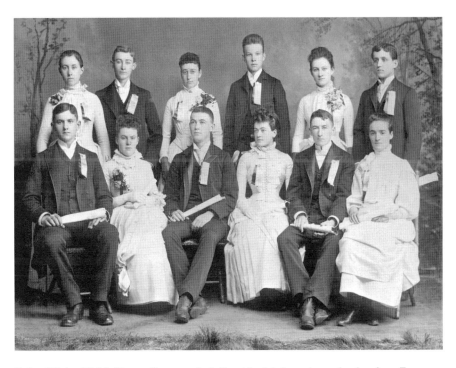

Father Michael J. McGivney (first row, far left) at his eighth grade graduation from East Main Street School in Waterbury in 1865. *Courtesy of the Knights of Columbus Museum, New Haven, Connecticut.*

His parents, Patrick McGivney and Mary Lynch, were natives of County Cavan, Ireland. Irish members of the McGivney Facebook site clarified their origins in Ireland. Patrick was from Crosierlough in Drunbee, and Mary was from Castlerahan Parish in Mountprospect, outside Ballyjamesduff, off the Old Castle Road near Clonkieffy. Father O'Neil married them on November 22, 1851, at Saint Peter's Church, where the future priest was baptized and attended school. Six of the couple's thirteen children did not survive. Like so many young people in the poorest families, Michael worked from age thirteen to sixteen in a factory to help support his family. The 1860 census revealed two other adult McGivneys in Waterbury: Michael and James, sharing the Patrick McGivney two-family house and working in a factory, like Michael's father. They may have been brothers of Patrick.[79]

In the 1870 census, Patrick McGivney was listed as a "moulder." Living in a single-family home with them were Irish immigrants John and Martin Horan, Nicholas Commerford, Michael Phalen and James Commerford.[80] By 1868, Reverend Hendricken had made it possible for the young McGivney to begin studies at Saint Hyacinthe in Quebec, Canada. This prepared him to enter Our Lady of the Angels Seminary in Niagara Falls, New York, and to study philosophy between 1871 and 1872 at Saint Mary's College in Montreal. In June 1873, Mary McGivney became a widow, after which time Bishop McFarland, of Hartford, assisted Michael in completing his theological studies at Saint Mary's Seminary in Baltimore, Maryland.

On December 22, 1877, in Baltimore, Cardinal James Gibbons ordained Michael McGivney, along with James O'Brien and John F. Murphy, who became pastors of Bridgeport parishes. Father McGivney was assigned to be a curate and remained at Saint Mary's Church in New Haven for seven years. The youngest members of his family, Patrick and John J., also received seminary degrees and became priests (and monsignors). In 1882, his association for Catholic men aged eighteen to fifty approved, Father McGivney reached out to his fellow priests, urging them to promote memberships from within their parishes. He explained the organization's objective "to prevent our people from entering Secret Societies, by offering the same, if not better advantages…to unite men of our Faith throughout the Diocese of Hartford, that we may thereby gain strength to aid each other in time of sickness; to provide decent burial, and to render pecuniary assistance to the families of deceased members."[81]

Reverend Patrick P. Lawlor was the first Supreme Chaplain (spiritual director) of the order. Upon Lawlor's death in 1885, Father McGivney stepped in, becoming the Knights' second Supreme Chaplain. His brothers

served in this capacity between 1901 and 1939, Father Patrick succeeding Michael (1901–28) and Right Reverend John succeeding Patrick. Father Patrick McGivney achieved much success as a priest in Middletown and New Canaan, Connecticut, and was very active during World War I in support of the soldiers. In 1924, he was promoted to domestic prelate by Pope Pius XI and received an honorary doctorate of law from Niagara University, where he had also earned his undergraduate degree. Right Reverend Monsignor Patrick J. McGivney, born in Waterbury on September 25, 1867, died in Paris, France, on May 8, 1928.

Reverend John McGivney served in Bridgeport and Meriden and then became the pastor of Saint Aedan's Church in Westville, New Haven. He was a priest for thirty-two years. Among his extensive accomplishments was the supervision of a $300,000 Nurse's Home at Saint Raphael's Hospital, where he served on the board of directors. His death, on March 16, 1939, was "one of the largest funeral services ever to be held in Bridgeport."[82] The McGivneys' sister Rose married Edward Finn, and three of their sons became priests, one of whom also served as Supreme Chaplain of the Knights.

His priesthood having lasted only thirteen years, Father McGivney died of tuberculosis as pastor of Saint Thomas Parish in Thomaston on August 14, 1890. He and other members of his family, including his brothers,

Waterbury Knights of Columbus march in a parade, August 1912. They are turning from South Main Street onto West Main, locally called Exchange Place. *Vintage limited edition "Real Photograph" postcard from the private collection of John Wiehn.*

were buried in Waterbury beneath a large monument at Old Saint Joseph Cemetery, where a stately stone still stands. His remains, however, were disinterred in 1982 and placed in a sarcophagus in Saint Mary's Church in New Haven, closer to the Knights of Columbus Museum.

Other Types of Work

Others who became recognized in the community included the following:

County Donegal–born **Thomas Dennis Dougherty** (1829–1878) emigrated as a young child with his father, Thomas, and mother, Eleanor McGonigh. After graduating in 1849 from Saint Mary's College in Emmitsburg, Maryland, he became a chemistry and Greek professor at Calvert College. He arrived in Waterbury in 1854 and became involved in a great many committees and boards. He received his medical degree from the College of Physicians and Surgeons in New York. He and his wife, Margaret Neville, daughter of Michael and Ann Neville, were the parents of eight children. Their son, Edwin M. (later, Edward), also became a physician. After Dr. Doughtery's death (November 22, 1878), Margaret ran a hotel on East Main Street until her death in 1910.[83]

Roscommon-born **Thomas Kelly**, known as "Kelly the Baker," rose from the status of an Irish immigrant to become a wealthy and widely respected entrepreneur, owner of at least seven businesses in Waterbury by 1912. Ads for his bakeries, confectionaries and dairy products were recognizable by their inclusion of a jaunty rooster, an early graphic design icon. Kelly regularly had something to announce in the papers to attract customers to his establishment, which functioned as a regular meeting place for the community. One of the founders of the West Side Savings Bank, Kelly proved to be wise on a great range of matters. His opinions about the poor state of roads, how fertile land miles outside the city center should be used and whether cows should be tested for tuberculosis were among topics considered newsworthy. His success led to the ownership of a large farm in Middlebury and a home at Lake Quassapaug.

The son of Peter Kelly and Catherine Ward, Kelly was already financially successful enough to board at the Scovill House on West Main Street in 1894, the year before his marriage to Margaret Bergin. The couple lived and

brought up two children at 414 West Main Street, and Kelly purchased his Middlebury land with an eye to one day having "one of the most modern and best equipped dairy barns in the state."[84] Attorney Franklyn Kelly, the Kellys' son, died at age twenty-seven. The loss devastated Thomas, who regretted not having spent enough time with his family while building his businesses, and he sold them shortly thereafter. The couple's daughter, Margaret, married Francis M. McDonald, who became a prominent prosecutor. When Thomas Kelly died in 1931, his pallbearers at Saint Joseph Cemetery included the current mayor, two former mayors and the brother of Waterbury's first mayor of Irish descent. The headline of his obituary summarized him: "Prominent Citizen [and] Successful Business Man for Over Half Century…Hard Work, Keen Mind and Driving Persistence Basis of Success." Mrs. Thomas Kelly (daughter of Daniel Bergin and Margaret Phelan) was vice-president of Saint Mary's Hospital Aid Association at the time of her death in 1946.

"Jingles" Donahue, Waterbury's policeman-poet, had ancestral roots in County Cork. Eleanor Roosevelt received one of his traffic poems while in Waterbury and invited him to the White House for a lighthearted radio broadcast. *Photograph courtesy of Carol Youle, via Lieutenant Scott Stevenson, Waterbury Police Department.*

The popular bakers **John and James O'Brien** had fifteen people working for them in 1893, having begun only six years before. Native Irishmen from County Cavan, aged twenty-five and twenty-three, respectively, they came directly into Waterbury to work for Kelly the Baker and were able to expand within four years to shops on both Baldwin and Bishop Streets, where they surpassed the productivity of all the bakers in Waterbury.

One of the leading hardware merchants of his time, **Peter Joseph Bolen** was the son of Lawrence Bolen and Mary Ann Dempsey, both natives of Westmeath, Ireland. His wife was Maria C. Seery, whose family hailed from Mount Temple, County Westmeath. Bolan, born in 1862 in Sandy Hook, Connecticut, worked as a bellboy to save money for schooling in Waterbury,

and he began to work in F.L. Allen's hardware store in 1878. When Allen sold the business to D.B. Wilson, Bolen remained working for him. The two became equal partners in February 1885. Bolen ran the business until December 1888, when he sold his share of 13, 15 and 17 East Main Street and purchased James Allen's hardware store, the oldest in Waterbury, at 90, 92 and 94 Bank Street.

A Democrat, Bolen was often asked to run for office, although he continually declined. He was a generous member of the Immaculate Conception Church and was involved in the Knights of Columbus, the Heptasophs, the Catholic International Order of Odd Fellows, the Benevolent and Protective Order of the Elks and the Foresters of America. "Socially he and his wife were highly esteemed...As a businessman, P.J. was one of the most energetic and progressive men in Waterbury."[85] Of P.J. and Maria Bolen's five children, only the last three survived. Their infant son, Thomas Harry, was the first person to be buried in Calvary Cemetery (June 1892). Fifty-three acres of land for this cemetery had been purchased in 1885 by Reverend Harty, with fourteen more purchased in 1891 by Reverend Mulcahy. P.J. Bolan joined his son in Calvary Cemetery in 1902.

Dr. John F. Hayes, born in Waterbury on January 18, 1857, was one of three children of Michael and Mary Hayes of Ireland.[86] He received his terminal degree at twenty-two years old, having studied with prominent physician/teachers in New York, Ireland, Scotland and England. He began an obstetrics practice in Waterbury in 1881 and purchased one of the most beautiful homes in town at the corner of Cole and South Main Streets. He married Mary A. Conran, a daughter of Ireland-born Patrick Conran and Julia Purcell, who settled in Naugatuck. Dr. Hayes had the largest medical practice in Waterbury in his time. He was involved with several professional and city associations, a member of the Board of Education, the Knights of Columbus and Court Wolf Tone, Ancient Order of Foresters, for which he served as examining physician. He and Mary were the parents of five children. In 1920, their eldest son, Michael C., was a clerk for the Waterbury Water Department. As of 1930, their only daughter, Julia, was a high school teacher, son John R. worked as a city engineer and son Francis J. worked for Yale College as an oral surgeon.[87]

Waterbury-born **Edward J. Finn** was considered a very successful shoe dealer in 1893, having taken over the original Geraghty & Finn in 1887. He was known for his large stock of children's shoes and fine men's shoes made by the J.&H. Fitzpatrick Company. His employee, Edward Deegan, was

equally admired for his care with customers and pleasant nature. Finn was a member of the Knights of Columbus and was serving on the Common Council by 1893.

James F. Phelan began to sell tea and coffee when he left school in 1882. He had a large store on Platt's block that also supplied "artistic articles in china, crockery and glassware" through the extended Waterbury area.

Jeremiah Luddy from Spittle, Ballylanders, County Limerick, and his wife, **Bridget Inglis** from Moanour, Galbally, Tipperary, were ancestors to several Connecticut families with roots in Ireland that extended through the surnames McMahan, Gorman, Maloney, McDermott, Conroy, Bourke, Ahearn, Kilbride and others. Their son Thomas settled in New Haven, but sons William and Jeremiah were in Waterbury by 1860, and the widow of their son John arrived there in 1881. One of the old Irish families of Waterbury, the Luddy family plots are in Old and New Saint Joseph Cemeteries.

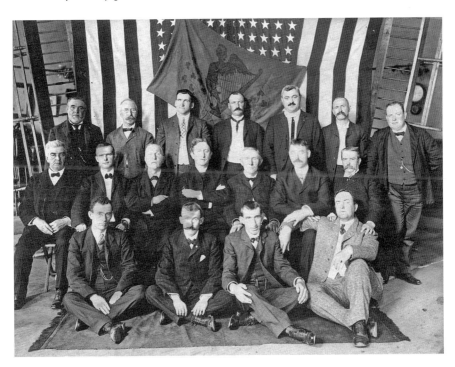

Waterbury's Timothy Luddy (first row, first on left), the New Haven County AOH president in 1903, with all the county officers of the Connecticut AOH State Board. *Courtesy of the Connecticut AOH State Board.*

John Luddy and his wife, Honora Barlow, had seventeen children, including Thomas Luddy, one of the first letter carriers in Waterbury. He was married to Anne Cecilia Duggan from Ardpatrick, County Limerick, and worked in the school system as a janitor for twenty years. A respected and involved member of Waterbury's fraternal organizations (Immaculate Conception Church Holy Name Society, Saint Joseph's Total Abstinence and Benevolent Society and AOH), Thomas was a charter member of the Thomas Francis Meagher Club and president of the Charles Island Band of Retreatants. The Luddy family cemetery plots are in Old and New Saint Joseph Cemeteries.[88]

Thomas Francis Bergin and his wife, **Anna McDonald**, raised fourteen children in County Laois, Ireland. They were a farming family, respected in the community as "industrious…thrifty…[people] who performed well the obligations of life." Their son, **Martin**, born in September 1845, was well educated in a private school in Dublin. When he turned eighteen, he and his sister, Mary, immigrated to Waterbury. Martin arrived in 1860, worked at the Waterbury Buckle Company and started his own business in 1869. In 1868 he married Elizabeth Maher of Ballyroan, Abbeyleix, Laois, whose family had immigrated in 1865.[89] Martin ran a stationery store in Southington, Connecticut, where they were living in 1880, and the couple began to raise their family of twelve children.[90] After their relocation to Waterbury, all but one of their offspring lived the rest of their lives there. Among them were a police lieutenant (John), policeman, public school teacher and stenographer. Like many of the more affluent Irish families, most of Martin and Elizabeth's children did not marry.

Elizabeth Maher Bergin was the daughter of Patrick Maher and (Maria) Bridget Phelan/Whelan from Crubeen, Ballyroan, Abbeyleix. The family, which included at least eight children, lived at 369 East Main Street, behind Old Saint Joseph Cemetery.[91] Elizabeth's brother Michael was an

Martin Bergin Sr., 1845–1903. *Copy of vintage photograph from the private collection of Ellyn Bergin Scully.*

engineer in 1869, appearing in a later *City Directory* (1871) as an electro-silver plater, while also in business with their younger brother, John, selling books, newspapers, religious articles and picture frames in their business, Maher Brothers. Michael had become an undertaker by 1880, the year their brother Edward died of tuberculosis. Michael; his wife, Sarah (Reid); and their brother, John, all died themselves in 1883, Michael and Sarah leaving two children. (Their daughter, Josephine, died in 1888.)[92]

Martin Bergin took over the undertaking business of his brother-in-law and established it under the new name Bergin's Funeral Home. When Martin was not available, his eldest son, Tom, took charge of the funerals. Martin died on December 24, 1903. In 1912, Tom Bergin and his brother Patrick solidified what became the largest funeral parlor in Waterbury. John, Martin Jr. and Daniel also joined the business, as did some sons in two more generations of Bergins: Martin's and Patrick's sons Stephen and Edward D. and Edward's sons, Patrick, Edward D. Jr. (Mike), William and Martin. Two of the men, Edward and his namesake son, also became mayors of Waterbury.

In 1918 Martin and Elizabeth's son John J. Bergin began working in the Plant Protection area of Scovill Manufacturing. Riding the plant's horse, Colonel, and joined by three other co-workers on horses from Shepard's Stable, the men began in 1920 to more effectively cover the extensive amount of property that needed inspection throughout the day. They also joined police in maintaining crowd control for large Scovill gatherings, picnics and parades. Chief Bergin retired from Scovill Manufacturing as head of the department.[93]

In 1893, **James Henry Mulville** was the proprietor of the newly opened Mulville's funeral home. Born on August 25, 1869, in Waterbury to Irish parents John Mulville and Bridget Rice, Mulville started out as a sixteen-year-old employee of his cousin, the undertaker William E. Dillon. After further studies, in June 1891, he opened his business "for rich and poor alike." Mulville was noted as "growing in favor and patronage every day, with no fear of competitors...honest and pleasant, and has a large circle of friends in the community. The future will see Mr. Mulville classed with Waterbury's solid businessmen."[94] Mulville and his wife, Julia C. Kenney, had three children by 1900. Connecticut-born Julia was the daughter of John Kenney and Julia McGrath.

As his undertaking business expanded, Mulville moved from an office across the street from Poli's Theater to the Trott Building and by 1895 was

at Saint Patrick's Hall. The townspeople grieved at his premature death at age forty on January 4, 1900. He had been very active in professional organizations and was a director of the state branch of the Undertakers' and Funeral Directors' Association. His civic memberships included the "Waterbury Lodge, Benevolent and Protective Order of the Elks; Fifth Division of the AOH; the Hendrickson Council, Knights of Columbus; Court Meany, Foresters of America; Court Waterbury, Ancient Order of Foresters; Silas Bronson Conclave, Improved Order of Heptasophs; Waterbury Aerie, Fraternal Order of Eagles; Patrick Sarsfield Club and Brooklyn Athletic Club." James Mulville's business was continued by John Joseph McAvoy and evolved into today's Alderson-Ford Funeral Homes.

In neighboring Naugatuck, the Honorable **William Kennedy**, son of John and Mary, who had settled there from Ireland in 1846, became a Connecticut state senator. He was elected in 1898 and 1900 and had a large practice as a lawyer in both Naugatuck and Waterbury. In 1896, he represented Connecticut at the National Democratic Convention, serving as chair that year and in 1898.

So many Irish had entered the successful fabric of Waterbury society that Reverend James H. O'Donnell emphasized in 1896 the harmony that finally existed by the end of the century. He wrote, "The Catholics of Waterbury join willing hands with their Protestant fellow citizens in laboring for the common weal."[95]

Sports

Sarah Bergin of Clonaslee, Laois, the daughter of Daniel Bergin and Mary Daly, and her husband, Dennis Phelan, of Baldwin Street were the parents of a star baseball player.[96] First baseman **Dan Phelan** (1861–1934) was one of the strongest players in Waterbury's first baseball team and Connecticut's first all-professional league, the Waterbury Nine. In its first season, 1884, Waterbury's mostly Irish group won the state championship. The lineup included right fielder Burke, left fielder Mellon, catcher Dailey, shortstop Magner, pitcher Lovett, second baseman Guest, third baseman Allman and first baseman Phalon (the name spelled several ways in print). Among the other teams that Waterbury beat (Hartford, New Britain, Willimantic

Dan Phelan, shown here in 1890, played major-league baseball as first baseman for the Louisville Colonels of the American Association. *Vintage photograph from the private collection of Taryn Phelan.*

and Rockville) was Meriden, where Baseball Hall of Famer Connie Mack (Cornelius McGillicuddy Sr.) began his illustrious fifty-year career in baseball. According to Neil Hogan, Phalon was one of the best players in both hitting and fielding. As evidenced by the *American* newspaper's coverage, he usually batted "clean-up." Among the accolades in the paper: "Phalon made two brilliant long-run fly catches and received two bouquets of applause"; "Magner played short stop without an error and Phalon at first base took all his chances finely"; "the team played one of its worst games, 'Phalon was one exception; he played first base without an error, having put outs with three safe hits in out of five times at bat'"; "the team had three brilliant double plays, one by solid old Punch Phalon alone"; "Lovett, Con Dailey, Magner, Phalon and Kennedy distinguished themselves by specially brilliant work."[97]

In 1886, a *New York Times* article commented on the team's erratic performances, despite its talent and having "the best manager in the

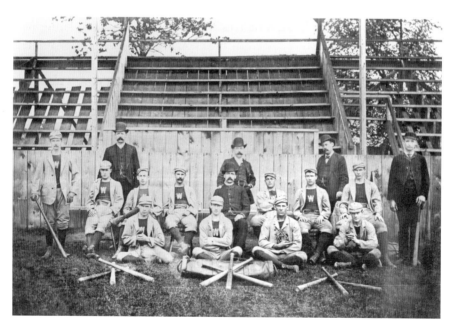

Waterbury Nine, 1884 state champions. *From left to right, front row*: Fitzgerald, O'Brien, C. Daily and Lovette; *second row*: Kennedy, Guest, Allman, Burke, Chas. Marston (manager), Magner, Phelan and E. Dailey. According to the Mattatuck Museum, the four unidentified men in suits may have been club officers. Officers included Theron Minor, president; William B. Philips, vice-president; C.A. Mason, secretary; T.H. Hayes, treasurer; and S.P. Williams, business manager. *Courtesy of the Mattatuck Museum, Waterbury, gift of Frank Hayes, 1919.*

Eastern League," Joe Simmons. It was learned that an old "Yankee" farmer living in Middlebury became friends with the team, "took them driving, gave them dinners, and no one knows what else." After having visited with "Farmer Johnson," drunkenness was observed among some of players, and it became apparent that in whatever way the farmer bet on the team, he won. Simmons began to fine the players if they drank before playing and was worried that the farmer might manage to get to the upcoming out-of-town game in New Jersey. Simmons was said to have admitted he could ward off "genuine sharpers, [but] these Connecticut Yankee farmers [were] too much for him."[98]

Dan Phelan went on to play for a major-league team of the American Association, the Louisville Colonels, in 1890. His batting average was .250 in eight games. He lived a good, long life until July 29, 1934, and was buried in Old Saint Joseph Cemetery.

Roger Connor was born in Waterbury on July 1, 1857, the third of eleven children born to Ireland natives Mortimer Connor and Catherine Sullivan. In 1860, the family lived in the Abrigador among many of the old Irish families. On the other two floors of the three-family house in which they lived were the families of Patrick Delaney and John Enright, a shoemaker. Next door were the families of James Kelley, Thomas Rafferty and Michael Bowes. Other neighbors included the Kilduffs, Bergins, Walls, Flynns, Morans, McDonalds and Rileys.[99] At twelve years old, Connor left school to work with his father in a Waterbury factory. In 1876, he entered professional baseball with the Waterbury Monitors of the Eastern League. From May 1, 1880, through 1882, he was a member of the Troy Trojans in the National League. In a game against his hometown team, the Waterbury Nine, on July 21, 1884, Roger Connor played second base. His team, the Giants, won by only one point. During that game, Connor "hit one out of the field—the first time this was ever done."[100]

Inducted into the Baseball Hall of Fame in 1976, Connor also played with the New York Gothams, Philadelphia Phillies and Saint Louis Browns but is best known for playing nearly eight seasons with the New York Giants. On that team, he set the record for career home runs that remained unbroken until 1921, when it was bested by Babe Ruth.

After retiring from playing baseball, Roger Connor returned to Waterbury and purchased the local minor-league team. He served as president and manager and played first base on the side. His wife—New York–born Angeline, of German descent—kept the team's books, and his daughter

Waterbury-born Roger Connor (left) with Goose Goslin (right), both members of the Baseball Hall of Fame. This image is from September 8, 1925. *Library of Congress.*

collected tickets. Connor also worked as a school inspector in the Waterbury school department. In 1920, he and Angeline lived in a heavily Irish section of Waterville Street.[101] He died at age seventy-three in 1931 and was buried in Old Saint Joseph Cemetery.

Saint Patrick's Church, Brooklyn

Those of Irish ancestry in Waterbury remained acutely aware of the continuing hardships in the old country. By the late nineteenth century, they knew that vast expanses of land had become vacant due to the massive number of deaths and immigrations that occurred throughout the Great Hunger and that many landlords were choosing to fence off property and repopulate it with income-producing livestock. For decades, landlords had callously evicted impoverished tenants or had "assisted" emigrations. Paid fare to leave Ireland and employment waiting in a place such as Waterbury benefited the tenants if they could survive the journey across the ocean in extremely difficult conditions. It also, however, greatly benefited the landlord, who could both clear his land of people and purchase more vacated properties. In 1880, the Irish community of Waterbury was galvanized in solidarity with those who still struggled over land issues.

A forty-one-page publication listing Waterbury subscribers to an Irish Relief Fund in 1880 provided a fascinating snapshot of the Irish community and included addresses and amounts of donations. Collections had been gathered from individual classrooms in eleven schools. Elm Street, East Main Street, Brooklyn, Clay Street, Dublin Street, Abrigador, Bishop Street, East Gaylord, Sperry Street and West Side Hill Schools, as well as the high school (with M.S. Crosby as principal), all participated. So did the Waterbury Roman Catholic Total Abstinence and Benevolent Society, heading off the list with a contribution of $200. The Young Men's Saint Aloysius Total Abstinence and Benevolent Society, Young Men's Catholic Institute and Pupils of the Convent of Notre Dame all contributed $100 or more, and the list continued, representing social, Catholic and benevolent clubs, employees or owners of many businesses and hundreds of individuals who donated what they could afford.[102]

By that year, the Immaculate Conception Parish had outgrown its building and needed an additional church. Waterbury's Catholics were divided into two districts, and a new church in honor of Saint Patrick was conceived

Saint Patrick's Church, 1903. *From* Memorial of the Dedication of St. Patrick's Church, 1880–1903, *from the private collection of Ellyn Bergin Scully.*

for the Brooklyn area of town. Father John H. Duggan was brought to Waterbury from his parish at Colchester, and he purchased the site for the new church on February 19, 1880. Living in the Immaculate Conception Rectory while he organized the new parish, Reverend Duggan became its official first pastor on April 18. He celebrated masses in Saint Patrick's Chapel at the corner of East Main Street and Phoenix Avenue between May 23, 1880, and December 1882. The chapel had been a Methodist church purchased in September 1876 for children's masses. It was sold in 1887.

The cornerstone for Saint Patrick's Church was laid on October 16, 1881, and a basement chapel built for $45,000 began to be used on December 17, 1882. The building of the main structure had begun in 1886, but Father Duggan died in 1895 before the church and rectory were finished. His vision for the exquisite granite-and-sandstone Gothic church included paying for it as construction progressed, so it became the job

Choir boys with their leader in Saint Patrick's Church. *From* Memorial of the Dedication of St. Patrick's Church, 1880–1903. *From the private collection of Ellyn Bergin Scully.*

Father Joseph M. Gleeson, second pastor of Saint Patrick's Church, is depicted in one of the stained-glass windows. *Photograph by John Wiehn.*

of Reverend Joseph M. Gleeson to complete the magnificent Irish-centric structure that was dedicated on January 8, 1903. While the architecture of this church is among the best of its time period, the most remarkable details are its masterfully crafted stained-glass windows depicting historical events in the life of Saint Patrick. Running across the bottoms of each are sections of the prayer associated with him, the Lorica, written in Irish. These were installed in 1905–06 at a cost of $9,500 and repaired in 1919–20 for $11,340. Father Gleeson's cousins, New York's Anthony and Mary Power, donated an attached Chapel of Saint Declan, fully intact with all its contents, in 1907. Saint Patrick Church's windows and statues represent an early history of Catholic Ireland and have been extensively documented through informative catalogues.

In September 1897, three sisters from Hartford's Saint Joseph of Chambéry Order came to run the Sunday school, living in a house at 1003 Bank Street that was redesigned as a convent. With the sisters in charge, Saint Patrick's School opened for 90 kindergarten and first grade pupils in September 1900 in Waterbury's Lyceum Building. By 1902, it had six teachers and 200 students, and by 1903, there were eight teachers and 377 students. Classes were also held in the church basement. The convent closed in July 1910.

Other Churches

Within only a decade's time, several additional Catholic churches entered the scene, needed by entire neighborhoods. On February 15, 1885, Sacred Heart Church began as another division of Immaculate Conception. It's pastor, Reverend Hugh Treanor, hired musician Mrs. Lucien Wolf, a graduate of Notre Dame Academy, to begin a choir. He celebrated Mass for this new parish at Saint Patrick's Chapel until the Sacred Heart basement chapel began to be used on March 14, 1886. By 1891, Sacred Heart's choir was so strong that it earned a long article in a Sunday issue of the *New York Herald*: "The people of Waterbury have looked upon the choir of the church as holding the first place in the rendition of beautiful and at the same time difficult church music...great progress made in a few years by a comparatively small parish." Father F.J. Murphy arranged most of the music for the group of thirty or more singers, with many soloists and rising theatrical stars mentioned in the review. Concerts and

plays, including Irish dramas, supplied entertainment for the community while raising funds for the church. They were often staged at the city hall and Jacques Opera House. Entertainment after the group's then most recent success had included a banquet at the Grand Army Hall, sponsored by Company E, Hibernian Rifles Regiment of the AOH, complete with a toastmaster. Sacred Heart Convent was founded in 1906 under pastor Reverend Thomas Skelley and mother superior Sister Mary Dominica Conniff. A school was built in 1905–06, opening with six grades and 425 students.

By the turn of the century, Waterbury had become a lively mixture of immigrant cultures. The Irish became intertwined with families of other nationalities who attended the predominantly Irish Catholic churches. Soon the other ethnic groups grew large enough to populate their own churches. A frame church on Dover Street was built for the French community in 1888–89. Saint Anne's Church, still a stunning Brass City landmark, was dedicated on December 17, 1922, having cost about $280,000. The German church, Saint Cecilia's, began in 1892 with Reverend Farrell J. Martin as pastor. He also owned and edited the weekly journal the *Valley Catholic*. Masses began for that parish in the old chapel of Notre Dame Academy. Saint Cecilia's had its own school, convent and rectory until 1920. Lithuanians primarily attended Saint Patrick's Church until Saint Joseph's began in 1894 with a community of 130 families.

The Washington Hill/Abrigador community was split between Saint Patrick's Church and Immaculate Conception until these residents were organized under Saint Francis Xavier, the first Mass being held on December 8, 1895, with Reverend Jeremiah J. Curtin as pastor. A frame church was built in 1896, which was later moved and used as a parish hall. A brick church was dedicated on May 30, 1896. Baldwin Street School was built in 1923–24.

For the Waterville section of Waterbury, Saint Michael's Parish was founded, having passed from the jurisdiction of the Immaculate Conception to Saint Patrick's Church (in 1895) until its own building was dedicated on August 8, 1897. Saint Thomas's Church, built by Reverend William J. Slocum, was meant to serve as a "chapel of ease" for those in the northern section of Waterbury, but it became its own parish on the day it was dedicated, September 24, 1898. The Italian church Our Lady of Lourdes, in the heart of downtown, was founded on June 5, 1899.

The first Immaculate Conception Church on East Main Street was renovated, redecorated and improved between 1884 and 1912 and was

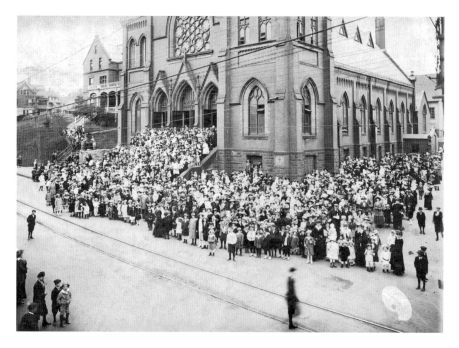

Saint Francis Xavier Church. Father Curtain, who died in 1917, is on the steps. The current church was dedicated on March 24, 1907. *Vintage photograph from the private collection of John Wiehn.*

no longer used after May 1928. A rectory next to the church was built in 1869–70 and used until 1928. It was then torn down in 1932. There were eight more resident pastors after Father Hendricken before the cornerstone was laid on August 15, 1926, for the current majestic building that faces the green.

Right Reverend Monsignor William Joseph Slocum (1851–1908) was the church's seventh deeply respected parish priest. He was the son of Westmeath, Ireland natives Michael Slocum (Slohen/Sloane) from Dromraney and Jane McCormick from Moate. Michael fled Ireland due to "having a price on his head" in 1835, changed the spelling of his surname and managed to find his way from Canada into Hartford and then to the town of Winsted, part of Winchester, Connecticut. Both a public school and Waterbury's division of the AOH were named after Michael's third son, the monsignor.[103] Among numerous accomplishments, Reverend Slocum reclaimed a large part of Saint Joseph Cemetery, purchased and opened New Saint Joseph Cemetery, directed the renovation of the entire interior of Immaculate Conception Church (1900) and led the

Immaculate Conception Basilica. *Photograph by the author.*

construction of Mulcahy Memorial Hall (1901) and an addition to Saint Mary's School (1903). He also contributed $20,000 toward the building of Saint Mary's Hospital. As chaplain of the Veteran's Association for Connecticut's "Fighting Ninth" Regiment, Monsignor Slocum was honored with a military funeral. The event of placing a monument over his grave in New Saint Joseph Cemetery the following year included a parade in which

> *thousands lined the streets…*[and] *representatives of every walk of life in the city took part…A reviewing stand included the mayor, members of the clergy…military divisions, the Saint Francis Drum Corp of Naugatuck, the French societies, the United Lithuanian societies, the United German societies, and members of the local Italian societies…*[and] *Company E of the Hibernian Rifles, the military arm of the AOH.*[104]

Waterbury's First Irish Mayor

Many Irish Kilduff families were in Waterbury by the time of the 1850 census. The family of Dennis and Jane Kilduff appeared in the following one. Dennis had arrived from Ireland at age eleven in 1846 with his parents and may have been the same person by that name who became a naturalized citizen in Waterbury in April 1853 and served in Company K, Connecticut Twentieth Infantry Regiment, in the Civil War between September 8, 1862, and July 3, 1864.[105] Jane L. Gilbert, born in New Jersey of Irish parents, married Kilduff in 1856. The couple's eldest son, Edward, was elected in 1893 by a large majority to become Waterbury's twenty-fourth mayor and its first Irish Catholic one.

Edward Gilbert Kilduff, born in January 1856, graduated from Waterbury High School. He also attended the commercial school in New Haven and studied law at the firm of O'Neill and Webster in Waterbury. In the fall of 1878, he was elected as Waterbury's city clerk, serving fourteen years. Voluntarily retiring in 1892, he had been considered "a thoroughly competent official, and most popular public servant...no one is more familiar with matters pertaining to the city."[106] With one of his brothers, John H., he founded E.G. Kilduff & Company in late 1891 on Bank Street opposite Apothecary Hall.

Kilduff was mayor from January 1, 1894, through January 3, 1898, followed by a term by Thomas D. Barlow, after which he served again from 1900 to 1904. As mayor, Kilduff led a committee expanding Waterbury's Wigwam and Morris Reservoirs. In 1894, he attempted to change the

Waterbury's first three mayors of Irish descent: (from left to right) Edward G. Kilduff (first), Francis P. Guilfoile (third) and Martin Scully (second). *Courtesy of Mattatuck Museum, Waterbury, Connecticut.*

city's charter by merging city, town and school governing boards. Although the proposal was defeated by the state legislature, the change eventually occurred. He determined that the public owned the roadways regarding the use of trolleys, and he successfully settled a trolley strike in 1903.

In February 1902, Waterbury suffered the greatest fire in its history, destroying thirty-two buildings over three acres. The damage cost the business district at least $2 million, hundreds of people were left homeless and more than one hundred businesses were lost. The rebuilding of the town center included the construction of Waterbury's grand and elegant Elton Hotel and the relocation of the old bandstand from the green to Hamilton Park.

Mayor Kilduff was nominated for state controller that year, but the Democrat ticket lost. When his term ended and John P. Elton was elected mayor, Kilduff closed his store in Waterbury and moved to New York to begin work in the brokerage firm of N.W. Harris. His family lived in Kew Garden, Queens, New York City, and he died on April 30, 1936.

Among the Kilduff graves in Old Saint Joseph Cemetery are that of his father (1835–1916), mother (1837–1921) and son, Dr. Gilbert J. Kilduff (December 4, 1957).

Queen's County/Laois/Leix, Ireland

Although Edward G. Kilduff's family origins in Ireland are unknown, it seems striking that the sequence of Irish mayors following him hailed from relatively the same area. Genealogical and cemetery evidence suggests that the earliest nineteenth-century Irish community came predominantly from the Queen's County/Laois area. An Irish social society centering on the major city there—Abbeyleix—existed in Waterbury from 1968 until at least February 1976, when its founder, Raymond J. Fanning, died. Fanning's own ancestors had settled in Waterbury in 1836. Retired executive editor of the *Waterbury Republican and American* newspaper, Fanning served as president of the society for its first two terms. The Abbeyleix Society included both sets of father and son Waterbury mayors: Martin and Vincent Scully and the Edward Bergins, Sr. and Jr. Joseph and Martin Scully, sons of the second Irish mayor, both served as vice-presidents for the group, Joseph as its first. Included in a memorial pamphlet honoring Fanning and the society was a reference to Waterbury emigrations from ancestral "homes in Abbeyleix, Ballyroan, Stradbally,

In Old Saint Joseph Cemetery are still an abundance of tombstones that cite origins in Queens County, and many of the surnames that appeared in the early nineteenth-century censuses. Among them are:

John Behan (1871), husband of Catherine
 Kenaugh (1878)
William Carroll (1883)
Patrick Cunningham (1871)
Patrick Dalton (1890)
James Delaney (1882) from Raheen
Michael Delaney (1878)
Michael Dunn (1899) and wife Bridget (1902)
Patrick Dunphy (1880)
John E. Finley (1897) and his wife, Ann Scully
 (1908), from Ballyroan and Ballyeagle
James Finn, husband of Mary Bowes (1871)
John Fitzpatrick (1872)
Mary Jones Tyrrell Flynn, widow of John Jones
 and wife of James J. Flynn from Cullenaugh
William Jones (1878), wife Mary and daughter
 Mary from Clonaslie [sic]
Daniel Keenan (1905) and wife Elizabeth
 Dowling (1900)
Jeremiah Kelly (died in Ireland), Mary J. Kelly
 (1872) and their daughter, Mary Ann
Nicholas Kenney (1895) and his wife, Jane
 Dalton (1892)
John Kilbride, husband of Eliza Phelan (1880)
James Lawler (1863)
Mary J. Phelan Luddy (1941)
John Pryor (187[?])
William Maher (1875); his sister, Annie (1863);
 and brother Patrick (1867)[107]
Mary McDonald, wife of John (1868)

John Neville (1851); his wife, Catherine (1849);
 their daughter, Mary (1879)
Ann Oxley, wife of Joseph (1872)
Mary Maria Phelan (1905) from Mountrath
Sarah Bergin Phelan, wife of Dennis (1869), from
 Clonaslee
Mary Walsh, wife of John McDonald (1868)
Michael Wall (1886) and his wife, Mary (1887)[108]

Mountrath, Rathdowney and nearby towns and villages to build new homes in Waterbury, Connecticut and surrounding towns."[109]

By midcentury individuals from many areas of Ireland had settled in Waterbury, with an increasing number from County Kerry. This developed into a tradition of "Queenies" being buried from Abbyleix-associated Bergin's Funeral Home and the "Kerries" from Mulville's. In addition to the mayors, examples of success achieved by Waterburians with Laois connections, as noted in the society's publication, included more than thirty professions and several more individuals: Mrs. R. Furshay, factory owner; Patrick Healey, Frank Healey and John Connor of Manchester, judges; Reverend C.A. McEvoy, president of Villanova College, Pennsylvania; Sister Mary Consolata O'Connor, president of Saint Joseph College (now University of Saint Joseph), West Hartford; and Archbishop John C. Murray.

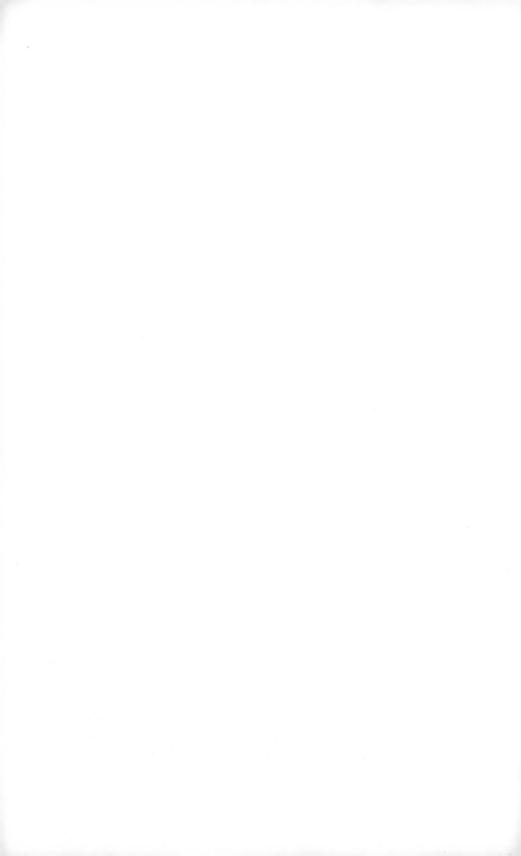

WATERBURY IRISH
IN THE TWENTIETH CENTURY

The Irish in Politics

By the turn of the century, many immigrants with Irish and other European ancestry had become financially established and owned their homes in Waterbury. Washington Hill was hopping. The fifth mayor after Kilduff, Martin Scully, was actually born in Ireland (1856, Ballyeagle, Laois). The son of Jeremiah Scully and Bridget Lawless, he came to Waterbury at the age of seventeen, completed his schooling there and went on to work in the newspaper industry for more than twenty years. Before his election in the fall of 1913, Scully had been active in the city as an alderman with the board of public works and the Bronson Library Fund while working as a reporter for the *Waterbury Democrat*. His first job was manager of the *Valley Catholic*. Scully's election to a second term was a unanimous victory throughout the city, and he served through 1917. Among his memberships were the Irish National League (serving in all offices), AOH, Knights of Columbus, Patrick Sarsfield Club and the Catholic Literary Association.

Saint Patrick's Day was an enormous celebration during this era. On Washington Hill in 1917,

> *everyone who was Irish or who could boast of having a little Irish in them celebrated the day. From the 200-foot flagpole belonging to Lieutenant John Cavanaugh floated "Old Glory" and underneath waving her folds to the breeze proudly streamed the emblem of Old Erin. Everyone had a piece of*

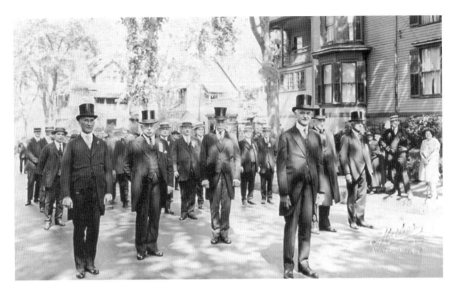

Waterbury's 250th Anniversary Pageant Parade was on June 7, 1924. *From left*: Former mayors (first) William H. Sandland, (third) Martin Scully, (fourth, leading the parade) Francis P. Guilfoile, others unidentified—possibly William Hotchkiss, Francis Reeves and William Thoms. *Copy of a photograph from the private collection of Jane Scully Parshall.*

green ribbon or shamrock pinned on his coat and those who were fortunate enough to have obtained the real shamrock sent by relatives in the "Ould Sod" had a spring placed in some noticeable place on their apparel...Some of the youngsters not being able to secure the needed penny necessary for purchasing a shamrock arrayed themselves in "home made" shamrocks made by cutting up pieces of wall-paper or other objects of bright green.[110]

On Saint Patrick's night more than 1,600 attended a Washington Hill dance at Buckingham Hall. The committee members in charge were Thomas Lawlor, Edward Holloran, Dr. James P. Galvin, Martin Campion, Jeremiah Crowley and Thomas Kelly. Officers of the Washington Hill Club included Edward Holloran, Jermiah Crowley, Thomas Lawlor and Edward Sheehan. McLean Orchestra supplied the crowd with "strictly Irish" music.

Waterbury-born Francis Patrick Guilfoile served four terms as mayor during difficult years, from January 1922 to January 1930. Guilfoile also came into his role on the heels of a postwar depression and the Eighteenth Amendment, something impossible to enforce. The economy improved for a few "roaring" years before the stock market crashed in October 1929, shortly before the end of his term.

Guilfoile's grandfather had been a businessman in Mountrath, Laois, for whom his father, Michael, worked. Michael ran a successful beef and produce company in Waterbury. He married Ireland-born Kate Lawlor, the daughter of Mary Little and Peter Lawlor, a Waterbury woolens manufacturer. Their first of eleven children, Francis Guilfoile (born 1875), became an esteemed lawyer, having studied at the College of Mount Saint Mary's in Emmitsburg, Maryland, and Catholic University in Washington, D.C., then working with Judge George Cowell. By age twenty-six, Guilfoile was already a representative in the Connecticut State General Assembly. In 1902, he represented Waterbury at the Connecticut Constitutional Convention. He was city attorney (1909–11), elected corporation counsel (1912–17) and made an unsuccessful run for lieutenant governor in 1916.

Guilfoile was a scholar of Irish history and folklore and an ardent supporter of Ireland's independence movements. In December 1905, Douglas Hyde, founder of the Gaelic League, stayed with him while visiting Waterbury on an American tour to seek support for the recognition of Gaelic arts and culture. (Hyde became the first president of the Irish Free State in 1938.) In 1908, Guilfoile married Margaret Mary, the daughter of prominent Waterbury surgeon Dr. Edward W. McDonald. The new Immaculate Conception Church on West Main Street was dedicated during his time as mayor. Guilfoile was said to have tried to curb the prevalent amount of alcohol and gambling activity that went on in Waterbury during the '20s despite Prohibition. However, he created a failed "water delivery system" that was a good idea but that some considered to have produced many "'no work' jobs."[111] Through his two newspapers, the *Republican* and the *American*, William J. Pape began in the 1920s to openly criticize the Democrats in charge of city governance. The city was in bad shape financially and taxes had increased greatly by Guilfoile's last years in office.

Meanwhile, in Ireland, Michael Collins, president of the Irish Republican Brotherhood, negotiated a truce with Great Britain that formed a provisional government. This included compromises he felt he had no choice but to make and allowed the six northern counties of Ireland to remain under British control. Civil war broke out, and Collins was killed in an ambush in August 1922 before the Irish Free State was formed in December. Éamon de Valera, who vehemently disagreed with Collins's decision, created the Fianna Fail Party in 1926. De Valera continued to seek full independence for Ireland and toured the United States to raise money for his cause, even beginning his own newspaper, the *Irish Press*. On April 26, 1927, he spoke to more than 2,500 supporters in Waterbury at Buckingham Hall. The *Waterbury*

Republican considered the crowd that came to greet him to be the greatest gathering ever assembled inside and outside the train station. With De Valera in the first car, the Fulton American Band led a parade of more than seventy cars up Grand Street while playing favorite Irish Republican songs. Mayor Guilfoile presented him the keys to the city. De Valera's rapt audience gave him a two-minute ovation, and Waterbury citizens donated more than $1,000 to him, including $500 from the local chapter of the American Association for Recognition of the Irish Republic.

Éamon De Valera during his tour of the United States, April 1927. *Photograph from the private collection of John Wiehn.*

Irish-American Social Club

Thirteen individuals created a nondenominational Irish-American Social Club on July 13, 1934. The first officers were Edward Loughrain, Arthur Lunny, Michael Fitzmaurice, Harold Boyce and John O'Sullivan. It included a Ladies Auxiliary, with officers Mary McKenna, Mrs. James W. Stenson, Mrs. Joseph Blum, Mrs. Frank Keaveney and Margaret Lynch. By 1935, the organization had grown to two thousand members, and four thousand people marched in that year's Saint Patrick's Day Parade "with more than 100 societies from all parts of Connecticut" participating. In November 1950, the club moved to 171 Bank Street, with William Boyle as acting president. It needed to move from that location in 1974 and ended officially in 2002–03.[112]

Former member Hazel Boyce Dalton recalled, "It was a rough and ready place. There were the occasional arguments or fights but it was a great place for the local Irish." Police officer Dan Clifford founded a dance school within it, playing concertina while his daughter, Maura, gave lessons. Maura performed for the classes at Saint Francis Xavier School every Saint Patrick's

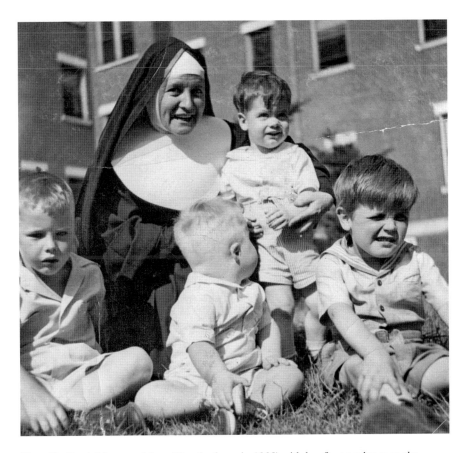

Sister De Pazzi (Margaret Mary Murphy, born in 1903) with her four nephews on the grounds of Saint Mary's Hospital in the early 1940s. The Sisters of Saint Joseph of Chambéry were the founding nuns of Saint Mary's Hospital, Saint Francis Xavier School and the short-lived Saint Patrick's Church School. Sister De Pazzi's parents were born in County Kerry. She entered the order in 1918. During sixty-eight years of religious life, she reached the highest order: provincial of the Sisters of Saint Joseph of the United States Province (1962–68). Stationed at Saint Mary's Hospital from 1974 until retirement in 1977, she died in 1985. *Photograph from the private collection of Margaret Murphy Jannetto.*

Day at the request of the nuns. "No blizzard could keep members away from Saturday night dances on the third floor of 171 Bank Street…There would be a three-piece band, piano, accordion and drums, and the place would be packed. A policeman kept peace at the door and in the club room," Dalton said. "Around midnight the band would stop and some of the members would go home, but others went around back and up the fire escape, would tap on the window and re-enter…They would often let in the cop on the Grand Street beat, Red Hurley, to warm up on cold nights."

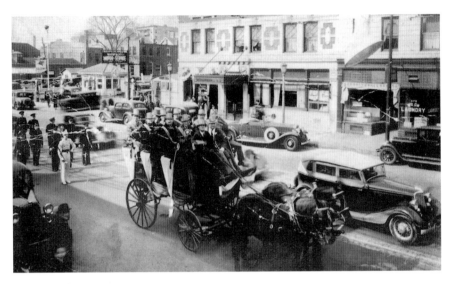

Louis Manzo, of Italian descent, a communicant of Saint Patrick's Church, riding (in back of coach with light jacket) with his Irish friends at a Saint Patrick's Day Parade, circa 1937–38. An Exalted Ruler of the Elks, Manzo lived in Bunker Hill and owned a hotel and restaurant supply business on Bank Street. He could list every county in Ireland and was best friends with Tommy Moynihan, the owner of the Wacki Grill. The epitome of Irish and Italian harmony in the twentieth century, the Manzos and Moynihans shared two sides of a grave site in Calvary Cemetery. *Photograph from the private collection of David Manzo.*

According to William Scully Jr., the bar stayed open all night, the party continuing as the sun came up. Then the stragglers walked over to attend the first Mass at Immaculate Conception Church. Mary Lyng, who came from County Kerry in 1959 and met her husband, James, at the Irish-American Club, remembered the annual Saint Patrick's Day banquets that the group held at the Elton Hotel. "There were too many speeches by too many politicians. Everyone wanted them to stop talking so the dance could begin!"[113] Lyng was a niece of Dan Clifford (mentioned earlier). James Lyng came to Waterbury in 1956 from New Ross, County Wexford. Both his uncles worked for Chase Brass Company at the time. James became a Waterbury police officer, retiring after twenty-eight years of service.

When the club closed, it had about forty paid members, but only about twenty active members. There was almost $4,000 in its treasury that was distributed to the Waterbury Monument Committee, the Silas Bronson Library (to purchase Irish books), the Special Olympics and the Immaculate Conception Church. The remaining members gathered for one last celebration.

T. Frank Hayes

The Democrats of Waterbury promoted T. Frank Hayes for election to mayor in January 1930. His chapter in Waterbury's politics is particularly tragic. While the Great Depression in America altered life as everyone knew it, Waterbury also endured a financial ruin the likes of which had seemed unimaginable. William A. Monti's book, *Publisher vs. Politician: A Clash of Local Titans*, thoroughly explains the Hayes administration's rise and fall when the excesses of the '20s turned into corruption in the '30s.

Hayes was born in 1884 to an affluent Irish family in Waterbury that owned a brewery and downtown Waterbury real estate, including the Jacques Theatre. He and his siblings were well educated out of state, Hayes graduating from Georgetown University, his sister from Trinity College and a brother from West Point. Upon their father's death in 1913, Hayes took charge of the family businesses while living with his mother and remaining a bachelor. He was director of a bank (lost in the Depression) and of the Lux Clock Company. Before his election to mayor, he was a state legislator and had served on both the Board of Charities and Board of Education. The Hayes ticket included Daniel J. Leary, owner of Diamond Bottling Company and the Waterbury Brewery, as the future financial comptroller.

In his early years as mayor, Hayes introduced change to the city charter that effectively gave his office the power to make every employment decision for the city. Between 1935 and 1939, while mayor, he also served as Connecticut's lieutenant governor. Initially, he was as popular among his constituents and the *Waterbury Democrat* as hated by William J. Pape, who tirelessly pointed out "irregularities" of all kinds through his *Waterbury Republican and American*. By 1935, an Independent Democratic Party had formed, with Roger V. Connor (the baseball player's nephew) as its mayoral nominee. Other groups also began to question the "racketeering" that seemed to be going on, and Hayes was reelected by only 1,772 more votes than the Republican candidate, John M. Burrell (16,750 to 14,978). Socialist candidate John W. Ring and Independent candidate Connor also received 1,141 and 2,821 votes, respectively.

In May 1938, along with twenty-six others, T. Frank Hayes was charged with conspiracy and the defrauding of more than $1 million in Waterbury. After the long trial details were featured daily in newspaper coverage, Pape received numerous accolades for his role in making sure the truth came out. He ultimately won the Pulitzer Prize in Journalism for Public Service in 1940. It was found that city records had been destroyed and a complex financial

coverup had been going on for years. Monti speculated that, at the time, those in governmental positions likely considered themselves to have been simply "taking care of their own…And, if along the way…[they] took care of themselves too, that was only right…because they had to stay in power to keep helping their own." He added, "No one in the Guilfoile administration had been punished despite the damning reports in 1930; why would it happen now?"[114] John Monagan recalled about the trial that "the atmosphere was not conducive to calm, impartial and measured deliberation…All in all, the prosecution was a tragic-comedy of errors which never could be duplicated under today's criminal laws and practice."[115]

Hayes and eighteen others were found guilty. He resigned as mayor on September 2, 1939. Daniel Leary fled town and remained under the radar in Chicago for five years until identified in 1946 and brought back to Wethersfield state penitentiary to begin serving his ten- to fifteen-year sentence. Hayes served seven years and one month of the same sentence. (Some reports note six years.) Released on parole, he returned to his family home, where he lived until a fatal heart attack in 1965. Throughout his remaining years in Waterbury, many people continued to feel an allegiance to him. (Republican) president of the board of aldermen Patrick M. Perriello stepped in as mayor until Vincent Scully began his term in January. Scully, the eldest child of Martin Scully, was a veteran of World War I and a graduate of Holy Cross College and, in 1923, of Yale Law School. He initiated a statewide campaign to help in the war effort, galvanizing Waterbury citizens to donate what became a small mountain of about fifteen thousand pounds of recyclable aluminum in front of city hall. He died in office on January 9, 1943. Two months later, the wife of former mayor Guilfoile found her husband dead in his law office. In 1946, the *Waterbury Democrat* closed its doors.

Others Among the Twentieth-Century Cast of Characters

Edward W. McDonald, MD (1845–1907) was the first president of Waterbury's Celtic Medical Society, formed in 1906 with twenty other Irish and Irish American doctors. A native of Kilfinnane, County Limerick, he came to the United States in 1868 and received his medical degree from

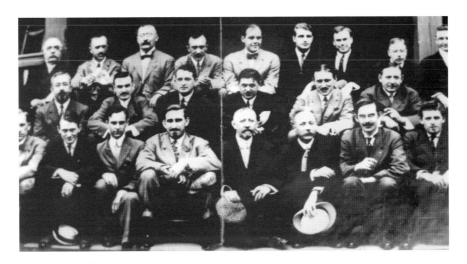

Celtic Medical Society (1906–09), formed by twenty-one doctors to create a hospital in Waterbury for Catholics, Saint Mary's, which was established in 1908. *Courtesy of Saint Mary's Hospital Library and Archives.*

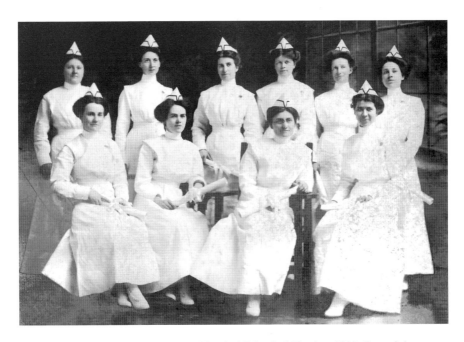

The first nursing class of Saint Mary's Hospital School of Nursing, 1912. One of the graduates of this class, Bessie Coffey, is remembered as Sister Mary Perpetua. In 1913, the ten original graduates, who worked as private duty nurses, formed the Saint Mary's Nursing School Alumnae Association. *Courtesy of Saint Mary's Hospital Library and Archives.*

New York University in 1871. When Waterbury Hospital opened two years later, he came to work there, remaining until his retirement in 1900. He died on March 12, 1907.

Andrew Monaghan came from Lattacrom, County Monaghan, Ireland, into Upstate New York in the 1850s. His son, John S., worked on a farm and served in the Civil War. After his marriage, he became employed in Connecticut's Bristol Brass Company and then, in 1891, came into Waterbury to work as a brass caster at Scovill Manufacturing. Although a dirty job, casting was an accomplished skill, involving the most advanced technological systems that existed. When the Catholic doctors in the Brass City broke through the glass ceiling of Waterbury's Protestant medical establishment in 1908, John's son, **Dr. Charles A. Monagan**, became a founding member of Saint Mary's Hospital. A plaque on the wall of the hospital lists a number of Irish heritage names, such as Dr. B.A. O'Hara, president; visiting physicians Drs. John F. Hayes, P.J. Dwyer, Michael J. Donahue, Thomas J. McLarney and James J. McLinden; surgeons Drs. P.T. O'Connor and Thomas J. Kilmartin; and consultants Drs. Frank E. Castle, W.J. Delaney, J.J. McGrath, J.T. O'Connor, Sullivan, W.J. Hogan, W.A. Reilly, Joseph Higgins and M.C. O'Brien, with many more listed by specialty.

Dr. Bernard Augustine O'Hara (Saint Mary's Hospital president, as mentioned previously) was born in Killimore, County Galway, in 1859. He was the son of Margaret Brennan and Mathias O'Hara. O'Hara and his wife, Margaret T. Holohan, had six children. Ireland-born **Dr. Michael Joseph Donahue** was the son of Thomas Donahue. With a private practice was **Patrick James Callaghan**, who was born in 1853 in Castleblaynay, County Monaghan. His parents were Mary McCartney and Michael.

Monsignor Slocum's uncle **James J. Fruin** (1850, County Limerick) was a stonecutter, monument maker and owner of a meat market and a hotel in Waterbury. Fruin was the son of Tipperary natives William Fruin (Glen of Aherlow) and Johanna Magner (Annagh), who emigrated with their seven children in 1854. James and his wife, Mary Jane, were the parents of **John William Fruin**, one of the first doctors at Saint Mary's Hospital. John played baseball for Waterbury High School before his graduation in 1902 and received degrees from Holy Cross College in Worchester, Massachusetts, and Long Island Medical College in Brooklyn, New York. He was first employed at Saint Mary's Hospital in Hoboken, New Jersey, followed by four

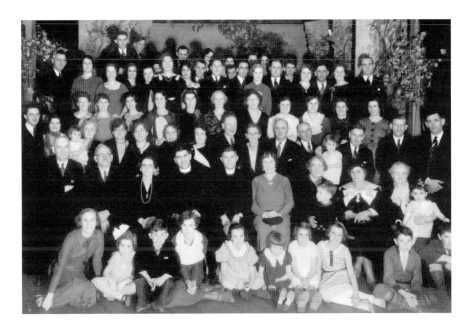

Buckley family reunion, circa 1932–33. Ellen Buckley Hennessy (second row, third from left), mother of Ann Hennessy Fruin, emigrated in 1883 from Ballylanders, Limerick. In this image, she sits among her children and grandchildren. Her son-in-law Dr. John W. Fruin is in the second row, first on left. Ellen's sister Mary Cecilia Buckley Skelly's children included her two priest sons, Reverend Bartholomew Skelly (who became a monsignor and served as a pastor at St. Theresa's in Trumbull, Connecticut, from 1948 to 1967) and Reverend Lawrence Skelly (a priest in the archdiocese of Hartford). They sit to the right of Ellen, wearing their collars. *Photograph from private collection of Kathleen A. Corbet.*

months at Waterbury's Saint Mary's Hospital. In 1909, he opened his own general practice on Grove Street and continued to work both as the medical inspector of the local schools and as a surgeon at Saint Mary's Hospital. During his tenure as Exalted Ruler of the Elks (1915–16), Dr. Fruin wrote the ceremony for and oversaw the dedication of Waterbury's stately clock on the green. He was a Democrat and member of Saint Margaret's Church. With his wife, Ann Hennessey, he had several children, including John, a high school science teacher who became vice-principal of John F. Kennedy High School and principal of Crosby High School.[116]

Bridget Madden came to America in 1914 and naturalized as a citizen in 1919. Working as a housekeeper she saved enough money to attend Saint Francis Nursing School, graduating in 1920 as a registered nurse. She was listed as "Mary" in that year's census but later changed her name to Beatrice

Bridget/Beatrice Madden (sitting) and her sister, Helen, from Upper Kilgarvin, County Kerry. *Photograph from the private collection of Maureen Burns.*

to minimize her "Irishness" and avoid discrimination. Wayne Burns, born in 1884, a locomotive engineer who drove a passenger steam train from Waterbury to Grand Central Station, became her husband the following year. The couple lived on Baldwin Street, then Sylvan Avenue, where they raised six children. Beatrice became known as the "Midwife on the Irish Hill...cherished by many for her exceptional care."[117]

George F. Mulligan (1880–1955) was born in England to an Irish father and English mother. His family immigrated to Waterbury when he was five. An excellent athlete, he founded the Washington Hill Athletic Club, which is still in existence. His more than forty-year career as a leading sports promoter in America included a short time as a boxer. In 1924, he began a semiprofessional football team, the Mulligan Blues. The following year, the team left Waterbury for Hartford, where he signed quarterback Harry Stuhldreher of Notre Dame's famed Four Horsemen as Connecticut's first professional football star. Mulligan promoted three world championship boxing matches, two of them in Waterbury—the Joe Lynch versus Pete Herman bantamweight bout in 1919 and the 1925 featherweight championship match between Kid Kaplan and Babe Herman in 1925. At the time of his death, Mulligan operated a restaurant opposite the entrance of Hamilton Park on East Main Street.[118]

Many who lived in 1950s Waterbury know of the terrible flood of 1955, when so many watched helplessly as homes crumbled into the Naugatuck River and were washed away. Relatively few residents remain who might remember what Waterbury looked like before Route 8 was created with the intention of providing a thoroughfare into Massachusetts and Route 84 completely bisected the urban center in the '60s, erasing the footprints of once vibrant interconnected communities. Some may, however, recall Waterbury's **Joan Joyce**, "the greatest female softball player ever," striking out baseball's best hitter, Ted Williams, at the Waterbury Stadium in 1961.[119] Joyce, born in 1940 and a graduate of Crosby High School, was elected to eleven Halls of Fame, including the National Softball Hall of Fame in 1989, the Women's Sports Foundation Hall of Fame in 1991 and Hank O'Donnell Sports Hall of Fame and Connecticut Sports Museum Hall of Fame in 1997. Since 1994, she has been the head softball coach for Florida Atlantic University, where she not only created the program but also led it to impressive championship status. When the new softball field at Waterbury Stadium is complete, it will be named in her honor. Joyce's grandfather

Thomas was from Killarney, County Kerry (born 1888). He married Mary Slattery in Holyoke, Massachusetts, and had become a Waterbury firefighter by 1930. Joseph Francis Joyce and Eugenia (Jean) Greggis were the parents of Joan, Joseph and Janis. Joseph Sr. worked for thirty-eight years at Scovill Manufacturing. He died in March 2013 at the age of ninety-eight.[120]

The State Theatre on East Main Street had a prominent plaque on an outside wall reminding everyone going to the movies that Waterbury was the birthplace of [Catherine] **Rosalind Russell**. Children of the '50s who regularly went there and to the nearby Lowe's Poli Theatre knew that "Roz" was, famously, "Auntie Mame" before they were old enough to see or appreciate her more than fifty films and plays. Among her accolades and awards are five Golden Globes for Best Motion Picture Actress and four

J. Farrell MacDonald (center), is shown here in 1936, in a publicity photograph for the film *Riff Raff* with Spencer Tracy (left) and Jean Harlow (right). Born in 1856, he was a member of Sarsfield Guards. His father, James, and both his mother's parents were born in Ireland. McDonald studied science and law and played football at Yale. After graduation, he worked as a reporter, sang in grand opera and was a stage actor. His film career began in 1906. He directed silent-era films, including *The Wizard of Oz*. After World War I, he acted in twenty-five films directed by his friend John Ford. By the time of his death in 1952, he had appeared in 850 films and was featured in 150. *Photograph from the private collection of John Wiehn.*

Oscar nominations for Best Actress in a Leading Role. She was married for thirty-five years to Carl Frederick Brisson Jr., a friend of Cary Grant's, and the couple had one son.

Born in 1907, Roz had been the middle child of six siblings. Her father, James Edward, had Irish ancestry. He was the son of Bridget Fahy and James Russell. Clara McKnight, her mother, had Scots-Irish roots. Edward was a successful lawyer with his own practice, a career that her eldest brother, James, also chose. Another graduate of Saint John's College (1886) and Yale Law School, he was assistant city attorney in 1894. The Russell home on lower Willow Street (number 114) was worth $40,000 in 1930, and even after the relatively early death of Russell's father, the family had a private cook and servant.[121] Rosalind Russell had a Catholic school education in Waterbury and attended Marymount College before setting out to become a legendary actress. A devout Catholic, Russell made charitable contributions and volunteer efforts standard practice throughout her lifetime. In 1973, she received the Jean Hersholt Humanitarian Award, presented to her by close longtime friend Frank Sinatra, at the Academy Awards. Roz died of breast cancer on November 28, 1976, and was buried in Los Angeles.

John S. Monagan

John Stephen Monagan, born in Waterbury in 1911, was the son of Dr. Charles A. Monagan (mentioned previously). His maternal grandfather was Thomas Mulry, a bank president in New York, a connection that extended his ancestry to Hollygrove, County Galway. His political career began almost without choice when he was nominated to run for alderman in 1939 as the Waterbury Democrats sought to reconfigure their leadership after the recent upheaval in the party. With a lifelong loyalty to the people of Waterbury, John Monagan managed to become a success in D.C. politics while retaining his community roots. In 1949, he married Rosemary Brady from New Jersey, and she shared the impressive path that brought him to prominence. He passed on his allegiance to his hometown to their five children, particularly Charles, who celebrated the state in print for more than twenty-five years as editor of *Connecticut Magazine*.

A state champion swimmer and football player at Crosby High School, Monagan graduated from Dartmouth and Harvard Law School. He was president of the Waterbury Board of Aldermen from 1940 to 1943, becoming

The fiftieth wedding anniversary of John S. Monagan and Ann Nolan (second row, couple on right) occurred in 1919 on Spencer Street in Waterbury. Their grandson, Waterbury's future mayor, is in the front row, second from left. *Photograph from the private collection of Charles Monagan.*

mayor upon the death of Vincent Scully. Elected twice, he served through 1948. During World War II, he kept up correspondence with Waterbury servicemen, finding the sending off of recruits at the train station to be one of his most difficult duties as mayor. Through his leadership, Waterbury government came into a new day. He established a more fair system for the awarding of city employment positions that included formal exams and physical requirements for police and fire department applicants. He also equalized pay for female teachers and integrated the police department.[122]

Monagan was a congressman in the House of Representatives for seven terms (1959–January 1973) and a delegate five times to the Democratic National Convention. His career included working with John F. Kennedy and Lyndon Johnson, thus experiencing from a governmental point of view the events of Korea, Vietnam, the 1967 riots (that included Waterbury), the shooting at Kent State and the deaths of too many of America's most influential and promising leaders. As chair of the Government Operations

Subcommittee, he "uncover[ed] irregularities in the Federal Housing Administration's financing of the Housing Renewal program."[123] Having lived through the 1955 Connecticut flood, Monagan continually brought up the topic of flood control with his colleagues. By 1972, Connecticut's Thomaston Dam became a realization. Monagan fought against advisory committees that held up decisions about important issues, and his bill "for the regulation, creation and termination of advisory commissions" was passed into law that year.[124]

An eloquent author and scholar, Monagan's memoir, *A Pleasant Institution: Key—C Major*, is a "must read." It deserves a special place beside Anderson, Bronson, Pape and others considered authorities about Waterbury's history, particularly in relation to post-Hayes politics. A glimpse into his "lace curtain Irish" life juxtaposes well with Bettejane Wesson's working-class tales (*Bold as Brass* and *A View from Cracker Hill*). Both authors' books are full of loving details about growing up during Waterbury's transitional times. Monagan recalled bishop "John Newman, in Burma, Monsignor James P. Kerwan, in

The 100th Anniversary Mass at Immaculate Conception Church, celebrated by the bishop of Hartford Diocese Henry Joseph O'Brien, was held on Sunday, December 7, 1947. On the back of this photograph was written, "Archbishop O'Brien, Msg. Finn, Mary Bennet, Jane Kilduff, Gov. Shannon, Judge Charles Summs, Chief Francis Scully, Mayor J.S. Monagan, Chief Wm. J. Roach." *Courtesy of the Mattatuck Museum, Waterbury, Connecticut.*

the Vatican Secretariat of State…One of Hollywood's brightest and most ebullient ladies, Rosalind Russell…Frank Hogan, Manhattan's incorruptible District Attorney" and others, in sharing his vivid memories.[125]

As a member of the Washington Institute of Foreign Affairs, Monagan kept in touch with other high-ranking retired officials on a regular basis, and he and his wife were actively involved in all the communities in which they lived. Waterbury's Congressman John S. Monagan lived to the age of ninety-three. (He died on October 23, 2005). His brother, Thomas, the husband of Margie Kehoe, was a well-known and much-loved pediatrician in Waterbury. The couple had twelve children, ten of them girls. David Farrell fondly recalled Dr. Monagan as his family physician and noticed a similarity of style between the brothers. He shared, "Dr. Monagan made house calls and cared for me several times when I was suffering from early childhood diseases. Congressman Monagan used a hands-on approach in addressing the needs and the concerns of his constituents. He swiftly cut through the red tape when people needed assistance in dealing with governmental agencies. He was there to serve, and he was there to satisfy his constituency."[126]

World War II

Residents of Waterbury played such a significant role in World War II that the city was chosen by directors Ken Burns and Lynn Novick as one of four areas of the United States to be given closer focus in their seven-part documentary, *The War*. The film appeared on public television in September 2007. While the trauma of war was such that many veterans did not choose to speak about their experiences, their families and friends celebrated their efforts and kept up to date with the news, eagerly awaiting letters from loved ones so dangerously far away. Twentieth-century descendants of Irish in Waterbury had been taught in their schools and churches to honorably serve God and country. They proudly supported America throughout its wars. Soldiers' monuments at the green and an honorary plaque outside the wall of Library Park pay tribute to the many men and women who gave their lives over generations of active combat.

Corporal Eugene L. (Lenny) McGarty, the son of a trolley driver who grew up on Luke Street off Baldwin Avenue, was awarded the Bronze Star

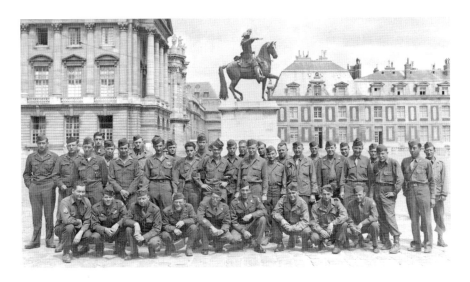

A photograph from Staff Sergeant Edward Maher's (first row, third from right, crouched) World War II album. Written on back is "Taken in the courtyard of King Louis the Fourteenth, Palace of Versailles. King Louis XIV is in the background. Aug. 2, 1945." *Photograph from the author's private collection.*

Medal at age twenty-two for meritorious service near Sassomolare, Italy, between March 3 and 12, 1945:

> *After infantry units had secured a high ridge and consolidated positions preparatory to any enemy counter-thrusts, McGarty braved hostile mortar and artillery fire, day and night, laying wire from the fire direction centers to the foremost forward observer, whose observation post had been established well in front of defensive perimeters. For a period of two days the lines laid by McGarty were the only means of communication between the infantry and its supporting artillery. Whenever enemy fire severed lines, he, unfaltering and with courageous devotion to duty, went out with other wiremen to service and repair damaged lines. His loyalty, dependability and disregard for his own safety are a tribute to his branch of the service, and reflect much credit on the Army of the United States.*[127]

Lenny married Ruth, the daughter of Raymond Conlon and Pauline Teller, and the couple settled in Bunker Hill. They were lifelong lovers of Ireland, immensely proud of their heritage and visiting the "old sod" on multiple occasions. They traveled throughout the world after retirement during their long marriage. Ruth's mother, **Pauline Conlon**, was a vital

Corporal Lenny McGarty being pinned with the Bronze Star in World War II, 1945. *Copy of photograph courtesy of Ruth Conlon McGarty.*

member of the Women's Democratic Committee, having served as both secretary and president. She remained close friends with other women and their husbands who were involved in Waterbury Civic organizations.

Edward James Maher, of Walnut Street, was "the pride and joy of Crosby," according to his 1942 high school yearbook. He had a special strength in mathematics, precision instruments and blueprint reading and was a toolmaker apprentice in the tool- and die-making department of Scovill Manufacturing before enlisting in World War II at eighteen. Within four months, he was promoted to staff sergeant, chief of Section 844, Battery C, 8th Armored Division of 405th Field Artillery Battalion. In this role, he supervised a section of six guns and crews and was responsible for control, coordination and tactical employment of crews and guns. Maher was an expert crewman light gunner and a marksman with a carbine pistol.[128] His fifteen-month tour of duty included legs in England, France, Belgium, Holland, Czechoslovakia and several towns in Germany. Upon returning home, he continued to serve in the National

Guard and was called up to fight again in Korea in the 2nd Infantry Division, H Battery, 15th Field Artillery.

His photograph albums and scrapbooks—along with one kept by his mother, Alice Whalen (daughter of Dennis Whalen and Mary Ryan, of Brook Street)—contained many newspaper clippings about the war. Alice had provided a newsletter for the neighborhood, sharing information about the "boys" abroad, such as this one:

> *Sgt. Eddie Maher dropped us a line from Germany during the past week. While he was recuperating in a Parish hospital, he met Johnny Donahue (Maple Ave.) They whiled away some pleasant hours talking over "old times." Both lads are now out of the hospital and back with their outfits. Mickey Killian spent a seven-day furlough traveling through Scotland. If his mother and father knew that he had seven days off and did not go to Ireland they would be afraid to meet their neighbors in the Abrigador. Sgt.*

Buddies Raymond Sullivan (left) and Edward Maher are pictured leaving for war, with Eddie's eldest sister, Kathleen (Mrs. Philip Kelly), and his mother, Alice. Kathleen was 1933 class president of Waterbury Catholic High School. A mother of six, she and her family lived on one floor of her French mother-in-law's three-story house on South Main Street before the family moved to Maine. Kay volunteered for John F. Kennedy's bid for the presidency, walking door to door to enlist support for him. *Photograph by James F. Maher from the author's private collection.*

Vots D'Ambrosio is back in this country but still in a hospital. His leg is still in a cast but he can sit up long enough to write a short letter. He says that in two or three months he will be able to get around again. Sgt. Jimmie Donahue (Orange St.) is somewhere in Germany and pining to get home for a look at Father O'Shea's secretary, Nancy McCarthy, his fiancé [sic]. Joe Bannon and John McGurk came through with letters from the Pacific Section. Joe is on board a ship and John is on an island investigating old Spanish shrines, when the Navy gives him time off. Gene Casey wrote for more news about Tote D'Ambrosio and to say that his legs were too short to catch up with the retreating Germans. We hear that Capt. Francis Allman is coming home from India. Sgt. George True is out of a German prison camp and also on his way home. Sorry to report that Sgt. Fran Kelley is still among the missing. In this country, Eddie Kelley, Fran's brother, has gone to an Air Corps Training Center in Texas. Frank Miller is out at Lowry Field in Denver, Colorado. Charles Butler, Lawrence Rogers and Bill Ryder have just entered the Navy. That's all for now but don't forget to keep the column going with your letters!

Newspaper photographs with captions that she saved provided further details about the neighborhood soldiers:

Cpl. Francis A. Shannahan's discharge; Sgt. Francis H. Durham on a thirty day furlough after two years overseas; Capt. Robert H. McNichols, of Hosey Place, returning to this country; Robert R. Nole, of Chase Parkway, formerly a gunner's mate, serving as an instructor of gunnery in Portland, Oregon; PFC James J. Smith, Jr., of Maple Street, reporting to an Army finance disbursement unit in Indiana after having served overseas for fifteen months; Sgt. John J. Holihan, of Cherry Street, home on furlough from thirty-two months in Northern Ireland, England and North Africa. Raymond Sullivan, son of Mr. and Mrs. Albert Sullivan, William Street, being promoted to Corporal; Sgt. James P. Donahue, of Maple Avenue, on furlough from the 95th Infantry Division of the Ninth Army, and his brother, who had been wounded in France, serving in Germany. Pvt. William J. McGrath, Maple Street, who had been active in athletics before the war, being hospitalized in England for a foot injury suffered in Germany. Asa (Buddy) York, Jr., of Cherry Street, a ground radio operator, being awarded five battle stars. Buddy's father, a veteran of World War I, served in the same battle areas in his time with the old 69th Infntry [sic] Regiment.

While in Austria, Raymond Cavanaugh, of South Elm Street, was promoted to sergeant. His clipping explained, "After Cavanaugh and his buddies drove up to Salzburg, Austria, the war officially ended for them…There was not any fighting there and the only Germans they encountered were a horse and buggy army. They all had a white flag waving on their carts and not one shot was fired, as the Yanks did not even bother to take any prisoners.

Private First Class John D. Brennan, son of the late Mr. and Mrs. Dennis Brennan of Cherry Street and husband of the former Elizabeth Luddy, was visiting relatives in Ireland after his thirty-three months in the army. Frank T. and William J. Keaveney, sons of Mrs. Ella Keaveny of Kenyon Street, were both serving with the navy. Frank was a motor machinist in "amphibious service." His brother was a seaman. Lieutenant Thomas McGrath, son of John J. McGrath of Maple Street and husband of Rosemary Cruess of Frost Road, spent twenty-one months in the Pacific.

Staff Sergeant Francis J. Kelly, a radio operator on a B-24 Liberator with the Eighth Air Force, was featured upon his promotion and again when he was missing in action over Germany. Private John J. Lynch Jr. and Private First Class Leo Frank were both reported killed in Germany. Like so many others, John had worked at Scovill Manufacturing. Twenty-one-year-old First Lieutenant Roger F. Carroll received a warm welcome home gala on South Elm Street after he had returned from twenty-one months as a pilot of a P-47 fighter plane. Son of Mr. and Mrs. Thomas Carroll, he was awarded the Distinguished Flying Cross and the Air Medal with three Oak Leaf Clusters. His brother Lieutenant William Carroll had recently left for the Pacific to serve as navigator aboard a bomber. Another brother was in his fifth year at LaSallette Seminary, and his youngest brother, ten-year-old Jackie, was "[holding] down the home front." An additional clipping noted "impressive ceremonies" held in Greensboro, North Carolina, when Carroll was returned to inactive status.

John F. Kennedy Comes to Waterbury

The visits of John F. Kennedy to Waterbury in 1960 and 1962 were monumental events. Thousands of Connecticut residents waited throughout the nights along his pathway to Waterbury hoping for a chance to wave and cheer his motorcade. An estimated forty thousand people were gathered on the green to hear JFK speak on November 6, 1960. At 3:00 a.m., the hopeful

Annual Saint Patrick's Day Party at the National Press Club, March 1960. John Monagan shared JFK's antipathy to be photographed wearing a "silly" hat. *From left to right, front*: Connecticut representatives Robert Giamo, Emilio "Mim" Daddario and John Monagan; *second row*: New Jersey representative Neil Gallagher, Senator Kennedy and Massachusetts representative Tip O'Neill. *Photograph from the private collection of Charles Monagan.*

candidate stood on the balcony of the Hotel Elton and greeted his supporters. At least one thousand people remained to watch him go into the Immaculate Conception Church to attend early Mass the next morning, accompanied by John Monagan and others. The former mayor's eldest son, Charles, related, "Everyone was watching to see if Kennedy knew all the Latin responses throughout the Mass."[129] From church, the entourage headed to New Haven for another appearance. Congressman Monagan had asked JFK if he would wave to his family, who were waiting at Oliver's Supermarket in Prospect to watch him pass. When they reached the spot, the future president told his driver to pull to the side of the road. He got out of the car and shook hands with all of Monagan's family, including each child and every niece and nephew.

John Monagan recalled his pride at seeing Waterbury's Mattatuck Fife and Drum Corps marching past the White House in President Kennedy's inaugural parade. He described the band as "one of the oldest such organizations in the country and full of my friends…in their Colonial uniforms, with their slow ancient cadence, the piercing clamor of their fifes and the massive boom of their bass drums."[130] Kennedy, he noted, personally thanked and shook hands with the many Democrats who came to Washington from all over the country to welcome the country's first Irish Catholic president.

On October 17, 1962, President Kennedy returned to Waterbury for a campaign rally on the green for Governor John N. Dempsey, Congressman Monagan, Bernie Grabowski and Abe Ribicoff. (Then mayor Edward D. Bergin was a grammar and high school friend of John Monagan.)

The president began:

> *Mr. Mayor, Mayor Bergin, Governor Dempsey, Senator Dodd, Congressman John Monagan, next Congressman at Large, Bernie Grabowski, members of the State Ticket, Ladies and Gentlemen,* [cheers] *I must say, having been here at 3 o'clock and now at 6:30, that Waterbury must be the easiest city in the United States to draw a crowd in or it must have the best Democrats in the United States!* [cheers] *In any case, our meeting here two years ago at 3:00 in the morning was the high point of the 1960 campaign and we will meet at 3:00 in the morning the last week of the 1964 campaign and see what's going to happen then!*

Tragically, of course, that did not occur.

Senator Robert F. Kennedy also addressed an enthusiastic Waterbury crowd in 1966, again accompanied by John S. Monagan.

Memories in the Present

It seems fitting to conclude with voices of descendants from the Abrigador, the Hill, the East End, Bunker Hill and Fairmount/Waterville Park. They collectively represent "all the Waterbury Irish whose ancestors arrived with little other than hope for a better future, strength to follow their dreams through all kinds of adversity and the ingenuity to take advantage of every opportunity."[131]

The Honorable Winifred Weis McDonald and her husband, **Attorney Edward J. McDonald**, exemplify the Irish immigrant success story. Descendant Suzanne McDonald Welles explained:

Weis was the daughter of Mary Ellen McGuinness, granddaughter of Marie Strahan and Michael McGuinness, who came to Waterbury in the early 1850s from the Clonever area of King's County, Ireland. Prior to 1860, Michael ran a successful Abrigador grocery store that served many Irish immigrants. The McGuinness and Strahan families married into well-known Baldwin Street inhabitants, including the Kilduffs, Rigneys, Fitzpatricks, Sheas, McMahons, Holohans and McElligots. Winifred's father, Dr. Xavier Charles Weis Jr., was a well-educated dentist whose father, Xavier Charles Weis Sr., emigrated from Niederbronn, Alsace, France, to New York City in 1855. In 1858, at the Immaculate Conception Church, he married Ann Loughman, daughter of Patrick and Margaret Loughman from Abbeyleix, Queen's County, Ireland. The couple built a thriving grocery store on Baldwin Street and acquired a substantial number of properties. When Charles died in 1873, Ann Loughman Weis, a strong and directed woman, went on to play a vital role in the development of the lower Baldwin Street area with a special interest in Saint Francis Xavier Church, for which she purchased the main altar. Three of her sisters—Anastasia, Alice and Eliza—also emigrated in the early 1850s and married into Baldwin Street Irish families: the Scullys, the Garritys and the Patrick McDonalds of Ridge Street. Ann's twin sister, Margaret, remained in Raheen and Cromogue, Queen's County, where she married Martin Dunne. In the 1880s, some of their children immigrated to Waterbury, marrying into the Campion, Balfe, Keefe, Magner, Connor and other families.

The successes of Winifred Weis's strong, intelligent and hardworking immigrant relatives gave her a "leg up" monetarily and socially. Unfortunately,

Officers of the Women's Democratic Committee, shown here in the 1950s, with Mayor Edward D. Bergin. Second from left is the "First Lady of Politics" Winifred Weis McDonald, second from right is Pauline Teller Conlon and at far right is Sadie Bedore. McDonald was elected secretary of state in 1948, the first Waterbury woman elected to a state office. She was recognized for her "performance of meritorious civic service" in May 1964. *Photograph from the private collection of Ruth Conlon McGarty.*

she also suffered great loss when, in 1898, her father died at the young age of thirty-three. Her mother also died young, at age thirty-six, in 1902. Winifred and her sister Annetta—ages ten and six, respectively—became boarding students at Saint Elizabeth's School (now Academy of Saint Elizabeth) in Convent Station, New Jersey. Winifred later excelled at the College of Saint Elizabeth, graduating summa cum laude and salutatorian in 1910. Armed with a college degree, she taught English at Ansonia High School and then at Crosby High School in Waterbury. Her political career began in 1912, when she campaigned for Woodrow Wilson. On November 6, 1912, at Saint Francis Xavier Church, she married Edward J. McDonald, a court reporter who was to become a lawyer and assistant corporation counsel. Ed and Winnie lived first on Crescent Street and then on Randolph Avenue while raising their sons, Robert and Edward Jr.

"When you go back to your various communities do not build a shell about yourself and hold aloof from your neighbors. Take an active interest in all vital problems of your community, whether social, political or philanthropic. Give them the benefit of your new ideas and cultural contacts," she was

told as a student.[132] McDonald took these words seriously and maintained an active role in civic and church affairs in Waterbury. During World War I, she sold Liberty bonds at the Liberty House on the green. She was one of the first two women to serve on a Waterbury Grand Jury. After working for women's right to vote, she became a member of the League of Women Voters and chairman of the Waterbury and New Haven County Councils of Catholic Women. In politics, she was the first woman to be a member, vice-chairman and chairman of the Waterbury Town Committee. She assisted in the formation of the Federation of Democratic Women's Clubs of Connecticut and was president of the New Haven County Democratic Federated Women's Club. She represented the Fifteenth District on the Democratic State Central Committee for almost a quarter century and was a delegate to the 1952 Democratic National Convention. The highlight of her career occurred in 1948, when she was elected secretary of state on Governor Chester Bowles's ticket, making her the first Waterbury woman to be elected to a state executive office.

The Crowley/Hussey/Goggin clan as children. *From left to right, front row*: Noreen Hussey, Eileen Hussey, Edmond Goggin, MaryLou Shannan, Mary Theresa Corbett, Ronnie Gean and Dennis Gean; *second row*: Margaret (Peggy) Crowley, Bridie Crowley (holding Donald Crowley), Joan Crowley, Patricia Hussey and Frances Corbett; *third row*: Laney Crowley, Anne Goggin and Joe Shannan. *Photograph from the private collection of Eileen Hussey Maroney.*

John Goggin's 1947 graduation from Crosby High. *From left to right, first row*: Noreen Hussey (O'Keefe), Eileen Hussey (Maroney), "Bibber" Goggin, Pat Hussey (Demsey) and Helen Crowley (Dolan); *second row*: John Goggin, Jerry Sullivan, Barry Danaher, Joe Hussey and John (Jack) Crowley; *third row*: Pat Hussey, Mary Brown Sullivan, Peg Hussey (Goggin), Ellen Cunningham (Hussey), Mother Flaherty, Peggy Crowley, Bridie Hussey Crowley (holding Donnie Crowley), Anne Goggin (Carey, wearing her brother's graduation hat) and Mike Goggin. *Photograph from the private collection of Betty Goggin.*

In her later years, McDonald was poll moderator at Kingsbury School, chairman of the Committee to Study Tax Burden on Elderly Citizens for Governor John Dempsey, special campaign aid for Ella Grasso's reelection to secretary of state and one of John F. Kennedy's greeters on his 1960 visit to Waterbury. She had the pleasure of meeting every Democratic president from Woodrow Wilson to Lyndon Johnson. When she retired from active politics in 1964, Representative John S. Monagan paid tribute to her as "the First Lady of Waterbury Politics" in the congressional record. "She has conducted her political activity on a high plane, and has treated the political calling as one worthy of respect." When Winifred Weis McDonald died on February 23, 1976, the *Waterbury American* wrote: "She served her party and her community well, always getting involved in causes in which she believed. In her quiet but persistent way, Mrs. McDonald left her mark on the people and politics of her city and state."

Edward Daniel Bergin Sr. was mayor from January 1956 through 1957, elected again to serve from 1960 through 1963 and again from 1970 until May 30, 1971, when he died in office. **Joseph Francis McNellis Jr.** served one term from January 1964 through 1965. McNellis's grandparents were all from Ireland. His grandfather Bernard was born there in 1842 and emigrated in 1861. Of their nine children, Joseph Sr., known as "Pop," married Lillian Baker of Naugatuck. Mayor McNellis was one of their children. Joseph Jr.'s wife, Monica, was born in Cork City, Ireland. Their eldest son, Thomas, recalled that the Democratic primaries were always "tight races."[133] His father had beat Mayor Bergin in the 1963 primary. In the election for what would have been his second term, Joseph McNellis Jr. lost to Bergin in the primary by only twenty-nine votes. The election that year, however, went to the Republicans. The elder McNellis children took the bus to Saint Mary's Grammar School downtown, and the family attended Blessed Sacrament Church. "My mother was very Irish," **Thomas McNellis** said. "The five of us knew where she came from and on Saint Patrick's Day she decked us all out in green." Years later, he also became active in politics. From the largely Republican district of Bunker Hill, Thomas was elected twice to the state legislature, serving for four years as the Democratic state representative (1969–72).[134]

Two more mayors were elected before **Edward D. Bergin Jr.** ("Mike") served from January 1976 through 1987 and then again from January 1992 through 1995. The combined legacy of Bergin mayors spanned a significant amount of time. Edward D. Bergin Jr. is credited with bringing the city out of an enormous financial crisis. The city was $11 million in debt when he took office. Under his administration, the remains of Scovill Manufacturing were removed, and the Brass Mill Center was created. Commenting on his successes, he explained, "I was raised that if there was something wrong and that changes were needed, don't wait around for someone else to do it."[135] It would not be until almost sixteen years later—in December 2011—that another Irishman was elected mayor of Waterbury.

Family bonds and friendships have extended an entire lifetime for **Anne Goggin Carey**; one of her sisters-in-law, **Elizabeth (Betty) Kennedy Goggin**; and **Eileen Hussey Maroney**, who grew up among a slew of first cousins (fourteen for some of them) descended from County Kerry clans. Two three-story houses on South Street (colloquial for South Main) were home to the group. The Goggins lived on the first floor of one and the Husseys on the third with the Crowleys two doors down. The children grew

up fondly, remembering having, essentially, "three sets of parents" and the fun of sometimes not being sure how they were all related. When someone asked, "are you a Hussey, a Crowley or a Goggin?" they did not always know the answer.

In the safe and innocent times of their childhoods, the neighborhood was "loaded with kids" who went to the same schools. Nearby Washington Park was an outside extension of their familial universe. On "The Hill" they could pick blueberries, climb on the cannon, participate in annual Saint Patrick's Day song and dance shows and play together every day, sitting outside together under the streetlights until called in for bedtime. As in Ireland, marriages in this and other long-standing Waterbury Irish American communities often occurred between couples that seemed to have always known each other, never having needed an introduction.

One cousin liked to say they lived in "a fifteen-room house with three bathrooms and its own intercom system!" Someone would knock on the heating pipes to call someone from a different floor to the party-line telephone. Those who wanted to listen to a conversation could hold a shot glass to a wall or floor. In time, a television arrived. Parents in '50s and '60s Washington Hill imparted a living identity as Irish to their children, nieces and nephews. At Christmas, the cousins, along with their friends the O'Connors, Stacks, and Shanahans, strolled from house to house singing not carols but Irish songs. They knew all the words to the anthems and patriot tunes. In the sad event of someone's passing, a family member would recite a special poem for the person, and all would sing his or her favorite Irish song at the grave site.

One of Eileen Maroney's happiest memories was doing Irish step dancing at Madison Square Garden, when her uncle John Crowley brought her and her friend to a feis. Her cousin Anne Carey taught her to dance. She, in turn, had learned from Bill Ahern of New Haven. "It was a great life!" the women wholeheartedly agreed, and though their numbers have dwindled over the years, family members still see one another regularly. Eileen habitually says "hello" aloud to all her Irish ancestors when driving past New Saint Joseph Cemetery. A friend who recently died declared his continued emotional attachment to the old neighborhood by requesting that his son scatter his ashes at Washington Hill Park.

Bridie (Bridget, "Auntie Bid") Hussey and her sister Margaret emigrated from Ahamore, located between the villages of Causeway and Abbeydorney in northern County Kerry, around 1926, followed by their brother Patrick Joseph. Of nine siblings, five remained in Ireland and England. Margaret,

Bridie and Patrick Hussey, their spouses and their children became the center of the extended interrelated clan in Saint Francis Xavier Parish. Bridie married John D. Crowley in Waterbury and had five children, extending their Irish family through marriages into the families of O'Connor and Dolan. Their son, Jack, was a teacher at Bunker Hill School. By 1940, Patrick Hussey had become a shipping clerk at the brass factory, moving his way up the socioeconomic ladder.[136] He married Ellen (Nell) Cunningham, who had emigrated from Lixnaw, County Kerry, with her best friend Anne O'Connor. Pat and Nell had four children, whose marriages extended their family lines into that of the O'Keefe, Maroney and Demsey families. Anne chose to return to Ireland, where she opened a pub in Tralee. One of the other Hussey relatives, Kitty, was remembered fondly as having been among the more glamorous and stylish women in town, recognized by her large hats decorated with feathers. She was the sister of Superintendent of Police Freddie Sullivan.

Bridie and Pat's sister, Margaret, met Michael J. Goggin in Ireland. He was from Killahan in Abbeydorney. The couple married early in 1929 at the Immaculate Conception Church, and Michael worked in the steel mill. The Goggin children included John, Anne, Dennis (nicknamed "Joe'), Michael (nicknamed "Bibber") and Edmond. Anne was a registered nurse in Waterbury for more than fifty years. John established the first major medical insurance policy for employees of Waterbury—the first in the United States to benefit an entire city. He founded the John F. Goggin Insurance and Real Estate Company in Waterbury. His many memberships included the Elks, AOH, Friendly Sons of Saint Patrick, Veterans of Foreign Wars, Officers Club and past president of the Rotary Club. The husband of Patricia McMahon, John Goggin, served as a first lieutenant in the army and graduated from the U.S. Army Adjutant General School, serving in this role under General Maxwell Taylor during the Korean War.

Michael Francis, a beloved Waterbury schoolteacher for thirty-three years, was the husband of Betty Kennedy Goggin for fifty-two years. Michael pitched a no-hit game in elementary school that was celebrated in print by a Waterbury sportswriter who casually referred to the young boy as "Bibber," after the minor-league baseball player, Jack Van Bibber. The nickname stuck. Goggin was known as "Bibber" by those close to him for the rest of his life. He retired from teaching in 1992 as chair of the Business Department at Wilby High School, also having taught at Walsh School and John F. Kennedy High and having been the recreation director for Waterbury parks and recreation centers. Like his siblings and many cousins from the Hill, "Bibber" attended

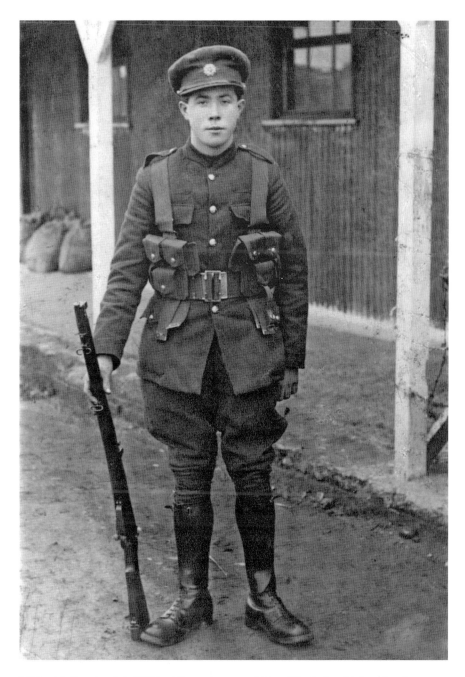

Michael J. Goggin, circa 1926, while serving as an Irish soldier before his immigration to Waterbury. *Photograph from the private collection of Anne Goggin Carey.*

Saint Francis Xavier Grammar School. He also was a graduate of Crosby High, the University of Bridgeport and Central Connecticut State University. He was a member of the AOH, Washington Hill Athletic Club, Elks, 1900 Club and Waterbury Sportsman Club, one year receiving the Sportsman of the Year award. He remained active in the Waterbury Teachers Association and Waterbury Retired Teachers Association, and both he and his wife had been Alumni of the Year in the Saint Francis Xavier Alumni Association. "Bibber" Goggin passed away on February 2, 2013, a year before John.

Betty was from Baldwin Street, one street away from "the cousins." Her paternal grandparents were John J. Kennedy and Honora (Nora) McCormack Kennedy from Tipperary; her maternal grandparents were Henry Quinn from Limerick and Anne Healy Quinn from Waterford. Both of Betty Goggin's grandfathers died before reaching fifty, leaving

Frederick John Wiehn (1930–1986) in the Korean War. A resident of the East End, he worked for more than thirty-three years as a draftsman for the American Brass Company. His mother, Elizabeth McMahon, was born in Limerick City in 1893 and immigrated with her parents and sister, Minnie, to Waterbury in 1916. During the 1920s, she and Minnie performed Irish dancing at Irish events in Waterbury. *Photograph from the private collection of John Wiehn.*

their wives to raise large families on their own—seven children in the Kennedy family and ten in the Quinns'. Despite the difficulty that it would undoubtedly have caused, Nora Kennedy ran a boardinghouse on lower Grand Street in Waterbury and was considered "a kind and gracious woman, always willing to help those in need." Anne Quinn was "full of fun, with a quick Irish wit, and a lot of old-fashioned wisdom, given with a gentle smile." All their children went on to become successful in careers that included accounting, store management, secretarial and business occupations and education.

Among the many members of this extended family who served in the armed forces, one was awarded a Purple Heart in World War II, and Pat Hussey's son, Joe, was a captain in the marines stationed in Okinawa during that war. Anne recalled their father having said, "If this country was good enough to live in, it was good enough to fight for!"[137]

Great-grandchild of Irish-born **John and Honora Luddy** (parents of Thomas, noted earlier), Waterbury's **Thomas Phillip Luddy** had achieved an amazing degree of accomplishments by the time he died in 2002 at only fifty-five years old. The son of John J. Luddy and Evelyn Maxine (Hoffman), his family considered him "a modest hero" and "a true patriot." His cousin Maureen explained that Luddy "set the gold standard for the rest of us." He attended Saint Mary's Grammar School and Sacred Heart High School before attending college in Emmitsburg, Maryland. During the Vietnam War, he was a captain in the Marine Corps. Before operating his own private security business, he was a U.S. Secret Service agent, working in the U.S. Treasury Department and protecting such famous figures as Gerald Ford, George Bush, Nelson Rockefeller, Pope John Paul II, Fidel Castro and John F. Kenney Jr. He was the head of Olympic security for the National Broadcasting Company for the winter and summer games in Atlanta, Nagano and Utah, where he suffered his fatal heart attack. NBC Olympics dedicated its broadcast in his honor.

Captain Luddy was buried from Murphy's Funeral Home with many Secret Service, FBI and NBC colleagues in attendance. All the pews seemed to be filled in the Immaculate Conception Church at his funeral Mass, and full military honors were given to him with a Marine Corps Honor Guard. Bagpipes and taps were played at Old Saint Joseph Cemetery, where family and friends at the graveside numbered about one hundred. "When the gun salute, the flag-folding presentation, the singing of the National Anthem and the farewell song of 'Danny Boy'

Saint Patrick's Day celebration at Hogan's Restaurant, Baldwin Street, 1954. Washington Hill residents referred to Hogan's, Healey's Restaurant, Harmon's Tavern and Hanley's as the "Four Hs." McGrath's Tavern on Baldwin Street, the West End's Wacki Grill and Egan's Diner were also popular places among the Waterbury Irish in the 1950s and '60s. *From left to right, front row*: Mary Greaney Powell and Margaret Barrett Greaney; *second row*: Helen Collins Murphy, Helen Barrett Wiehn and Francis Dunn. *Photograph from the private collection of John Wiehn.*

was over, the people lingered despite the bitter wind. No one wanted to say goodbye…to [this father of four children, with sharp wit and humor] who had the gift of making everyone he met feel important."[138]

The demise of the Brass City factories is a complex story. In reply to an in-depth article published about it, **Jaime Ryan L'Heureux**, a graduate of John F. Kennedy High School, had his own memories to share.[139] L'Heureux was a great-grandson of New York–born John McHugh and Irish-born Ellen Ryan, who lived on Sylvan Avenue in the early 1900s. The family relocated to Walnut Street, East Main, Highland Avenue and then Fairmount, where Jaime and his siblings grew up. L'Heureux was also related to Henry Butler, likely the son of Edward (from Ireland) and Mary Butler (from Pennsylvania), whose family tombstone is among the oldest in Old Saint Joseph Cemetery. Henry, born in 1888, was an architect who designed many buildings in Waterbury. His younger sister, Helen, was a grammar school teacher.[140]

L'Heureux recalled his mother, Mary Butler Cook, who passed away in February 2014 at age eighty-six, as being "100 percent Irish, red hair and a poet's flair…the stories she told were hilarious examples of Irish culture and wit."[141] Regarding the factories, he recounted:

I can only speak of the last few years at Chase Brass and Copper. I was fortunate to land a job there a few months after graduation in 1972. There had been a hiring freeze for a long time, so when I got there, it was an older workforce who greeted me. I remember my first half mile walk from the parking lot to the rod mill where I worked; the smell of various lubricants and the sounds of the big rigs banging and clanging the rods and tubes into shape; and the buzzing saws screaming in short bursts that another piece of pipe or rod was finished. I'd watch with awe as the cranes roared overhead delivering their heavy loads to finishing benches or cleaning tanks for degreasing. And then there were the jitneys and their extroverted drivers who honked at anything that moved as they transported jobs from machine to machine.

The men of the mill were from another generation, another mindset, another reality. Though the age gap between us was large I could not wish for a better group of men to have as friends and mentors. They came from all walks of life, African-Americans, many who were transplants from the south, Polish, Lithuanians, Irish, Italians, Portuguese, Puerto Rican, and many other nationalities. Most fought for freedom in WWII, while others were currently fighting for freedom in the civil rights movement. They all brought a survivor's mentality to the mill. The jobs were hot, hard and monotonous. The hours were long. The personalities, the humor and the stories made the hard work and modest pay tolerable. As the baby in the department, I had the benefit of thirty or so "Dads or Granddads" looking out for me. They would share the stories of the mill and of their lives, (most were humorous and all had a point), while we performed some repetitious function during a typical twelve-hour day. They told me to find something else to do in life for this was a dead-end place. Looking at the aging building and aging workers, I knew they were right. They told me to go back to school, so I did, part time. They pulled strings and had me take over a heat-treating job that would give me lots of down time between runs to read my college books. The plant manager found out I was taking classes and set up a scholarship program for me. My classes at Mattatuck Community College were paid for by Chase. [Human Resources] eventually, after the layoffs that hit our department put me out of work, directed me to a

university where I received a degree several years after the mill closed. Most of the men are gone now. I did visit recently one of my closest friends from the mill who is 86 and living in Atlanta. He taught me how to play chess, not how to move the pieces, for I knew that, but how to really play chess. We would set up the board at the beginning of the shift and make moves as we could. I never did beat him, but in every game I did win something. Like most of the men in the rod mill, he gave freely to me the gift of his friendship and the wisdom of his experience that I still honor and rely on forty years later. Your historical account of the brass industry, the reasoning behind the owner's decisions and the political events during those times is a good read. A better one would include the people and their stories from the floor of the mill. There are a few remaining mill workers living to tell these tales, but time is running out to record the full history of the brass and copper mills of Waterbury.[142]

Michael J. Dalton's grandfather immigrated to New York in 1912. Although he returned home after two years, he advised others in the family to try their luck at a potentially more prosperous life in the United States. Due to lack of work, Michael's father, John, had served in the Irish army while he was a teenager, an endeavor that at least ensured his daily meals. Among the multitudes of Waterbury's young men who had eagerly signed up to serve in World War II, many came from families who had suffered greatly during the Depression, including a good number of Irish American descendants. As in wars past, their patriotism simultaneously served as a means to help support their own families at home, as they sent their pay back to Waterbury. Many, the Daltons among them, also joined the Korean conflict, followed by Vietnam.

Michael was almost five when his father decided to come to America. When he secured employment and found a place for his wife and son to live, he was allowed to bring them over. John Dalton had hoped to work in New York or Boston, but even in the mid-1950s, he was confronted with signs announcing, "No Irish Need Apply." His sister and one of his brothers already lived in Waterbury, and they encouraged him to settle there. Michael and his mother left Athlone, County Westmeath, and joined his father and his father's siblings in 1956. Having received several inoculations, they boarded the America-bound ship and made the trip across the Atlantic Ocean that millions of other Irish had weathered before them. Like their less-than-wealthy predecessors, they were forbidden to spend time on the top deck. "It was like the film, *Titanic*," Dalton recalled, "we were downstairs

with the other Irish immigrants in ten-bunk sleeping quarters…somehow I snuck up to the top deck." He remembered his surprise at seeing a crowd of waiters serving the higher-classed passengers, including the first African American Dalton had ever encountered.

The adult Daltons worked in the Scovill factories with the rest of Waterbury's immigrant population. "We lived modestly," he explained. "When I think back, I'm impressed how the immigrants, whether Italian, French or Irish, lived within their means. They would not buy anything they could not afford. I remember going to Saint Mary's Grammar School, and it would be peanut butter sandwiches. We weren't getting the meals they get today. It was quite different. I used to walk at least a mile to school, up and back, and sometimes, the way things were then, the police would walk with you. Everyone was safe."[143]

At first, the Dalton family lived on South Elm Street, where the current Sacred Heart High School is. The area was full of three-family houses that were torn down when Route 84 was constructed and a bridge built to connect some of the south and east sections of town. "Even South Leonard Street, where some of the Irish lived, was wiped away by the highway." In 1962, the Daltons moved farther east and purchased their first home.

Those days, wherever you lived was where you went to school. When I first got here, I had an accent. I used to even do Irish dancing. But people made fun of me. The Beatles weren't here yet. Then *accents became really cool, but with me, it was different. I ended up going to a school that was three-quarters Latino—Maloney School. I stuck out, but it worked out. Being an only child, and with my parents working ten-hour days, I had to find my way. I had no young cousins, and all the older members of the family were working all week. So I had to learn by myself and fight my own fights. I would only see my parents early in the morning. I'd get myself off to school,* [and] *then I'd see them again at night.*

It was the three of us, [my parents and me]. *The real social gathering was at the Irish-American Club, where Webster Bank is now. That was huge. Every weekend everybody was there at the Saturday night dances. The Irish worked hard all week, but on Saturday nights, they all went there. That's where the mayors were elected. On any given night there could be anybody—a senator, mayors all the time, whether Mayor Bergin, the father, whatever. If you were running for office you needed the Irish-American Club behind you. At that time, the Irish may have been the largest population, with the Italians next. That's what I remember.*[144]

Michael Dalton (middle) with his parents at the Irish-American Social Club. His father was the last president of the club. *Photograph from the private collection of Michael Dalton.*

All the high schools were downtown then: Wilby, Crosby, Sacred Heart, Croft (formerly Leavenworth), Catholic High and Notre Dame. Dalton recalled the enormous number of students who converged around the green when schools let out. There were nights of basketball games and dances at the Armory on Field Street bringing people together from all parts of town. The State and Palace movie theaters were big draws for crowds, as were the soda shops; places to eat good, inexpensive pizza; and a record store where anyone could listen to forty-fives before deciding whether or not to purchase them. Downtown buzzed with people socializing and shopping. Yet another generation's heyday was focused at the center of the city. "That's what I wish we had today. Downtown had movement then, which we don't have now.

There was so much going on. The atmosphere was terrific! Waterbury was really at its peak."

Dalton's uncle Michael was among those drafted as an infantryman in the Korean War. His wife, Hazel, knew that he had been in several serious firefights, yet he never talked about the war. His namesake nephew thus didn't learn the details surrounding his uncle's Bronze Star award. He achieved the same recognition when he was drafted into Vietnam. Michael J. Dalton—who was later elected Waterbury's city clerk for five terms—saved the life of another soldier, whose clothing had caught on fire during an attack. When the serviceman began to run, Dalton chased him down under fire in the attempt to keep his comrade from burning further while searching for something with which to put out the fire. The unfortunate soldier was brought by helicopter to a hospital for intensive treatment. "I was nineteen years old," he recalled, "Nothing could stop me. We were kids. We grew up there. The difference between the soldier then and the soldier now in our all-volunteer army is that we were all in shape, we were young guys, not married, guys who would just follow orders. Now they're grandfathers and worried about their 401Ks. It's a big difference. Maybe we were easier to talk into it."

Left to right: Michael Dalton, Mayor Edward Bergin Jr. (Mike), four-time Olympic Irish runner Eamonn Coghlan and Michael's father, John Dalton, on the occasion of Coghlan's receiving the Key to the City from the Irish American Social Club. *Photograph from private collection of Michael Dalton.*

Dalton became a long-distance runner, which inspired a return trip to his native home with his parents. Rather than participating in a marathon in the States, he decided to run the one in Dublin in 1998. The family embarked on their only trip back to their home country together, and a great many cousins whom Dalton had never known came to see him run. While in Ireland, Dalton and his parents visited the house in which he had been born: "[It was] down a long dirt country road…a little house, about the size of this [office]." He hadn't known either of his grandmothers but was able to visit their graves. He walked through the town by himself and looked around thinking, "This is where I'm from!"

As the family rode the train from Dublin through small towns in the countryside, his father told stories about the places where he and his young wife used to dance, sharing memories of life before America. Dalton learned that his family still held titles to one-hundred-year-old cemetery plots at Clonmacnoise in County Offaly when his father said he'd like to be buried there. Years later, when Mrs. Dalton was close to her death from cancer, Dalton asked, "Do you want me to take you home?" In true Irish style, he explained:

I go to Murphy's and tell them, "You've got to help me out here. I want to take my mother to Ireland for her burial," and seven days later, I was burying her in Clonmacnoise, where they even had a wake for her. I had two undertakers. Four and one half years later, I ended up taking my father over, too. The two of them are close to the path near the entrance. Tourists walk right past them.

We fly into Dublin, and of course, the caskets are big in America. In Ireland, the caskets are wood. A typical small Irish hearse comes up from my hometown, and I don't know if we can fit it in there. We get my mother in, and we're starting to drive when it hits me, "We've got an eighty-eight-mile drive to Clonmacnoise!" We're about halfway to Athlone, and the hearse driver stops and says, "Michael, I don't know how to tell you, but I don't think we have the right grave for you." I say, "Are you sure?" and he's says, "I'm sure." So we're driving, and I'm up a day and I'm tired. I'm saying to myself, "What am I going to do now?" He says to me, "Well, we may find something." He's not even panicking, and I'm a wreck!

So we bring her to Athlone to a place that's connected to a hospital, and that's where I'm going to wake her. Some people came, but there were not many since she was not young. All of a sudden I turn around and a whole group of nurses, nuns, came in and started circling my mother,

praying for her. We walked a mile from there behind the hearse to Saint Michael's Church for her Mass. In Ireland, they leave the casket in the church overnight. At Clonmacnoise, they explain to me there is a mix-up, and they want to bury her down the hill near the Shannon. I said, "I can't put my mother so close to the water. Who's the manager here? Who's running the place?" A guy comes over, and we negotiated. I said, "Look, I can't take my mother back. I need the right grave." He says, "Michael, I'm going to help you," and he takes his shoe and marks out a space on the ground. This is how he measured. He says, "Let me see if I can get a spot for you here," and he gets a map of the graves. "If the spot is in pen, it's already taken, but I've got some in pencil. I can get something for you since your mother's already here."

They dig the graves there with little shovels. There are no backhoes. Three guys dug the grave, their shirts off, and I went out to get beer for them. They were so nice to us. They found me a great spot. There's a picture of my mother on the stone and some writing on it. I had the marathon medal engraved and put that on the stone, too. It's different [in Ireland]. *People don't panic as much. There's a lot of history in Clonmacnoise. The Pope said Mass there. He said it was the holiest place he'd ever felt. So my parents are in a good place, but it wasn't fun getting them there!*[145]

Mayor Neil O'Leary

Waterbury's current mayor, Neil O'Leary, is the ultimate cheerleader for his hometown. His enthusiasm and level of engagement has brought back a rolling up of one's sleeves and getting the job done kind of spirit. Mayor O'Neil is well liked and very much feels of this place.

His grandparents, Jeremiah Murphy, Elizabeth Houlihan, John O'Leary and Margaret Duggan, joined a large group of Kerry-based Irish when they arrived in Waterbury in the early 1900s. The O'Learys lived on lower Baldwin Street in the Abrigador and the Murphys farther back on Washington Hill. Though poor, "like everyone else," they quickly found employment through cousins and other family who had already settled in the bustling factory town. Like so many of Irish ancestry, the walls in their homes included references to Ireland and Catholicism and, eventually, a picture of John F. Kennedy. The marriage of Peggy Murphy and Neil (Cornelius) O'Leary produced six children, who still live within twenty miles of one another. The

Peggy Murphy, mother of future mayor Neil O'Leary, pinning a mother-of-the-bride corsage on Elizabeth Houlihan Murphy. *Photograph from the private collection of Christine Murphy.*

mayor remembered being surrounded by and deeply involved in a large Irish community when he was growing up in Waterbury. Sitting around the living room organ with extended family singing Irish songs was a common occurrence. "We knew every single one of them! We grew up around Irish brogues!" his sister, Christine Murphy, added. Their father, a firefighter, and their mother, a registered nurse, raised their children to understand and take pride in their roots, and all became deeply interested in politics. The family was very close to Mayor Edward D. Bergin Sr. "Bergin used to be at our house every Sunday night," O'Leary recalled, as his father hosted a regular game of set-back, a popular card game. "My father was lucky enough to shake the hand of President Kennedy when he came to Waterbury in 1962."

The time would come when the younger O'Leary had the occasion to spend an entire day with the former president's son John F. Kennedy Jr., who came in honor of John F. Kennedy High School's twenty-fifth anniversary. "My boss was an Irish guy from Washington Hill," O'Leary explained, when he was given the duty of escorting JFK Jr. throughout Waterbury. John Jr. "asked me to take him to the Elton hotel, where he could stand on

the same balcony in the same spot that his dad [had] stood while addressing the enormous crowd of people who came out to see him in 1960." O'Neil remembered JFK Jr. as having arrived in a yellow convertible VW bug. "He was an extraordinary guy...very engaging."

Neil O'Leary Sr. had been extremely upset at the news of the plane crash in which Kennedy, his wife and sister-in-law died and had been following the news all day, checking in regularly with his son, then police chief of Waterbury. In a tragic parallel coincidence, by the end of the night, on July 16, 1999, Mayor O'Leary's father would also be dead, of a heart attack.

Neil O'Leary has been to all the places his ancestors lived in Ireland and still has family there. "The first-generation sons and daughters in the Irish, Italian and Lithuanian communities maintained beautiful neighborhoods, and believed that education was the absolute stalwart of success," he recalled. "When my generation came back from college, Waterbury became less attractive." Neil O'Leary set out to work on behalf of the city, entering the police department in 1980. He retired in 2009, having been a detective, sergeant, lieutenant, captain, commander of the Criminal Investigation Bureau and chief of police from 2003. He was elected a Distinguished Fellow of the Academy of Certified Polygraphists Polygraph Science, and he still serves on several boards.

On July 8, 2014, the mayor, with Waterbury AOH president Chris Casey, presented the Omagh Thunder Youth Basketball Team of Northern Ireland with a proclamation at the Waterbury Hibernian Hall. The Catholic and Protestant youths aged fourteen to sixteen played a local Waterbury team and a joint team composed of players from Blessed Sacrament, Mount Carmel and St. Mary Magdalen schools during their two-day stay. Money for the trip to Connecticut was raised through local Waterbury Hibernian (AOH) fundraisers. The mayor celebrates Waterbury's diversity, explaining, "This used to be a city of ethnicities, but really it was mostly Irish and Italian...Now there are thirty-five different languages spoken here." In the third year of what has become an annual "Gathering," fifty different countries were represented, and more than five thousand participated, including every school, in a colorful and lively downtown parade that ended at the grounds of Library Park, where more than ten thousand people enjoyed multicultural food, music and dancing. Unwaveringly optimistic, Mayor O'Leary sees and is a catalyst toward a bright future in Waterbury.

He admits there is blight in some sections of town but is proud that under his administration more has already been done to improve the situation, including the razing of buildings, than has been throughout the previous

ten years. He explained that the Fanny Mae scandals affected Waterbury badly. Banks were giving out mortgages to people who could not afford to buy many of the old Victorian homes that are now in severe decay. New owners anticipated being able to support payments with rental income, but when that was not possible, they simply abandoned the properties. O'Leary is quick to state, however:

> *We're not quitters. We've been successful…We continue to pay for the sins of the past, but we still have a city of people who are proud to be here, and who believe in Waterbury. I'm very glad to say that we are still together, a respectful community. We don't have to deal with a lot of the things that other communities do. We have strong middle-class neighborhoods and the highest bond rating we've ever had. Fiscally, we are very strong. Our crime rate is very low, and our people get along.*[146]

Among many of his achievements in bringing back pride of place to the community, Waterbury's current mayor will likely be most remembered as the one who returned the cross to the top of Pine Hill. For those who did not grow up with memories of this major city landmark, it is necessary to digress. Starting in 1958 and lasting perhaps twenty years, attorney John Baptist Greco's "Holy Land U.S.A." was an integral part of the Brass City, a visible presence atop the Abrigador, attracting visitors on a regular basis, particularly in the Christmas season. In 1971, it was called "one of the fastest growing tourist attractions in the Northeast" by the *Catholic Transcript*, averaging "about 2,000 people a day."[147]

A Waterbury native (born in 1895), Greco, with the help of about ninety volunteers carrying buckets of concrete up the hill, re-created in miniature about two hundred Jerusalem and Bethlehem buildings associated with the life of Jesus. Holy Land U.S.A. was open to denominations of all faiths and ethnicities, and the Irish were as fond of the place as Italians in the predominantly Christian city. The fourteen-acre work was a serious act of devotion, intended to educate and communicate with others. Many Waterburians treated the site reverently; some proudly valued its sheer accomplishment, and others enjoyed its "theme park" feel. The site contained a Nativity crèche; a Star of David; underground catacombs, which included martyrs encased in glass; many statues; and plaques with quotations from the Bible that had been handwritten on hand-poured concrete and then painted. It also had an ecumenical chapel. At the top were three crosses with life-sized figures: Christ flanked by the two thieves. The pièce de resistance,

however, was the Pine Hill Peace Cross that could be seen for miles around. It was thirty-two feet high, fourteen feet across and lit by neon lights at night. A new metal one with bright orange edges replaced the first in 1968. Continual improvements and dedications for new additions—complete with the Mattatuck Fife and Drum Corps, dignitaries and members of various civic organizations—attracted large audiences.

Although there was some embarrassment about Holy Land's existence and the concept of a cross on Pine Hill at all, the popularity of the city attraction could not be denied. By the later '70s, however, it had seriously begun to decay, and Greco himself was having difficulty maintaining what

Looking up from the Abrigador at what was once attorney John Grecco's "Holy Land," you can view the new cross on Pine Hill. *Photograph August 2014 by the author.*

he had created. By the time of his death in 1986, the weathered site had been repeatedly vandalized and was generally dangerous, a ghostly vestige of its former self. Fascinating, nonetheless, as environmental folk art in a place where the best views of the city were still to be had, Holy Land's era had passed. The lighted cross also had to be taken down. A small band of nuns were left in charge of the site, albeit without the ability or funds to prevent continual deterioration.

Mayor O'Leary, with his friend the successful Catholic businessman Fritz Blasius, came up with a brilliant solution for restoring the integrity of Pine Hill, protecting it from further vandalism and bringing back the cross that for decades had been a landmark in the city once known as the most Catholic one in America. Many citizens and fundraisers supported the mayor's project, including within the Muslim community. The two men negotiated a $350,000 deal as private citizens to literally purchase the top of the mountain. The deed for the land was worded such that the place will be "Holy Land" forever. President of Pisani Steel, Joe Pisani, who had grown up at the hill's base, built the new twenty-two-ton, fifty-two-foot cross that is lit from within by five thousand LED lights, changing color with the liturgical calendar.

The new cross was first lighted on December 22, 2013, accompanied by block parties throughout downtown as Waterbury people cheered the

Washington Hill eighth grade graduation, 1936. *Photograph from the private collection of Ruth Conlon McGarty.*

Saint Margaret's School eighth grade graduation, 1942. *First row from left*: Patricia Crean, Irene Dowd, Ethel [surname unknown], Josephine Russell (cousin of Rosalind), Father Conlon (pastor), Bernice Ladden, unknown, Katherine McInerny and Nina [surname unknown]; *second row, from left*: Ronnie Proux, Mary Driscoll, three unknown boys, Betty Doran, unknown boy, Joan Brennan, four unknown children and Ruth Conlon; *third row, from right*: two unknown children, Mary Breen, Maria Hajjar and Roz Flannigan [remaining children unidentified]; *fourth row, from left*: unknown boy, Ed Cavanaugh, two unknown boys, Jack Greene, unknown boy and George Bergin [last four unknown]. *Photograph from the private collection of Ruth Conlon McGarty.*

positive, collaborative accomplishment. A Mass at Our Lady of Lourdes Church was celebrated before the event, and two thousand people filled the streets in front of Sacred Heart Church to welcome the return of a potent symbol. The Brass City's complex ethnic and religious history was transformed into a new present, and its beacon returned.

Upon accepting the 2008 Waterbury Hall of Fame induction on behalf of his relative Monsignor Slocum, John Fruin summarized a basic salt-of-the-earth connectivity that permeates Waterbury. "There's a richness here, back then as it is now, and it stays with you…Waterbury is an oversized small town. If you're from Waterbury, and you look through [an] article from 100 years ago, I'm sure there are persons' last names you'll recognize, and it's most likely a relative of someone who lived on your street, or with whom you went to high school…and the name will

stoke a memory, which will lead to a story, which you'll feel an urgency to tell someone!"[148]

Irishness remains in Waterbury like the currents that flow beneath its green, blended through the blood streams of many generations. Waterbury's heart beats strongly in a community that continues to change and rebuild itself from hopes, dreams and hard work. May the stories continue, the dreams be realized and people of every nationality thrive there.

Notes

Introduction

1. Sullivan, interview, 2015.

Chapter 1

2. *Connecticut Catholic*, "Catholics and the American Revolution."
3. Stone, *Irish—In Their Homeland*, 76.
4. O'Donnell, *History of the Diocese*, 95–96.
5. *Connecticut Journal*, April 12, 1798, 3.
6. Bronson, *History of Waterbury*, 248.
7. Allin, *General Laws and Liberties*, 28.
8. Bronson, *History of Waterbury*, 315.
9. Anderson, *Town and City of Waterbury*, 1:422.
10. Bronson, *History of Waterbury*, 288.
11. Lathrop, *Brass Industry in Connecticut*, 21.
12. Brecher, Lombardi and Stackhouse, *Brass Valley*, 5, citing P.W. Bishop, "History of Scovill Manufacturing Company," manuscript in Scovill collection, Baker Library, 175–78.
13. Lathrop, *Brass Industry in Connecticut*, 23.
14. ANC, U.S. Census Records, Waterbury, New Haven, Connecticut, 1840, Roll 28, p. 208, Image 422, FHL 0003021 (Corcoran, Moran); ibid., p. 214, Image 434 (Donnelly, Donahue, Riley); ibid., p. 215, Image 436

(Burns, Gallavin, Martin); ibid., p. 224, Image 454 (Carroll, Kavenaugh); ibid., p. 212, Image 430, and Page 209, Image 424 (Delany, Neville, Cochran); ibid., p. 213, Image 432 (Henessey).

15. ANC, U.S. Census Records, Waterbury, New Haven, Connecticut, 1850, Roll M432_45.

16. Anderson, *Town and City of Waterbury*, 2:243.

17. ANC, Barbour Collection of Connecticut Town Vital Records, Connecticut Town Marriage Records, pre-1870.

18. ANC, U.S. Census Records, Waterbury, New Haven, Connecticut, 1840, Roll 28, p. 208, Image 422, FHL: 0003021.

19. O'Donnell, *History of the Diocese of Hartford*, 383, notes William and Bridget's marriage (undated) with their first child born on May 11, 1837. A short film was produced in 1994 about John Reed that recounts the story of a recluse who lived in his family homestead at the outskirts of Waterbury. Considered a miser by the community, he was brought into the fold of a Franciscan group that ran a place for lonely people and wanderers, St. Christopher Inn. The Franciscan Friars (and Sisters) there established a local "Society of Atonement" in 1902 with John Reed as its first member. It may be that this story extends back to the Reed/Reid family of the 1850 census. This person, later known as Brother Philip, "had never wasted or squandered so much as a penny during all his long life of eighty-two years. He toiled early and late, eating the bread of carefulness. He never married, but he distributed alms secretly in practically every part of the Catholic missionary world." Begun as an Episcopal group in 1898, the society became part of the Catholic Church in 1909.

20. Santovasi, *Waterbury Named Places*. The file noted, "The origin of the name is of special interest. See p. 51"; however, no page 51 exists.

Chapter 2

21. Scully, "Early Irishman of Waterbury, Conn.," 159.

22. Anderson, *Town and City of Waterbury*, 3:728.

23. ANC, Barbour Collection of Connecticut Town Vital Records, Connecticut Town Marriage Records, pre-1870.

24. *Story of 100 Years*, 30.

25. FHL, Microfilm No. 1412840, town records, vols. 1–3, 1680–1851. They were followed by James Donnelly (aged two years, six weeks, April 1,

1835); Mary Corcoran (age three weeks, April 15, 1835); Ellen Donnelly (February 25, 1836, but born on the sixteenth); Catherine Moran (May 11, 1837); a child of Michael and Ann Neville (June 15, 1837); a child of Patrick and Mary Martin (1837); John Burns (October 12, 1837, but born on the third); John Thomas Delaney (May 8, 1837, but born on February 11); a child of James Tobin and Mary Ryan, who were married in Ireland (1838); John Delaney, son of Patrick and Mary (April 9, 1837); twins Susan and Catherine Delaney (October 21, 1839, but born on the fifth); and James Riley (June 14, 1840, but born on the second).

26. O'Donnell, *History of the Diocese of Hartford*, 382, 384.

27. Sheppard, phone interview and e-mails with the author, Corcoran family information, 2014. According to Sheppard, Timothy Corcoran died very young, and his children were raised by his brother. Arthur Corcoran, a descendant of Timothy's, was a marine master sergeant who served in Korea and was a past exalted leader of the Elks. He began the Marine Corps League in Waterbury, a youth group for teens that still exists.

28. O'Donnell, *History of the Diocese of Hartford*, 384.

29. Ibid., 333, 334.

30. Ibid., 382.

31. *Connecticut Catholic*, "Catholicity in Waterbury."

32. Anderson, *Town and City of Waterbury*, 3:732. A footnote references this editorial note within the O'Donnell section about Waterbury's Catholic history.

33. O'Donnell, *History of the Diocese of Hartford*, 383.

34. ANC, U.S. Census Records, Waterbury, New Haven, Connecticut, 1840, Roll 28, p. 212, Image 430, FHL 0003021

35. Ibid., 1850, Roll M432_45, p. 53A, Image 112.

36. Ibid., 1860, Roll M653_84, p. 122, Image 123, FHL 803084.

37. Anderson, *Town and City of Waterbury*, 3:1,220.

38. Ibid., 3:1,221.

39. Ibid.

40. Waterbury City Hall, Vital Records, 256. The debilitating condition can affect the throat, then turn to bronchitis and finally to consumption.

41. FHL, Microfilm No. 1412840, town records, vols. 1–3, 1680–1851; ibid., record of births, marriages and deaths, 1852–1871; ANC, Barbour Collection of Connecticut Town Vital Records, Connecticut Town Marriage Records, pre-1870.

42. FHL, Microfilm No. 1412885, record of marriages, vol. 1, item 3.

43. Gruber, "Waterbury's Forgotten Hero."

44. Maher, Old Saint Joseph Cemetery transcriptions. His mother, Ann, died at age seventy (April 6, 1877). Two of Michael and Ann Neville's sons died while they were still very young: Martin, age one (January 21, 1841) and John, two years, nine months (October 22, 1847). Timothy, who married Joanna Riley, died in New York at age sixty-one (November 26, 1898). Matthew F., who married a woman named Catherine, was sixty-three at his death on March 21, 1900.

45. Stone, *Irish—In Their Homeland*, 79.

46. O'Donnell, *History of the Diocese of Hartford*, 385.

47. *Times*, "Know Nothingism."

48. Ibid., "Naturalization."

49 *Litchfield Republican*, "What is Know-Nothingism?"

50. Anderson, *Town and City of Waterbury*, 3:1,023.

51. *Sunday Herald*, "Our Warm Hearted Brothers."

52. Kearney, domestic prelate and prosyndal judge of the Archdiocese of Hartford, Connecticut, was the highest-ranking monsignor outside Rome. His extensive notes about the churches of Connecticut were prepared for a book he intended to write. He died on June 14, 1974.

53. O'Donnell, *History of the Diocese of Hartford*, 386.

54. "Mummery" and "papist" quotes are taken from a long story that was printed in the *Boston Pilot*, dates not included, shared through e-mail by Betty Politivo on May 1, 2011. Potalivo shared her family research about Bishop Hendricken and her Ancestry.com tree. Also, Clarke, *Lives of the Deceased Bishops*, 155.

55. O'Donnell, *History of the Diocese of Hartford*, 386.

56. Ibid.

57. Anderson, *Town and City of Waterbury*, 2:528.

58. Article in Judd scrapbook and Anderson, *Town and City of Waterbury*, 2:752 (mention of Rice). Monsignor Francis Kearney put the date as March 10, 1860, for the purchase of fourteen acres at $2,000, perhaps adding to the initial purchase.

59. ANC, U.S. Census Records, Waterbury, New Haven, Connecticut, 1860, Roll M653_84, p. 114, Image 115, FHL 803084.

60. ANC, Index to New England Naturalization Petitions, Roll 17.

61. Ibid., U.S. Census Records, Waterbury, New Haven, Connecticut, 1870, Roll M593_112, p. 735A, Image 593, FHL 545611; ibid., 1880, Roll 103, FHL 1254103, p. 32B, Enumeration District 035, Image 0066; ibid., 1900, Roll 148, p. 13B, Enumeration District 0426, FHL 1240148.

62. ANC, U.S. Census Records, Waterbury, New Haven, Connecticut, 1870, Roll M593_112, p. 802A, Image 727, FHL 545611. Note: Vital Records include the death of Irish-born widower William J. Hendricken on July 5, 1876, aged thirty-five. He and his wife, Susan, had two children by 1870.
63. Providence had been a place of religious tolerance since its founding in 1636.
64. O'Donnell, *History of the Diocese of Hartford*, 386.

Chapter 3

65. *Columbian Register*, "Draft in Waterbury."
66. Maher, Old Saint Joseph Cemetery transcriptions.
67. Find a Grave, "Richard Ryan (1851–1933)."
68. Ninth Regiment Connecticut Volunteers 1861–1865, "Corporal Michael P. Coen."
69. *Souvenir Edition*, 4–5.
70. *Waterbury Democrat*, December 10, 1887.
71. *Souvenir Edition*, 1.
72. *Waterbury Democrat*, "Death of Stephen J. Meany."
73. *Evening Sun* reprint.
74. Ibid.
75. I have composed data from charts that Judd provided at the end of every ward section in the census.
76. Wesson, e-mails and conversations, 2014 and 2015.
77. Mattatuck Historical Society, *Ancient Burial Grounds*, 14.
78. *Sunday Herald*, "Scenes in a Cemetery."
79. ANC, U.S. Census Records, Waterbury, New Haven, Connecticut, 1860, Roll M653_84, p. 47, Image 48, FHL 803084.
80. Ibid., 1870, Roll M593_112, p. 780B, Image 684, FHL, 545611.
81. Letter dated April 1882, in the collection of the Knights of Columbus Museum.
82. "K. of C. Supreme Chaplain Buried."
83. ANC, U.S. Census Records, Waterbury, New Haven, Connecticut, 1900, Roll 148, p. 2B, Enumeration District 0436, FHL 1240148; ibid., Connecticut, Hale Cemetery Inscriptions and Newspaper Notices.
84. Farrell, post on CT-Waterbury-L listserv, May 16, 2013.
85. Ibid., e-mails and articles of information shared about the Bolans (and Kellys).

86. ANC, U.S. Census Records, Waterbury, New Haven, Connecticut, 1860, Roll M653_84, p. 76, Image 77, FHL 803084; ibid., 1880, Roll 103, FHL 1254103, p. 43D, Enumeration District 035, Image 0088.

87. Ibid., Waterbury Ward 5, New Haven, Connecticut, 1920, Roll T625_195, p. 8B, Enumeration District 470, Image 822; ibid., Waterbury, New Haven, Connecticut, 1930, Roll 280, p. 8A, Enumeration District 0257, Image 767.0, FHL 2340015.

88. Burke, e-mails, 2014, 2015; Find a Grave information.

89. Bergin, interviews, e-mails and printed materials, 2014, about the early Bergins and a particular branch of the Mahers of Laois about whom I have done further research not included here; ANC, U.S. Census Records, Waterbury, New Haven, Connecticut, 1900, Roll 147, p. 10A, Enumeration District 0423, FHL 1240147. The census states 1872 as their marriage year; however, she was not in the Maher census of 1870, which supports the possible earlier marriage date.

90. ANC, U.S. Census Records, Southington, Hartford, Connecticut, 1880, Roll 99, Family History Film 1254099, p. 83B, Enumeration District 030, Image 0167.

91. Ibid., 1870, Roll: M593_112, p. 727B, Image 578, FHL 545611. Online baptism records from the area of Ballynakill, County Laois, provide information about Patrick's family and tie to other graves in Old Saint Joseph Cemetery. The records were mislabeled "Ballinakill, County Galway." Patrick was listed in the Waterbury *City Directory* of 1868–69 and in the 1876 census. In 1870, his name appeared as "Mar."

92. Waterbury City Hall, Vital Records.

93. *Scoville Bulletin*, "When Scovill Had Mounted Policemen."

94. *Souvenir Edition*, 5.

95. Anderson, *Town and History of Waterbury*, 3:727.

96. Phelan, interviews and e-mails over the years, Phelan research. Dan was both her and Bettejane Wesson's ancestor.

97. Neil Hogan, editor of the *Shanachie*, a publication of the Connecticut Irish-American Historical Society, New Haven, CT, compiled research on the team.

98. *New York Times*, "Waterbury's Baseball Nine."

99. ANC, U.S. Census Records, Waterbury, New Haven, Connecticut, 1860, Roll M653_84, p. 36, Image 37, FHL 803084; ibid., pp. 35 and 38, Images 36 and 39.

100. Neil Hogan, in an e-mail to Taryn Phelan.

101. ANC, U.S. Census Records, Waterbury Ward 3, New Haven, Connecticut, 1920, Roll T625_195, p. 15A, Enumeration District 452, Image 64.

102. Ellyn Bergin Scully pamphlet from ancestors' collection (Subscribers to the Irish Relief Fund).

103. ANC, U.S. Census Records, Winchester, Litchfield, Connecticut, 1860, Roll M653_81, p. 51, Image 52, FHL 803081.

104. Silas Bronson Library's Waterbury Hall of Fame Biographies, Fruin, John acceptance speech.

105. ANC, U.S. Census Records, Waterbury, New Haven, Connecticut, 1860, Roll M653_84, p. 67, Image 68, FHL 803084; ibid., Index to New England Naturalization Petitions, Roll 19, Dennis Kilduff, age twenty-one, April 2, 1853.

106. *Souvenir Edition*, 25.

107. This stone may refer to children of Patrick and Bridget Maher, parents of Elizabeth Maher Bergin.

108. Maher, Old Saint Joseph Cemetery transcriptions.

109. Taryn Phelan shared her ancestor's copy of this pamphlet; Barber, *History of Abbeyleix.*

Chapter 4

110. *Waterbury Republican*, "Washington Hill Column."

111. Monti, *Publisher vs. Politician*, 14.

112. Dalton, Scully, Lyng and Lyng, interviews and correspondence with John Wiehn about the Irish-American Social Club; McGrath, online communication with John Wiehn about the Irish-American Social Club.

113. Dalton, Scully, Lyng and Lyng, interviews and correspondence with John Wiehn about the Irish-American Social Club; McGrath, online communication with John Wiehn about the Irish-American Social Club.

114. Monti, *Publisher vs. Politician*, 162.

115. Monagan, *Pleasant Institution*, 150.

116. Corbet, interviews and e-mails, 2014.

117. Burns, interview, 2014.

118. Scully and Doolan, interviews with John Wiehn, November 2014.

119. Scheiber, "Best Ted Williams Ever Faced," 2011.

120. John Wiehn interviewed Joyce's brother, Joseph, and niece, Eileen, in fall 2014.

121. ANC, U.S. Census Records, Waterbury Ward 2, New Haven, Connecticut, 1920, Roll T625_194, p. 1B, Enumeration District 440, Image 861; ibid., Waterbury, New Haven, Connecticut, 1930, Roll 279, p. 3B, Enumeration District 0219, Image 629.0, FHL, 2340014.

122. Charles Monagan, telephone interview, January 2015, and e-mails; Monagan, *Pleasant Institution.*

123. Estrada, "Congressman John Monagan Dies."

124. Monagan, *Pleasant Institution*, 368–69.

125. Ibid., 3.

126. David Farrell, e-mail comment after reviewing a portion of this manuscript, April 24, 2015.

127. Ruth Conlon McGarty, many interviews, photographs and memories shared, 2014, 2015.

128. Maher, photograph albums, scrapbooks and war records.

129. Monagan, phone interview, 2015.

130. Ibid., *Pleasant Institution*, 274.

131. Welles, "Honorable Winifred Weis McDonald."

132. Ibid.

133. McNellis, phone interview and e-mails, 2015.

134. Ibid.

135. Silas Bronson Library's Waterbury Hall of Fame Biographies, "Edward Daniel Bergin, Jr."

136. ANC, U.S. Census Records, Waterbury, New Haven, Connecticut, 1940, Roll T627_521, p. 7B, Enumeration District 5-241.

137. Goggin, Moraney and Carey, interviews, phone calls and mail with the author.

138. Burke, e-mails with author regarding Luddy family, including information from his relatives Maureen Luddy and Geri Maxwell, 2014, 2015.

139. Guest, "Myriad of Factors."

140. ANC, U.S. Census Records, Waterbury Ward 2, New Haven, Connecticut, Roll T625_194, p. 20A, Enumeration District 442, Image 992.

141. L'Heureux, phone interview and e-mails, 2015.

142. Ibid., "My Short Time at Chase Brass and Copper."

143. I recall walking a mile to school four times a day, as my friends and I came home for lunch during our K through eighth grade years at Bunker Hill School.

144. Dalton, interview and e-mails, summer 2014.

145. Ibid.
146. O'Leary, interview in summer 2014 and e-mail with his sister, Christine Murphy.
147. Mathews, *Italian Hill Town*, 7.
148. Silas Bronson Library's Waterbury Hall of Fame Biographies, John Fruin, acceptance speech.

BIBLIOGRAPHY

Books

Allin, John. *The General Laws and Liberties of Connecticut Colony: Revised and Published by Order of the General Court Held at Hartford, in October 1672*. Cambridge, MA, 1673. Reprint, Hartford, CT, 1865. Accessed via Google Books.

Anderson, Joseph, DD, ed. *The Town and City of Waterbury, Connecticut, from the Aboriginal Period to the Year Eighteen Hundred and Ninety-Five*. Vols. 1–3. New Haven, CT: Price and Lee Company, 1896.

Bologna, Sando. *The Italians of Waterbury: Experiences of Immigrants and Their Families*. Portland, CT: Waverly Printing Company, 1993.

Brecher, Jeremy, Jerry Lombardi and Jan Stackhouse (Brass Workers History Project). *Brass Valley: The Story of Working People's Lives and Struggles in an American Industrial Region*. Philadelphia: Temple University Press, 1982.

Brinkley, Douglas, and Julie M. Fenster. *Parish Priest: Father Michael McGivney and American Catholicism*. New York: Harper Perennial, 2007.

Bronson, Henry, MD. *The History of Waterbury, Connecticut: The Original Township Embracing Present Watertown and Plymouth, and Parts of Oxford, Wolcott, Middlebury, Prospect and Naugatuck, with an Appendix of Biography, Genealogy and Statistics*. Waterbury, CT: Bronson Brothers, 1858.

A Business Directory of New Haven County (Excepting City of New Haven). New Haven, CT: R.S. Dillon & Co., J.H. Beham & Son, Printers, 1869.

Clarke, Richard H., LLD. *Lives of the Deceased Bishops of the Catholic Church in the United States*. Vol. 3. New York: Richard H. Clark, 1888.

Clark, Samuel, and James S. Donnelly Jr., eds. *Irish Peasants: Violence and Political Unrest 1780–1914*. Madison: University of Wisconsin Press, 1983.

Collins, Alan C. *The Story of America in Pictures*. Garden City, NY: Doubleday & Company, Inc., 1956.

Connolly, S.J., ed. *The Oxford Companion to Irish History*. 2nd ed. Oxford, UK: Oxford University Press, 2002.

Driver, Jack M. *Freemasonry: Illustrated History of the Once Secret Order*. London: Kandour, Ltd., 2006.

Dunleavy, Janet I. *Douglas Hyde: A Maker of Modern Ireland*. Berkeley: University of California Press, 1991.

Ginty, Thomas M., and Maria Medina, eds. *Lift High the Cross*. Strasbourg, France: Éditions Du Signe, 2003.

Hart, Samuel. *Encyclopedia of Connecticut Biography, Genealogical-Memorial, Representative Citizens*. Compiled with assistance of an advisory committee. Boston: American Historical Society, Inc., 1917.

History of Waterbury and the Naugatuck Valley Connecticut, Illustrated. Vol. 2. Chicago: S.J. Clark Publishing Company, 1918.

Hogan, Neil. *The Cry of the Famishing: Ireland, Connecticut and the Potato Famine*. New Haven: Connecticut Irish American Historical Society, 1998.

———. *"Strong in Their Patriotic Devotion": Connecticut's Irish in the Civil War*. New Haven: Connecticut Irish American Historical Society, 2003.

Hometown Memories: A Picture Book of People and Places in Litchfield County, Greater Waterbury and the Naugatuck Valley. Waterbury, CT: Republican American, 2005.

Hopkins, G.M., CE. *Atlas of the City of Waterbury, Connecticut, Compiled, Drawn and Published from Actual Surveys*. Philadelphia: Office of the Librarian of the Library of Congress, 1879.

Joyce, P.W., LLD. *'98 Centenary Souvenir, Atlas and Cyclopedia of Ireland*. Part 1, *A Comprehensive Delineation of Thirty-Two Countries* and Part 2, *The General History, as Told by A.M. Sullivan, and continued by P.D. Nunan*. New York: Murphy & McCarthy, 1900.

Keneally, Thomas. *The Great Shame and the Triumph of the Irish in the English-Speaking World*. New York: Random House, 1998.

Kerr, Roy. *Roger Connor: Home Run King of 19th Century Baseball*. Jefferson, NC: McFarland & Company, 2011.

Maher, Janet. *From the Old Sod to the Naugatuck Valley: Early Irish Catholics in New Haven County, Connecticut*. Baltimore, MD: Apprentice House, 2012.

Maloney, Cornelius F., Margaret S. Sargent and William H. Watkins, eds. *Waterbury 1674–1974: A Pictorial History by the Mattatuck Historical Society*. Chester, CT: Pequot Press, 1974.

Monagan, Charles. *Greater Waterbury: A Region Reborn, a Contemporary Portrait.* Chatsworth, CA: Windsor Publications, Greater Waterbury Chamber of Commerce and the Waterbury Convention and Visitors Commission, 1989.

Monagan, John S. *A Pleasant Institution: Key—C Major.* Lanham, MD: University Press of America, 2002.

Monti, William A. *Publisher vs. Politician, A Clash of Local Titans.* ID: 714798. N.p.: www.lulu.com, 2007.

Murray, Thomas Hamilton. *History of the Ninth Regiment, Connecticut Volunteer Infantry, the Irish Regiment, in the War of the Rebellion, 1861–65.* New Haven, CT: Price, Lee & Adkins Co., 1903.

O'Donnell, Reverend James H., *History of the Diocese of Hartford.* Boston: D.H. Hurd Co., 1900.

Orcutt, Reverend Samuel. *History of Torrington, Connecticut, From Its First Settlement in 1737, with Biographies and Genealogies.* Albany, NY: J. Munsell, Printer, 1878.

Pape, William Jamieson, ed. *History of Waterbury and the Naugatuck Valley, Connecticut, Illustrated.* Vol. 1. Chicago: S.J. Clarke Publishing Company, 1918.

Prichard, Katharine, comp. *Ancient Burying-grounds of the Town of Waterbury, Connecticut.* Waterbury, CT: Mattatuck Historical Society, 1917. https://archive.org/details/ancientburyinggr00pric.

Record of Service of Connecticut Men in the Army and Navy of the United States During the War of the Rebellion. Compiled by the authority of the General Assembly under direction of the Adjutants General. Hartford, CT: Press of the Case, Lockwood & Brainard Company, 1889.

Reynolds, Edith, and John Murray. *A Brief History of Waterbury.* Charleston, SC: The History Press, 2009.

Russell, Howard S. *Indian New England Before the Mayflower.* Hanover, NH: University Press of New England, 1980.

Sheils, Damian. *The Irish in the American Civil War.* Dublin: The History Press Ireland, 2013.

Stone, Frank Andrews, ed. *The Irish—In Their Homeland, in America, in Connecticut.* The Peoples of Connecticut Multicultural Ethnic Heritage Studies Series, No. 1. Storrs: University of Connecticut, 1975.

Taylor, William Harrison. *Taylor's Legislative Souvenir of Connecticut.* Vol. 3, *1901–1902.* Putnam, CT: William Harrison Taylor, 1901. http://babel.hathitrust.org/cgi/pt?id=nyp.33433081884656;view=2up;seq=10.

Wallace, Patrick F., and Raghnall O Floinn, eds. *Treasures of the National Museum of Ireland, Irish Antiquities.* Dublin: Gill & Macmillan, National Museum of Ireland, 2002.

The Waterbury Directory for the Year 1869, Containing a General Directory of the Citizens. New Haven, CT: R.S. Dillon & Co., J.H. Beham & Son, Printers, 1869.

The Waterbury Directory for the Years 1868–9, Containing a General Directory of the Citizens, a Business Directory, a Record of the City, Town, and State Governments, Courts, Institutions, Societies, &c, &c, also Waterville Business Directory. New York: Webb & Fitzgerald.

Wesson, Bettejane Synott. *Bold as Brass.* Bloomington, IN: Xlibris Corporation, 2013.

———. *The View from Cracker Hill.* Bloomington, IN: Xlibris Corporation, 2008.

Wiehn, John, and Mark Heiss. *Waterbury 1890–1930.* Postcard History Series. Portsmouth, NH: Arcadia Publishing, 2003.

Woodham-Smith, Cecil. *The Great Hunger, Ireland 1845–1849.* New York: Penguin Books, 1962.

Journals/Catalogues/Pamphlets/Ephemera

Anderson, Reverend Joseph, DD. Uncited [probably the *American*] newspaper clipping of talk on April 27, 1884, in Sturges M. Judd scrapbook, collection of the Mattatuck Museum, Waterbury.

Barber, Norah, ed. *History of Abbeyleix, Abbeyleix Society, Founded by Raymond J. Fanning, 1893–1976, Retired Executive Editor of the Republican and American Newspaper.* N.p., ca. 1976.

Bergin, Ellyn Sully, interview with author, research mutually shared, in person and through mail, 2014.

Bohan, Ellen, Patricia Heslin, Paul Keroack, Bernard Singer and Roseanne Singer. *Early New Haven Irish and Their Final Resting Places: The Old Catholic and Saint Bernard Cemeteries.* Hamden: Connecticut Irish American Historical Society, 2013.

Burke, John, Jr. E-mails with author regarding Luddy family, including information from his relatives Maureen Luddy and Geri Maxwell, 2014, 2015.

Burns, Maureen. Written interview at AOH Hall, 2014.

Corbet, Kathleen Fruin. Interviews and e-mails with author, 2014.

Dalton, Hazel Boyce. Interview with John Wiehn about the Irish-American Club, 2014.

Dalton, Michael. Interview and emails with author, summer 2014.

Doolan, Francis "Pup." Interview with John Wiehn about George Mulligan, November, 2014.

Farrell, David. E-mails and articles of information shared with author about the Bolans, Kellys and Monagans, 2014, 2015.

Gelinas, Jean-Paul, *The True Knight of Columbus, Are You One?* 6th ed. Erie, PA: School of Languages, 1961.

Goggin, Betty, Eileen Maroney and Anne Goggin Carey. Interviews, phone calls and mail with author regarding the Goggin/Hussey/Crowley clan, summer 2014.

Hogan, Neil. "Connecticut's Irish Domestics." *Connecticut Explored* 11 (fall 2013): 26–31.

———. "Irish Leaders from Wooster Neighborhood in Wartime and Peacetime." *The Shanachie* 25 (2013): 9.

———. Research on the Waterbury Nine shared with Taryn Phelan, who shared it with the author, 2014.

Immaculate Conception Parish. *The Story Continues…Celebrating the One-Hundred Fiftieth Anniversary of the Church of the Immaculate Conception, 1847–1997.* Waterbury, CT, n.d.

Joyce, Eileen, online communication with John Wiehn about Joan Joyce, fall 2014.

Joyce, Joseph, interview with John Wiehn about Joan Joyce, fall 2014.

Judd, Sturges, M. *Inhabitants of the City of Waterbury, County of New Haven, State of Connecticut, 1876.* Microfilm, Silas Bronson Library, Waterbury, CT.

———. *A Record of Burials in the Burying Grounds of Waterbury, Conn. (Excepting Riverside and St. Joseph Cemetery) Compiled from Personal Research, with a Map of the Grand Street Cemetery. Duplicate of this deposited in Citizen's Bank. Collection of the Mattatuck Museum, Waterbury.* N.p., 1884.

———. Scrapbook, collection of the Mattatuck Museum, Waterbury, CT.

Kearney, Monsignor William Francis. Research notes for all the Catholic Churches in Connecticut (Immaculate Conception, Our Lady of Lourdes, Sacred Heart, Saint Ann's, Saint Cecilia's, Saint Francis Xavier, Saint Joseph's, Saint Michael's, Saint Patrick's Saint Thomas'). Archdiocese of Hartford Archives, Hartford, CT.

Kilmartin, Edward J. "Edward W. McDonald M.D., Waterbury." *Proceedings of the Connecticut State Medical Society, 1907: 115th Annual Convention Held at Hartford May 22 and 23, Connecticut State Medical Society.* Edited by Walter R. Steiner. Hartford: Connecticut State Medical Society, 1908.

Lathrop, William G. *The Brass Industry in the United States: A Study of the Origin and the Development of the Brass Industry in the Naugatuck Valley and Its Subsequent Extension Over the Nation.* Rev. ed. Mount Carmel, CT: Wilson H. Lee Company, 1926.

————. *The Development of the Brass Industry in Connecticut.* Tercentenary Commission of the State of Connecticut, Committee on Historical Publications, 49. New Haven, CT: Yale University Press, 1936.

L'Heureux, Jaime. Phone interview and e-mails with author, 2014.

The Life and Legacy of Father Michael J. McGivney. Knights of Columbus pamphlet.

Lyng, Mary, and James Lyng. Interview with John Wiehn about the Irish-American Social Club, 2014.

Maher, Edward J. Photograph albums, scrapbooks and war records.

Maher, Janet. Old Saint Joseph Cemetery transcriptions, photographs taken and notes generated from tombstones between 2006 and 2014, unpublished.

Mass of Rededication, Church of Saint Patrick, Waterbury, Connecticut. Pentecost Sunday, June 2, 1974. Pamphlet. Archdiocese of Hartford Archives, Hartford, CT. Copies in possession of the author.

Mathews, Cristina. "An Italian Hill Town with a Neon Cross: The Short-Lived Alchemy of Holy Land U.S.A." Unpublished paper, Yale University, September 1991.

McGrath, Pat. Online communication with John Wiehn about the Irish-American Social Club, 2014.

McNellis, Thomas. Phone interview and e-mails with author, 2015.

Memorial Dedication of St. Patrick's Church. Waterbury, CT, January 18, 1903.

Monagan, Charles. Telephone interview and e-mails with author, January 2015.

Morrissey, Rev. Francis J. "The Life of the McGivneys." Typed document. Archive of the Knights of Columbus Museum, New Haven, CT.

Murray, Thomas Hamilton. *The Journal of the American-Irish Historical Society, Volume II.* Boston: American-Irish Historical Society, 1899.

O'Leary, Mayor Neil. Interview with author, summer 2014.

One Hundred Years of Columbianism in Waterbury. Sheriden Council No. 24, May 2, 1885–May 2, 1985.

O'Reilly, Sister Mary Cecilia. *Sisters of Mercy in the Dioceses of Hartford.* Edited by Sister Mary Valerian Reilly. Imprimatur: John J. Nilan, Bishop of Hartford, December 12, 1931. Hartford, CT: R.S. Peck & Co., 1931.

Phelan, Taryn. Conversations, interviews and e-mails with author over several years, particularly 2014.

Politivo, Betty. E-mails with author regarding her family research about Bishop Hendricken and her Ancestry.com tree, particularly in May 2011

The Roman Catholic Church of Saint Patrick. Waterbury, CT, 2003.

Saint Patrick's Church, Waterbury, Connecticut. South Hackensack, NJ: Custombook, Inc., 1980.

Santovasi, Steven P. *Waterbury Named Places.* PDF text file recovered from the Map Vault of the City Engineer, 37 pages. Waterbury, CT, n.d.

Scovill Manufacturing Company. *Scovill Brass Works.* Historic American Engineering Record. National Park Service, Northeast Region. Philadelphia Support Office, U.S. Custom House, 200 Chestnut Street, Philadelphia, PA.

Scully, Martin. "An Early Irishman of Waterbury, Conn." In *Journal of the American-Irish Historical Society.* Vol. 2. Edited by Thomas Hamilton Murray. Boston: American-Irish Historical Society, 1899.

Scully, William, Jr. Interviews with John Wiehn about the Irish-American Club, George Mulligan and other related topics, 2014.

Sheppard, Robbin. Phone interview and e-mails with author regarding Corcoran family information, 2014.

Souvenir Book of the Charity Bazaar Under the Auspices of the United Catholic Societies for the Benefit of the New St. Mary's Hospital at City Hall, in Waterbury, Connecticut, April 13th to 22nd, 1907. The Waterbury Blank Book Manufacturing Company, April, 1907.

Souvenir Edition, Waterbury Democrat, April 1893. Collection of the Connecticut Historical Society, Hartford.

Souvenir of the Dedication of the New Church of the Immaculate Conception, Waterbury, Connecticut. May 20, 1928. Archdiocese of Hartford Archives, Hartford, CT.

The Story of 100 Years, 1847–1947. Pamphlet. Immaculate Conception Parish, Waterbury, CT.

Subscribers to the Irish Relief Fund, Waterbury, Conn., 1880. Hartford. CT: Case, Lockwood and Brainard Company, 1880.

Sullivan, Alfred E., conversations, phone interviews and e-mails with author over several years, particularly in 2015.

Sunday Herald. "Scenes in a Cemetery: The Rise and Fall of the Grand Street Burial Place, Removing the Bones, Picture of 'Father Judd', the Philosopher and Philanthropist." Judd scrapbook, collection of Mattatuck Museum, Waterbury, CT.

Waterbury City Hall. Vital Records. Volume 2, Deaths, 1874–1886.

Waterbury Republican-American. *Western Connecticut's Great Flood Disaster, August 19, 1955.* Waterbury, CT, 1955.

Welles, Suzanne McDonald. "The Honorable Winifred Weis McDonald." Unpublished manuscript in author's possession.

———. Interviews and e-mails with author over several years, particularly in 2014, 2015.

Wesson, Bettejane. Interviews and e-mails with author, 2014 and 2015.

Articles

Catholic Transcript. "K. of C. Supreme Chaplain Buried." March 23, 1839.

Columbian Register. "The Draft in Waterbury." August 29, 1863, 1 (GenBank).

———. "Election Returns." April 9, 1870, 2 (GenBank).

Connecticut Catholic. "Catholicity in Waterbury, First Irish Settlers—Rapid Growth and Development-First Mass, Etc." January 2, 1886.

———. "Catholics and the American Revolution." July 8, 1876, 1.

Connecticut Journal, April 12, 1798, 3 (GenBank).

Dooling, Michael. "More Than a Meetinghouse, History of City Hall Is a Tale of Tragedy, Triumph." *City Hall: A Symbol of Civic Pride*, November 28, 2010. *Sunday Republican* magazine supplement.

Estrada, Louie. "Congressman John Monagan Dies." *Washington Post*, October 25, 2005.

Evening Sun reprint in the *Waterbury Democrat*, February 9, 1888.

Gruber, Bill. "Waterbury's Forgotten Hero, Capt. Edwin M. Neville Won the Medal of Honor but He Remains an Obscure Figure in the City's History." *Sunday Republican Magazine*, May 22, 1988.

Hartford Courant. "Death of Waterbury Merchant." September 23 1902, 1.

———. "George Mulligan, Famed Promoter of Fights and Pro Football Dies." July 28, 1955, 17.

———. "Guilfoile Urges Police Activity." January 25, 1925, B7.

———. "Major F.J. Bannigan, Speaker at Banquet in Waterbury Tonight." March 16, 1935, 14 (ProQuest).

———. "Mayor Kilduff Going to New York," December 30, 1903, 1 (ProQuest).

———. "Pictures: Lighting Up the Holy Land U.S.A. Cross." December 22, 2013. http://www.courant.com/community/waterbury/hc-pictures-lighting-up-the-holy-land-usa-cross-20131222-photogallery.html.

———. "Tribute Is Paid St. Patrick by 3000 Marchers, Prominent State Figures Review Parade Held in Waterbury." March 16, 1936, 4 (ProQuest).

Irish World. "Fenton Phelan." Obituary, October 20, 1894, 2 (GenBank).

Litchfield Republican. "What Is Know-Nothingism?" March 8, 1855, 2 (GenBank).

Maloney, Cornelius F. "Gallery of Mayors." *Waterbury Republican Sunday Magazine*, November 2, 1975, 6–7, 12.

New Haven Register. "Are All in Line for It. The Democratic State Ticket." September 26, 1894. NewsBank and/or the American Antiquarian Society (GenealogyBank.com), 2004.

New London Day. "George Mulligan." Obituary, July 28, 1955.

New York Herald. "Bishop Thomas Francis Hendricken." Obituary, June 13, 1886 (GenBank).

———. "Connecticut, Stars in the Choir, Performances by Clever Singers of a Waterbury Parish, Their Latest Success." March 22, 1891.

New York Times. Ahles, Dick, "Kickbacks and Payoffs in the 1930s." February 1, 2004. http://www.nytimes.com/2004/02/01/nyregion/kickbacks-and-payoffs-in-the-1930-s.html.

———."Mayor V.A. Scully of Waterbury Dies." January 10, 1943, 50.

———. "Stephen J. Meany's Remains." February 10, 1888, 3 (ProQuest).

———. "Waterbury's Baseball Nine, How They Are Cared for by a Shrewd Yankee Farmer." July 11, 1886.

Republican-American. "A Gathering of Culture." Larson, Andrew. May 16, 2015. http://www.rep-am.com/articles/2015/05/16/news/local/881731.txt.

Scovill Bulletin. "When Scovill Had Mounted Policemen, Picture Leads to Story of Four-Horse Plant Protection Patrol." June 10, 1946, 2.

Special, Hartford Courant. "Father Duggan Dead: Fall Proves Fatal to One of the Leading Priests of the Diocese." Nov. 11, 1895, 9. (ProQuest).

———. "Irish, 10,000 Strong, to March in Waterbury." March 11, 1936 (ProQuest).

———. "6000 March in Waterbury's Parade Today, St. Patrick's Day Celebration Will Be That City's Largest." March 17, 1935, 14 (ProQuest).

Sunday Herald. "Our Warm Hearted Brothers." March 17, 1889, 1.

Times. "Know Nothingism." November 22, 1854, 2 (GenBank).

———. "Naturalization." December 16, 1854, 3 (GenBank).

Unknown newspaper (possibly *Waterbury Democrat*). "Thomas F. Bergin, Late Mortician, Sterling Citizen, School Commissioner, Widely Known, Highly Respected in Community, Out Easter Attends Funeral, Waterbury, Connecticut." Monday, January 31, 1938.

Waterbury American. "Bronze Medal Awarded to Cpl. McGarty." June 13, 1945, 22.

———. "Guilfoile Rites 10 A.M. on Monday: Former Mayor Is Found Dead in Office." March 20, 1943, 1, 12.

———. "Thomas Kelly." Obituary. May 18, 1931, 1.

Waterbury Democrat, December 10, 1887.

———. "Death of Stephen J. Meany." February 8, 1888, 1.

———. "Former Mayor Kilduff Dies." May 1, 1936, 1.

———. "Funeral of Stephen J. Meany." Reprinted, uncited article from the *New York Sun*.

———. Obituary of Dennis Kilduff. November 30, 1916.

Waterbury Evening Democrat. "The Dead Irish Patriot." 1888 (undated printed article).

Waterbury Observer, "Myriad of Factors Led to the Collapse of Brass Production in Waterbury." Raechel Guest, February 29, 2012. http://www.waterburyobserver.org/node/807.

———. "My Short Time at Chase Brass and Copper." Comment on "Myriad of Factors Led to the Collapse of Brass Production in Waterbury." L'Heureux, Jaime, March 1, 2012. http://www.waterburyobserver.org/node/807.

Waterbury Republican. "Demise of P. J. Bolan." September 23, 1902, 2–3.

———. "Macdonald Raps 'Red Pen Stories,' Character Star of 'Iron Horse' Visits Waterbury. His Birthplace—Guest of Sister and Brother-in-Law, Dr. and Mrs. M.J. Lawlor—Starts New Picture Soon." May 29, 1927.

———. "Many at Dance: Over 1,600 attend Washington Hill A.C. Affair." March 18, 1917.

———. "Omagh Brings Thunder." Palladino, Joe, July 9, 2014, B09, B12.

———. "Thomas Kelly." Obituary. January 5, 1946, 10; January 9, 1935, 6.

———. "Thomas Luddy." Obituary. December 24, 1936.

———. "Washington Hill Column." March 18, 1917.

Family Search Online Resources

Family Search, microfilm rentals. Waterbury (Connecticut) Registrar of Vital Statistics. Salt Lake City, UT: Filmed by the Genealogical Society of Utah, 1985. www.familysearch.org. Abbreviated FHL in notes.

Microfilm Nos. 1412840 and 1412841. Record of births, marriages, and deaths, 1852–1871.

Microfilm Nos. 1412841, 1412884 and 1412885. Records of deaths. Vols. 1–4, 1864–1902.

Microfilm Nos. 1412843, 1412883 and 1412884. Records of births. Vols. 1–5, 1871–1901.

Microfilm Nos. 1412885 and 1412886. Records of marriages. Vols. 1–5, 1851–1854, 1867–1906.

Microfilm Nos. 1412886 and 1412840. Town records. Vols. 1–3, 1680–1851.

Ancestry.com Online Resources

Subscription enabled the researching of censuses, other historic data and newspapers (abbreviated ANC in the notes).

The Barbour Collection of Connecticut Town Vital Records. Connecticut Town Marriage Records, pre-1870, Provo, UT: Ancestry.com Operations Inc., 2006.

Connecticut, Hale Cemetery Inscriptions and Newspaper Notices, 1629–1934 [database online]. Provo, UT: Ancestry.com Operations, Inc., 2012.

Index to New England Naturalization Petitions. Washington, D.C.: National Archives and Records Administration, 1791–1906 (M1299). Rolls 17 and 19.

U.S. Census Records. Waterbury, New Haven, Connecticut, 1840, 1850, 1860, 1870, 1880, 1900, 1930, 1940.

———. Waterbury Ward 5, New Haven, Connecticut, 1920.

———. Waterbury Ward 3, New Haven, Connecticut, 1920.

———. Waterbury Ward 2, New Haven, Connecticut, 1930.

———. Winchester, Litchfield, Connecticut, 1860.

———. Southington, Hartford, Connecticut, 1880.

Other Online Sources

Alderman, Joel, "Waterbury's Own Home Run Champion Held Record Before Ruth." *SportzEdge.com*, July 13, 2013. http://sportzedge.com/2013/07/13/waterburys-roger-connor-made-hall-of-fame-set-career-record-for-home-runs-that-babe-ruth-broke.

Ancient Order of Hibernians, Friendship, Unity and Christian Charity. "AOH History." http://www.aoh.com/aoh-history.

Archdiocese of Hartford Ministries. "Our Own Story, The *Catholic Transcript*." http://www.archdioceseofhartford.org/ministries/transcript.htm.

Atonement Friars. http://www.atonementfriars.org/who_we_are/friars_history.html.

Biographical Directory of the United States Congress. "Monagan, John Stephen (1911–2005)." http://bioguide.congress.gov/scripts/biodisplay.pl?index=M000847.

Boston College. "Boston College Launches Nation's First On-line Database for Tracking 'Lost' 19th and Early 20th Century Irish Emigrants." http://www.bc.edu/bc_org/rvp/pubaf/04/IrishAds.html.

Clare Library. "Stephen Joseph Meany (c.1825–1888)." http://www.clarelibrary.ie/eolas/coclare/people/stephen_meany.htm.

Connecticut Women's Hall of Fame. "Joan Joyce." http://www.cwhf.org/inductees/sports/joan-joyce#.VVDTi6aNSM4.

D'Angelo, Anthony Tyler. "The 1866 Fenian Raid on Canada West: A Study of Colonial Perceptions and Reactions Towards the Fenians in the Confederation Era." Master's thesis, Queen's University, Kingston, Ontario, Canada, September, 2009. http://qspace.library.queensu.ca/bitstream/1974/5192/1/D'Angelo_Anthony_T_200909_MA.pdf.

Encyclopedia.com. "Sachem of the Wampanoags Philip." http://www.encyclopedia.com/topic/Sachem_of_the_Wampanoags_Philip.aspx.

Farrell, David. Post on CT-Waterbury-L listserv, May 16, 2013. http://archiver.rootsweb.ancestry.com.

Father McGivney.org. "Venerable Michael McGivney." http://www.fathermcgivney.org.

Find a Grave. "Richard Ryan (1851–1933)." Contributed by Don Morfe. http://www.findagrave.com/cgi-bin/fg.cgi?page=gr&Grid=57005785.

———. "Roger Connor." Contributed by John Griffith. Memorial No. 21218. http://www.findagrave.com/cgi-bin/fg.cgi?page=gr&GSln=Connor&GSfn=Roger&GSiman=1&GScid=103553&GRid=21218&.

———. "Thomas Luddy." Old Saint Joseph Cemetery, Waterbury, Connecticut, Memorial No. 6301123. Contributed by John Burke Jr. http://www.findagrave.com/cgi-bin/fg.cgi?page=gr&GSln=Luddy&GSfn=Thomas&GSiman=1&GScid=103553&GRid=6301123&.

Florida Center for Instructional Technology. "The Seminole Wars." http://fcit.usf.edu/florida/lessons/sem_war/sem_war1.htm.

Friars of the Atonement, Union That Nothing Be Lost. "Buried Treasure , The Miser of Waterbury—A True Story (the life of John Reed)." http://vimeo.com/38530153.

Fruin, John. Acceptance speech on behalf of Monsignor Slocum. Silas Bronson Library Waterbury Hall of Fame induction, 2008. http://youtu.be/n8kev3ealTg.

Genealogy Bank, paid subscription, historical newspapers (©2004, NewsBank and/or the American Antiquarian Society, abbreviated GenBank in notes).

Gold, Ilana. "Holy Land Cross Raised in Waterbury." NBC Connecticut. http://www.nbcconnecticut.com/news/local/Giant-Holiday-Cross-Raised-in-Waterbury-236818351.html.

Greater Waterbury.com. "Waterbury CT Mayors." http://www.greaterwaterbury.com/waterbury_mayors.php.

Guest, Raechel, "Waterbury Thoughts." http://waterburythoughts.blogspot.com.

Halperin, John. "PX 67-12a Motorcade During President Kennedy's Visit to Waterbury, Connecticut." October 17, 1962." http://www.jfklibrary.org/Asset-Viewer/fbneTwchQkKeuugvkgqh9g.aspx.

"History of the *Republican-American*." http://www.rep-am.com/about/history.

Holy Land Waterbury. "Lighting Up the Holy Land USA Cross." http://holylandwaterbury.com/index.php/features/articles.

Information Wanted. "A Brief History of the *Boston Pilot*." http://infowanted.bc.edu/history/briefhistory.

Irish Ancestors, *The Irish Times*. "Roman Catholic Parish Registers," http://www.irishtimes.com/ancestor/fuses/rcparishmaps/index.cfm?fuseaction=showidrecords&CityCounty=Laois&parish=Ballynakill&churchid=690.

Jane Doe No More. "Bio: Neil O'Leary." https://www.janedoenomore.org/about/bios/74.

"JFK in Connecticut." ctpost.com, November 21, 2013. http://www.ctpost.com/news/slideshow/JFK-in-Connecticut-74592.php.

John F. Kennedy Library. "Remarks of Senator John F. Kennedy, Street Rally, Waterbury, Connecticut, November 6, 1960." http://www.jfklibrary.org/Research/Research-Aids/JFK-Speeches/Waterbury-CT_19601106.aspx.

————. "Remarks on the Green in Waterbury, Connecticut, 17 October 1962." Audio. http://www.jfklibrary.org/Asset-Viewer/Archives/JFKWHA-140-003.aspx.

Kenneally, Ian. "The Fenian Invasion of Canada, 1866." The Irish Story. http://www.theirishstory.com/2011/09/16/the-fenian-invasion-of-canada-1866/#.VJ2P5Z0QE.

Legacy.com. Joseph Francis Joyce obiturary. http://www.legacy.com/obituaries/palmbeachpost/obituary.aspx?n=joseph-francis-joyce&pid=163907628.

Library of Congress. Roger Connor image. http://www.loc.gov/pictures/resource/npcc.14317.

MaherMatters: Ancestry Maher/Meagher/Meachair. "Meagher/Maher Women, Some New Connections." May 13, 2013. http://mahermatters.com/2013/05/13/meaghermaher-women-some-new-connections.

Mattatuck Museum. "Fortune's Story, Burial Locations: Waterbury's Early Cemeteries." http://fortunestory.org/religionandslavery/burial.asp.

Murphy, Dan. "The Day the Irish Invaded Canada." Irish America, April/May 2012. http://irishamerica.com/2012/03/the-day-the-irish-invaded-canada.

Ninth Regiment Connecticut Volunteers 1861–1865. "Corporal Michael P. Coen." http://www.ninthregimentcv.com/soldiers/corporal-michael-coen.html.

Official Site of the Florida Atlantic Owls. "Softball: Joan Joyce." http://www.fausports.com/sports/w-softbl/mtt/joan_joyce_48524.html.

Pilgrim Hall Museum. "King Philips War & The Continued Presence of Native People." http://www.pilgrimhallmuseum.org/ap_king_philip_war.htm.

Political Graveyard. "Politicians in Trouble or Disgrace." http://politicalgraveyard.com/trouble/embezzlement.html.

Proquest Historical Newspapers, database at Connecticut State Library.

"Rosalind Russell Receiving a Special Oscar Statuette." http://www.vidoevo.com/yvideo.php?i=MU50SWdPcWuRpOF9YNVk&rosalind-russell-receiving-a-special-oscara-statuette.

Scheiber, Dave. "Joan Joyce: The Best Ted Williams Ever Faced." ESPNW, August 5, 2011. http://espn.go.com/espnw/news/article/6833700/best-ted-williams-ever-faced.

Silas Bronson Library's Waterbury Hall of Fame Biographies. "Captain Edwin M. Neville." http://www.bronsonlibrary.org/filestorage/33/neville.bmp.

———. "Edward Daniel Bergin, Jr." bronsonlibrary.org/filestorage/1521/1545/Dan_Bergin.pdf.

———. "Joan Joyce." http://www.bronsonlibrary.org/filestorage/1521/1545/J_Joyce.pdf.

———. "Rosalind Russell." http://www.bronsonlibrary.org/filestorage/33/russell.bmp.

———. "Rt. Rev. Msgr. William J. Slocum 1851–1908." http://www.bronsonlibrary.org/filestorage/1521/1545/Slocum.pdf.

———. "Winifred Weis McDonald." http://www.bronsonlibrary.org/filestorage/1521/1545/MCDONALD%5b1%5d.jpg.

Tougias, Michael. "King Philip's War in New England." The History Place, A Writer's Corner, 1997. http://www.historyplace.com/specials/writers/kingphilip.htm.

Waterbury Time Machine: Vintage Views and Memories of the Brass City. Created and maintained by an ex-Waterburian. http://www.freewebs.com/waterburyct.

Wenzel, Joseph, IV, and Jill Konopka. "New Cross Installed at Holy Land in Waterbury." *Eyewitness News* 3, December 19, 2013, updated January 16, 2014. http://www.wfsb.com/story/24264956/new-cross-installed-at-holy-land-in-waterbury.

INDEX

About the Collaborators

Author Janet Maher is a professional artist who directs the studio arts program at Loyola University Maryland. The first full-time art teacher at Holy Cross High School, she created the curriculum for the school's Art Department.

Photograph by Anastasia Tantaros, 2014.

Collaborator John Wiehn is the director of Prospect Public Library. A lifelong resident of Hopeville, he has served in all Ancient Order of Hibernian elected state offices over the past fourteen years, most recently as state president.

Photograph by John Wiehn.